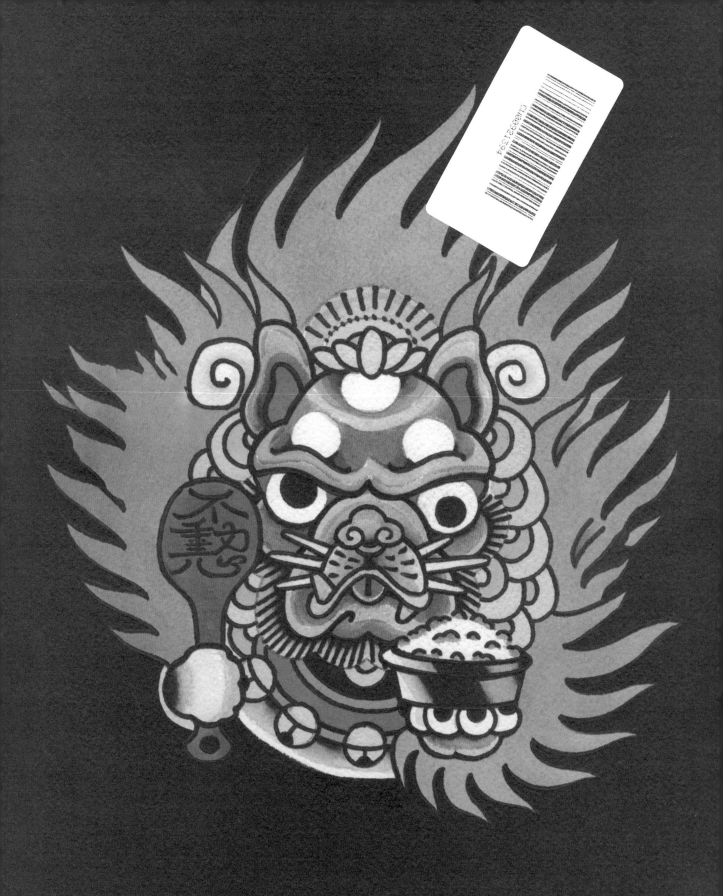

KNIVES

and

NEEDLES

TATTOO ARTISTS IN
THE KITCHEN

SCHIFFER
PUBLISHING
4880 Lower Valley Road • Atglen, PA 19310

Molly A. Kitamura

John Agcaoili

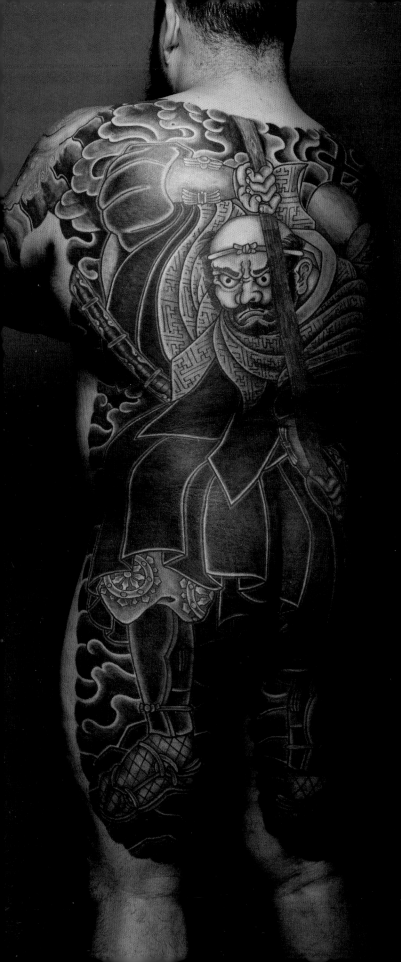

Other Schiffer Books on Related Subjects:

Bushido: Legacies of the Japanese Tattoo, Takahiro Kitamura, ISBN 978-0-7643-1201-4
Musical Ink, Jon Blacker, ISBN 978-0-7643-4443-5
TattooIsMe, Chris Coppola, ISBN 978-0-7643-4298-1

Designed by Molly Shields

Photos by John Agcaoili unless otherwise noted
Type set in Archer/Caxton

ISBN: 978-0-7643-5814-2
Printed in China

Published by Schiffer Publishing, Ltd.
4880 Lower Valley Road
Atglen, PA 19310
Phone: (610) 593-1777; Fax: (610) 593-2002
E-mail: Info@schifferbooks.com
Web: www.schifferbooks.com

For our complete selection of fine books on this and related subjects, please visit our website at www.schifferbooks.com. You may also write for a free catalog.

Schiffer Publishing's titles are available at special discounts for bulk purchases for sales promotions or premiums. Special editions, including personalized covers, corporate imprints, and excerpts, can be created in large quantities for special needs. For more information, contact the publisher.

We are always looking for people to write books on new and related subjects. If you have an idea for a book, please contact us at proposals@schifferbooks.com.

TABLE OF CONTENTS

I'm going to keep this short and sweet. I love cooking and am fortunate enough to have enjoyed a successful career doing what I feel passionate about. Another art I have devoted my life and body to is the art of tattooing, and again, I am very lucky to know some of the best tattooers in the world. I know I am not the only one with these obsessions! Over the years, I've noticed so many similarities between tattooers and chefs, from their creativity and their transient lifestyles to the way the public has come to embrace these formerly frowned-upon and often-dismissed communities. Through television programs and social media, these traditionally "working class" types have become pseudo celebrities. A few years ago I started a blog, knivesandneedlesblog.com, to explore this subject. I kept it light, with candid interviews from foodie tattooers and tattooed chefs on their lives, cooking tips, recipes, and beautiful tattoos. This naturally led to collecting them all into one book.

In this cookbook, my friend and photographer John and I have curated some of the best tattoo artists in California (and a few beyond) and some of their favorite dishes. To round out the book, we also asked a small, select group of chefs working in California to submit one of their many recipes—and of course we shot their tattoos! I hope you enjoy this beautifully shot and useful tattooed cookbook John and I have put together.

I would like to thank, first and foremost, my husband, Taki—without his support and encouragement I would not have been able to create this book. I would also like to thank John Agcaoili, who is one of the most talented photographers I know and took this journey with me!

Lastly, but certainly not leastly, I would like to thank Aithor, Bill, Junii, Blake, Carolynn, Cats, Chad, Chris, Chuey, Doug, Drew, Eric, Freddie, Horitomo, Jason, Jeff, Jen, Jose, Joseph, Juan, Koji, Mary Joy, Megan and Ryan, Philip, Rob, Steve, Teddie, Tony, Yoshiyuki, and Zac for all participating in this project and being so generous with their time, energy, and amazing creativity. Due to time and location, we needed the talents of a few other photographers along the way, so a special thank you to: EJ in San Francisco, Chris Henley in Dallas, Michelle Haefs in Vegas, Janet Scheinbaum in Santa Fe, and Mary Morales in Hesparia. We could not have made this without you!

Author's note: Since compiling this book, Bill Salmon has passed away. This book is dedicated to his life and memory.

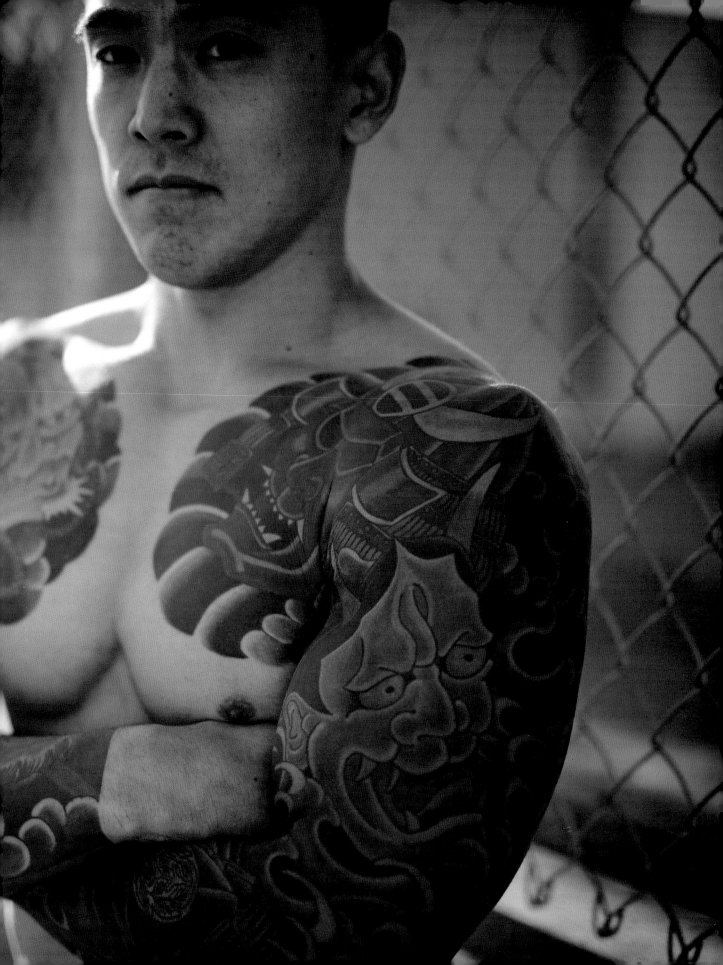

FREDDY CORBIN

What can I say about Freddy that hasn't already been said, written, seen, or experienced? Through decades of living history, he has become an iconic tattoo legend with style for miles. His personal depth and soul come out in every tattoo he does—you can see it in his eyes and the generously wise words. He is one of those rare people who has been there, done that, and come out the wiser for it. Freddy has and continues to be hugely influential in the tattoo world and is a pillar of the Bay Area tattoo community. Despite his significance, Freddy is humble, kind, and welcoming to all.

Dining with Freddy means that you're in for a fun time at a local Oakland gem. We thought it would be fun to ask Freddy for a recipe to kick the book off with, and he certainly did not disappoint! Check out this fun one from Freddy Corbin! Thank you, Freddy!

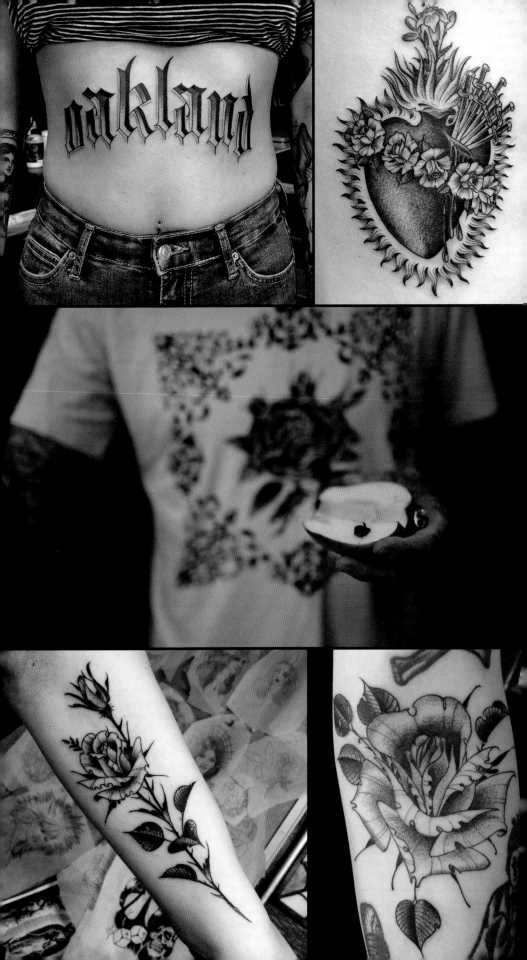

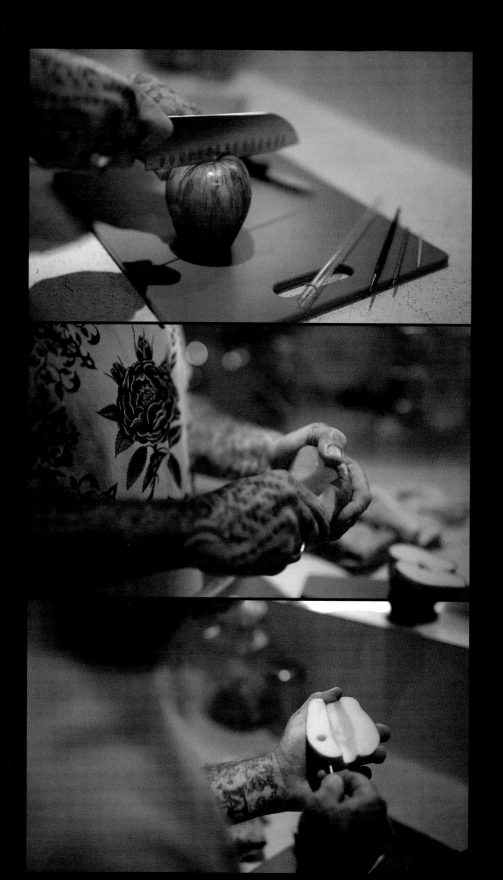

FREDDY'S APPLE PIPE

- ✤ 1 medium to large apple
- ✤ 1 chef's knife
- ✤ 1 Tim Hendricks skin pen

Cut the apple in half and cut out the core.

On one end, carve out a small divot the size of a dime for the bowl.

Use the Tim Hendricks skin pen to create the shaft by tunneling out the apple from the bowl through to the opposite side of the apple.

On the side of the apple you'll hold, carve out a carb with the pen connecting to the shaft.

Get some grade A pot.

Smoke and enjoy cooking the rest of the book!

AITHOR ZABALA

Aithor Zabala is a very talented chef and has a pretty awesome tattoo collection from some of the best tattoo artists in the world. He has been tattooed by Chad Koeplinger, Deno, Bryan Burk, and many others. Good palette, good taste! Aithor is from Barcelona and currently lives in Los Angeles, working as the corporate chef for the Jose Andres restaurant group. Jose Andres owns over a dozen acclaimed restaurants and is often credited with bringing small-plate dining to the United States. *Time* magazine included Jose Andres in their 2012 issue of 100 Influential People. Needless to say, being his corporate chef is not an easy position to attain and keep!

Aithor started cooking during his mandatory military requirement in Spain and has been in the kitchen ever since. However, being a "chef" has never been his goal—he just loves to cook! He believes in cooking and eating consciously. Aithor's love of tattoos started at a young age as well. At the age of seventeen, inspired by the death of his father, he got his first tattoo. Since then, he has covered most of his body with a beautiful collection. For his next tattoo, he would like two mandalas on his knees.

When selecting a dish for this book, Aithor wanted to cook something traditional from his mother country. He hopes you enjoy re-creating this classic Spanish comfort food—a dish that reminds him of home.

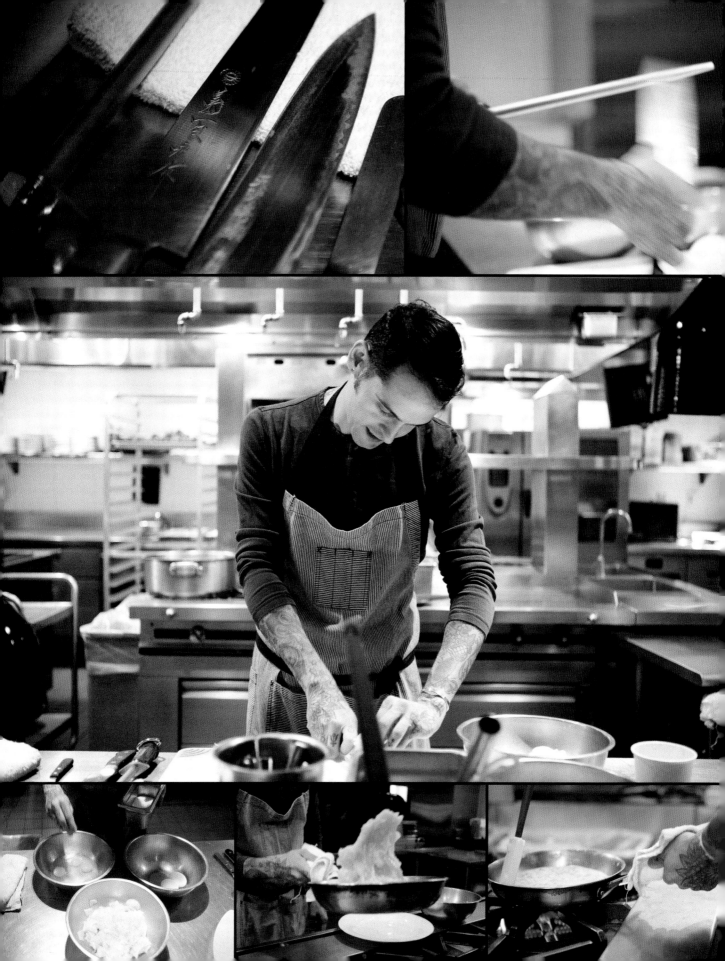

AITHOR'S SPANISH OMELET

- ⚜ ²/₃ cup olive oil
- ⚜ 2 cups russet potatoes, cut into thick slices
- ⚜ 1 yellow onion, chopped or thinly sliced
- ⚜ 6 large eggs
- ⚜ Salt and pepper, to taste

Heat up olive oil in a large frying pan over medium-high heat. Add the potatoes and onions, turn down the heat, and stew gently until potatoes are tender, about 15–20 minutes. Strain the potatoes and onion into a large bowl. Save the oil! Beat the eggs in a separate bowl, and salt and pepper to taste. Add them to the potatoes and onions. Heat the strained oil in a medium-sized frying pan over medium-high heat and gently add the egg mixture. Shape the omelet into a cushion shape with a spatula, if needed. When the omelet is almost set, place a plate over the pan and flip the pan so the omelet sits on the plate. Slide the omelet back into the pan and cook for a few more minutes. Invert the omelet once more on a plate, keeping the cushion shape. Let it cool for 5–10 minutes before serving.

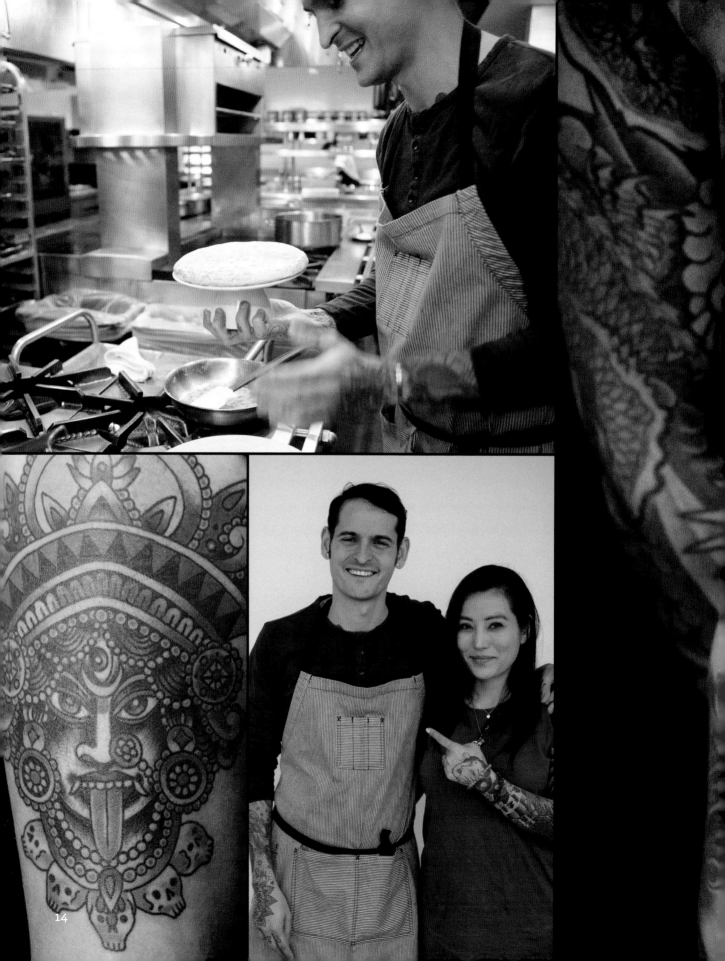

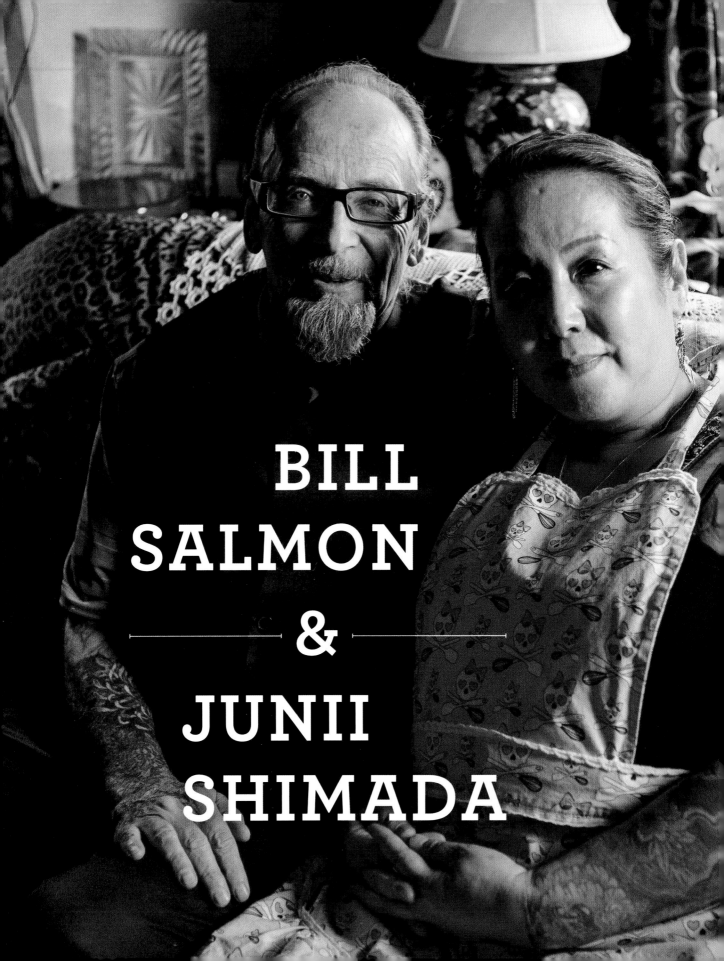

BILL
SALMON
&
JUNII
SHIMADA

Bill Salmon has earned the status of living legend after tattooing for more than three decades. He belongs to the generation that forever changed tattooing and built the foundation of what we now take for granted. San Francisco was a hotbed of tattoo activity and counterculture, and he was right in the middle of it! He is actually the only one from this group still residing full time in San Francisco. Originally from New York, he has called San Francisco home for most of his life. He is the owner and operator of Diamond Club Tattoo on Van Ness Boulevard alongside his beautiful wife, Junko Shimada.

Bill's recipe is an old one, a tomato sauce he has perfected over time. It is a sauce you can enjoy on its own or as a base for something more elaborate. His cooking advice is simple: crispy is OK—but do not burn it! Simple words from a man known for his quick wit and punchy humor. Thank you for sharing your recipe with us, Bill!

Junko "Junii" Shimada's home cooking is almost as legendary in the tattoo community as her tattoo work and persona. She is a living legend and highly influential in the propagation of Japanese tattoo culture. It has been said that she was the first woman photographed to have a full *munewari* (split chest) bodysuit, a tattoo style predominantly seen on men, and this undoubtedly inspired many people, men and women alike. She has been tattooing for over twenty-seven years and learned from her husband, the legendary tattoo artist Bill Salmon. Together they own and operate Diamond Club Tattoo in San Francisco. Her childhood love of tattoos began after seeing a yakuza movie, a very popular movie genre in Japan, in which the hero sported a full bodysuit. The dramatic unveiling of tattoos in the movie struck her: it was love at first sight. After this, she wanted not only to be tattooed, but to be a tattoo artist. In addition to being the first documented woman to get a full bodysuit, she was the last person to get a bodysuit entirely by *tebori* (Japanese hand tattooing) from tattoo master Horitoshi of Ikebukuro, Tokyo. Her bodysuits have been photographed many times, and she is an icon in the industry.

As for getting tattooed, Junii says, "Get want you want! Do not bend to the will of others!" These are certainly words she has lived by; she is the foremost female pioneer in the world of the Japanese tattoo. As I said before, she is also legendary for her cooking. She has such a warm spirit and loves to host guests and cook big home-cooked meals! Junii wanted to share a recipe she picked up in her many years of living in San Francisco; it is healthy, easy to prepare, and delicious!

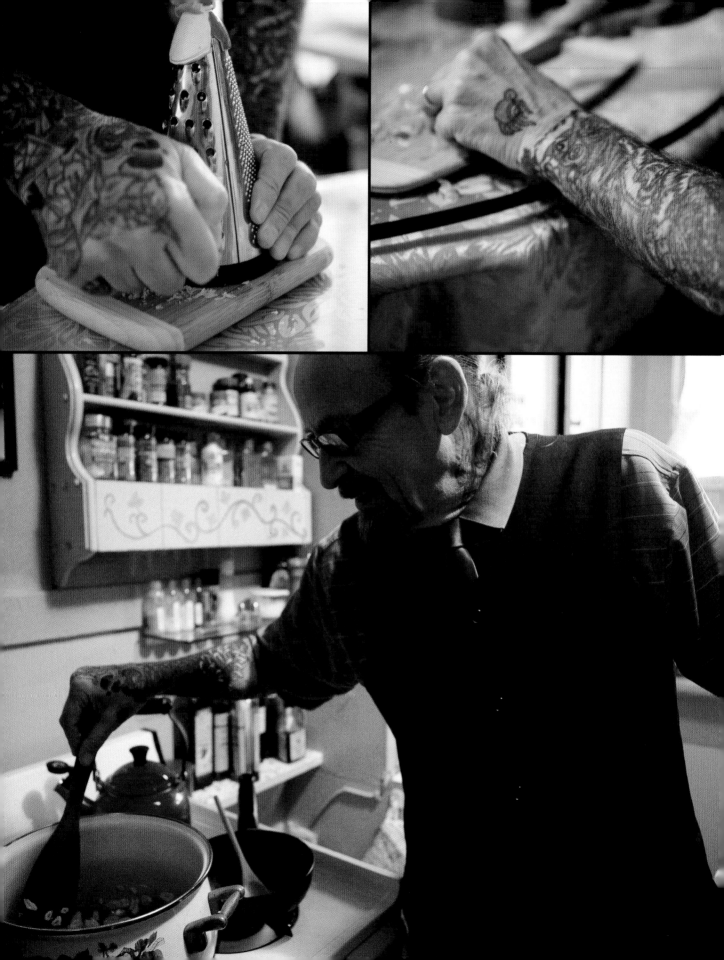

BILL'S TOMATO SAUCE

SERVES 6–8

- ¼ cup olive oil
- 1–2 bay leaves
- 1½ bulbs of garlic, roughly chopped
- 2 28-ounce cans stewed tomatoes, sliced
- 4 tablespoons sugar
- 1 6-ounce can tomato paste
- ½ cup grated Parmesan cheese

Heat up the olive oil over medium-high heat in a medium stockpot or sauce pan. Sauté the bay leaves and garlic until the garlic becomes soft: about 3–5 minutes. Be careful not to let the garlic burn. Add the stewed tomatoes and sugar and bring the sauce to a light simmer for about 20 minutes. After simmering, stir in the tomato paste and Parmesan cheese. Let the sauce lightly simmer for another 10 minutes. Serve with the pasta of your choice.

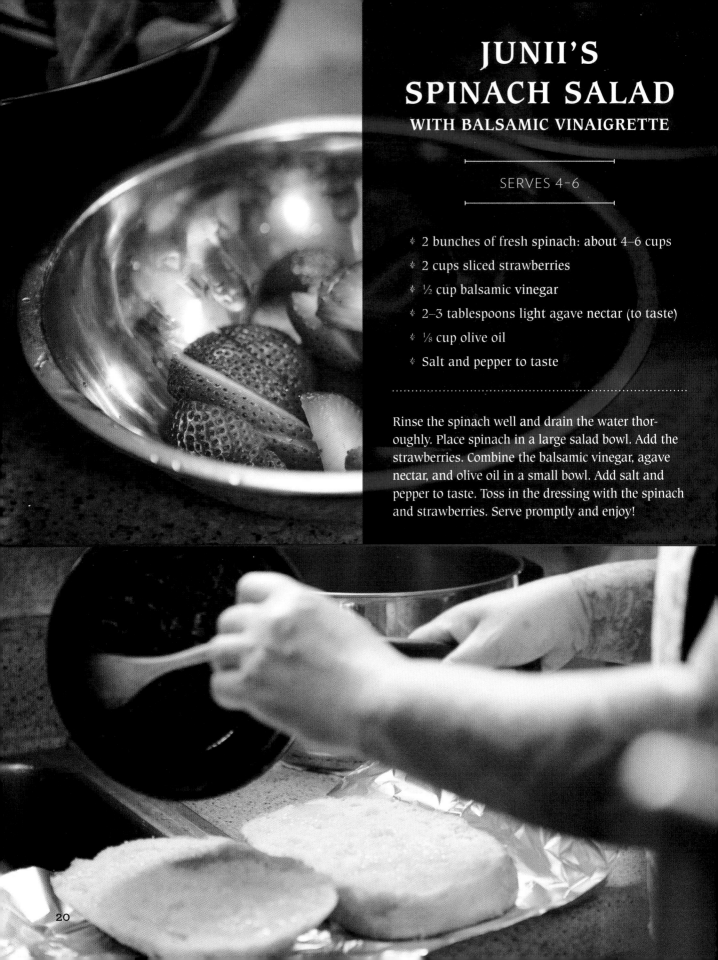

JUNII'S
SPINACH SALAD
WITH BALSAMIC VINAIGRETTE

SERVES 4–6

- 2 bunches of fresh spinach: about 4–6 cups
- 2 cups sliced strawberries
- ½ cup balsamic vinegar
- 2–3 tablespoons light agave nectar (to taste)
- ⅛ cup olive oil
- Salt and pepper to taste

Rinse the spinach well and drain the water thoroughly. Place spinach in a large salad bowl. Add the strawberries. Combine the balsamic vinegar, agave nectar, and olive oil in a small bowl. Add salt and pepper to taste. Toss in the dressing with the spinach and strawberries. Serve promptly and enjoy!

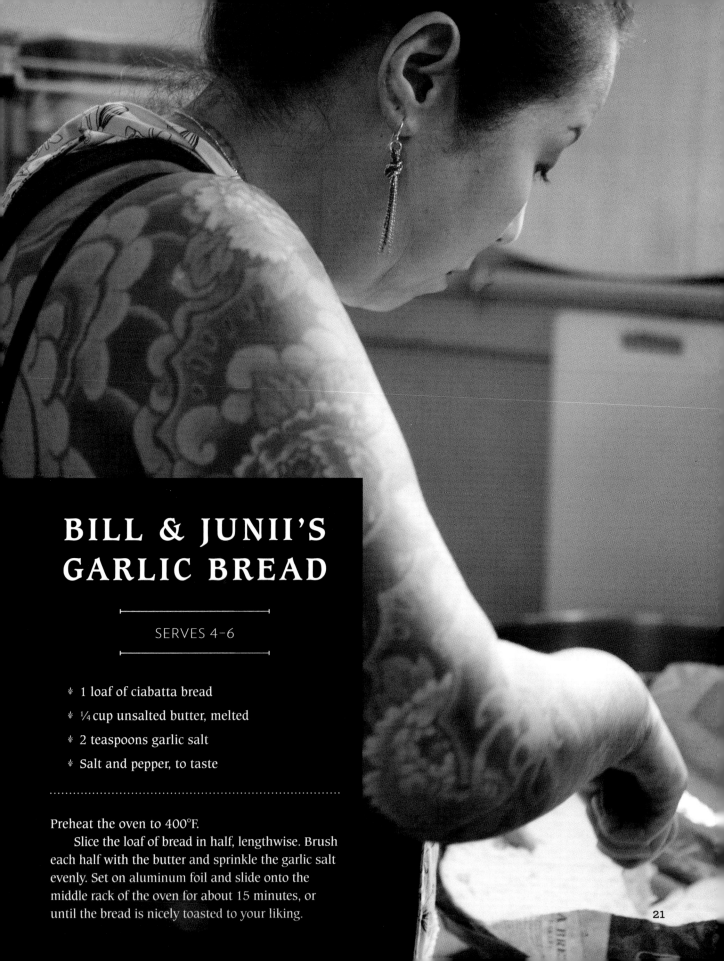

BILL & JUNII'S GARLIC BREAD

SERVES 4–6

- ⚘ 1 loaf of ciabatta bread
- ⚘ ¼ cup unsalted butter, melted
- ⚘ 2 teaspoons garlic salt
- ⚘ Salt and pepper, to taste

Preheat the oven to 400°F.

Slice the loaf of bread in half, lengthwise. Brush each half with the butter and sprinkle the garlic salt evenly. Set on aluminum foil and slide onto the middle rack of the oven for about 15 minutes, or until the bread is nicely toasted to your liking.

21

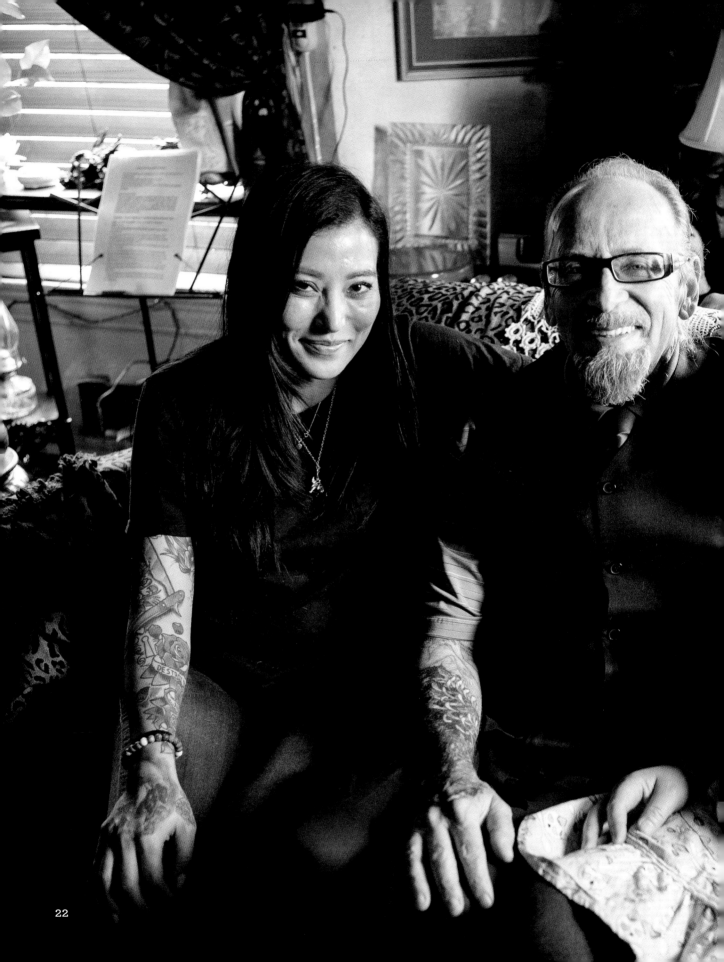

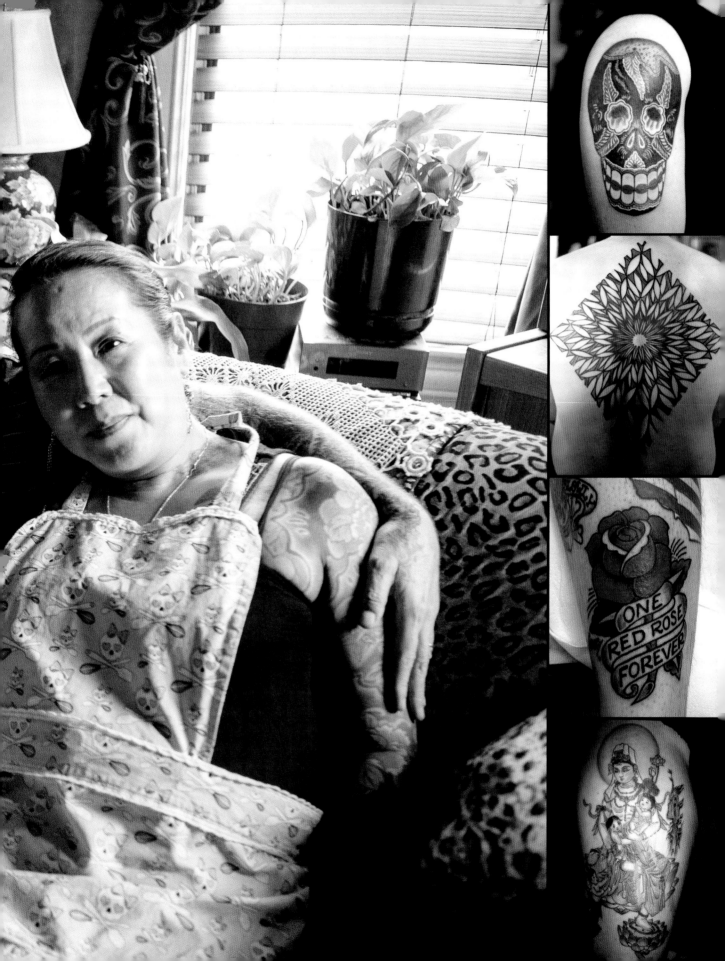

BLAKE
BRAND

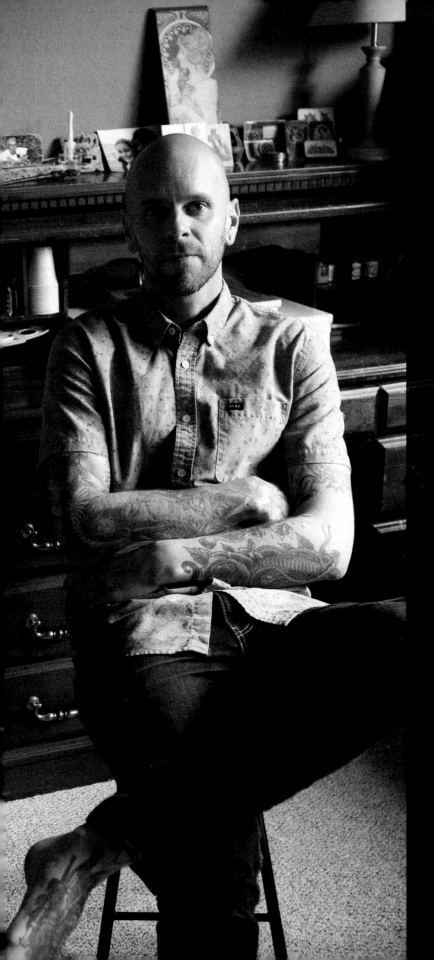

J ohn and I thought it would be cool to have Blake in the book, not only because he is an awesome tattooer and all-around great guy, but because he lives a vegan lifestyle. We thought it was important to represent, and who better to do that than Blake Brand? Blake has been tattooing for fourteen years and works at State of Grace Tattoo in his hometown of San Jose, California. He is an avid surfer and in another lifetime would have loved to be a firefighter. Another creative passion he's had for a few years now is making surfboards from scratch. Blake is really into the precision and concentration it takes to make a surfboard, which is also why he enjoys cooking, and tattooing for that matter.

Blake's journey to veganism started out as going vegetarian. He slowly started cutting out dairy, eggs, and other nonvegan ingredients from his diet. Being vegan does not define Blake, however, and he never judges people who are not vegan. Having said that, he does from time to time find it difficult to see eye to eye with nonvegans on some issues. But Blake would never push his opinions on others—he is literally one of the nicest people I have ever met! Understandably, the only nonvegan food he misses is a good pizza. There is just something about the combination of flavors that he misses.

He wanted to debunk one misconception about being vegan: that it is expensive and difficult to cook a good meal. That is definitely not so, as I see from his delicious lunches every day! Blake's recipe is an original creation. His advice to beginner vegans is to follow recipes at first and build your own style from there. Thanks, Blake— definitely food for thought!

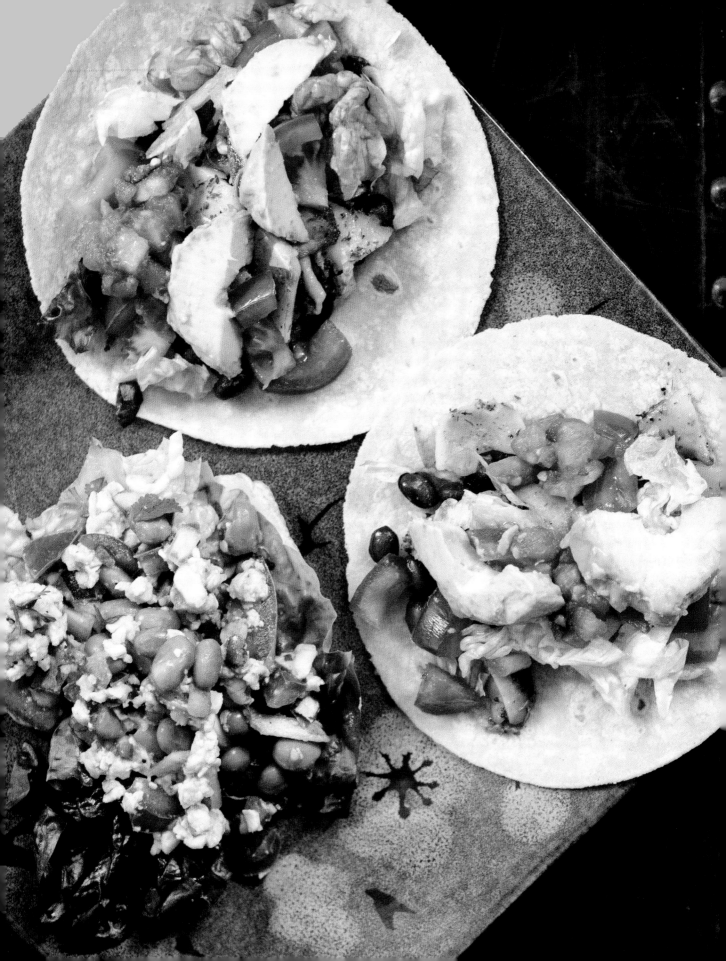

BLAKE'S VEGAN TACOS & CEVICHE

SERVES 2–3

Tacos

* 1 coconut, broken open and meat scraped out
* 2 tablespoons lemon pepper or spice of your choice
* 1 15-ounce can black beans, strained
* 2–4 tablespoons nutritional yeast (to taste)
* ½ avocado, sliced
* Corn tortillas
* Salsa of choice

Marinate coconut meat in spices for 20–30 minutes.

Put the beans and nutritional yeast into a small saucepan and heat them up on medium-low heat. Stir occasionally.

While the beans are heating up, grill or sauté the coconut meat for 2–3 minutes, or until browned and slightly crisp, then dice into bite-sized pieces.

Take beans and coconut meat off the heat and assemble your tacos with the beans, coconut meat, avocado, and salsa to taste.

Tempeh Ceviche

* 1 4.2-ounce package of raw tempeh
* 2–3 tomatoes, diced small
* ½–1 red onion or yellow onion, diced small
* 3 serrano chilies or jalapeños, chopped
* ½ bunch of cilantro, chopped
* ½ avocado, diced
* 3 lemons or 4 limes, juiced (or to taste)
* 1 15-ounce can of pinto beans, strained
* Salt and pepper to taste
* 2–3 butter lettuce leaves

Slice the tempeh and steam over the stove for about 30 minutes. When it's finished steaming, the tempeh should be a bit softer, so mash it with a fork into bite-sized chunks.

Mix tomatoes, onion, chilies/jalapeños, cilantro, avocado, and lemon/lime juice in a bowl and throw in the tempeh. Let the tempeh marinate for about 30 minutes.

Meanwhile, heat up the pinto beans in a small saucepan over medium-low heat, stirring occasionally.

Once the beans are warmed through (do not let them start to boil), add them to the ceviche. Salt and pepper to taste.

Serve over the butter lettuce.

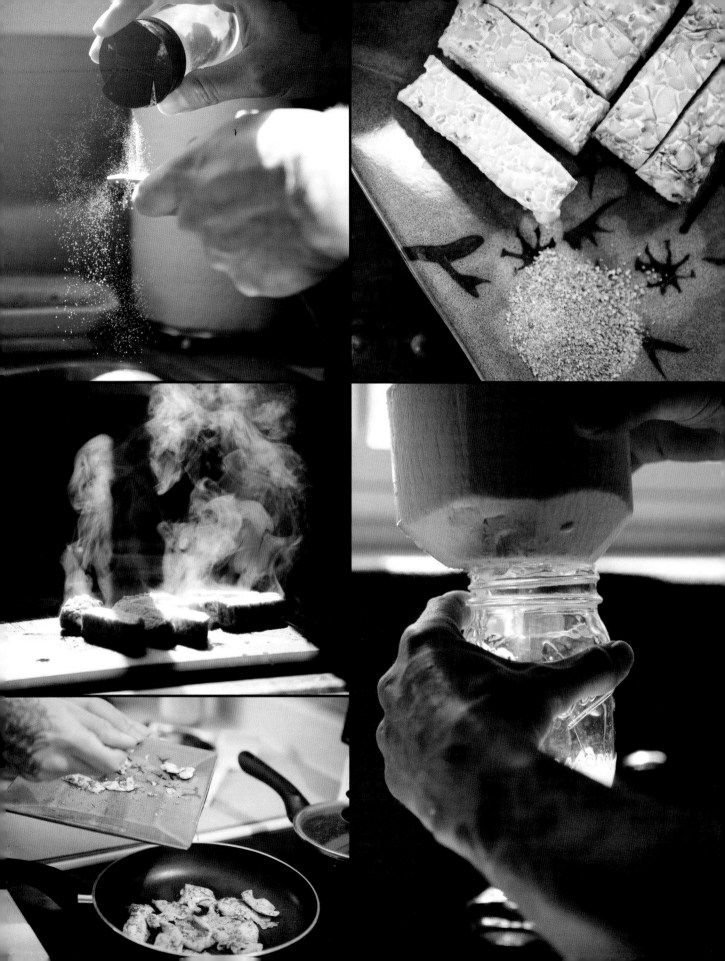

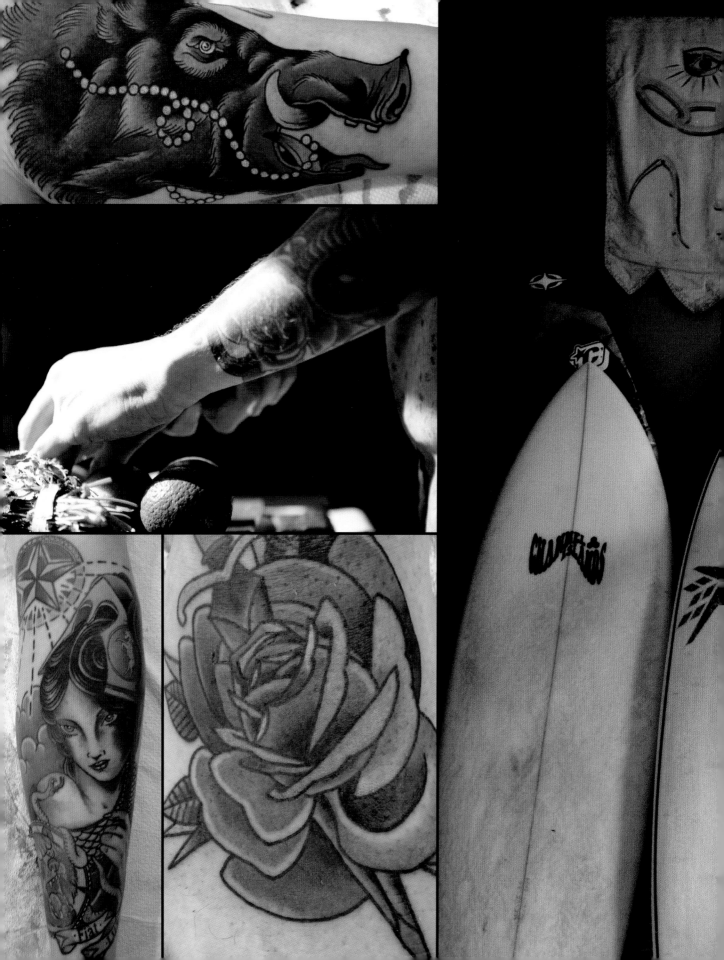

CAROLYNN SPENCE

Carolynn Spence is the executive chef of the legendary Chateau Marmot in Hollywood, California. The hotel is a landmark, and meals there tend to be eaten by a literal "who's who" of the silver screen. Needless to say, Carolynn has cooked for some very famous people! Being the chef of such a huge operation is extremely time consuming, so I was struck by how accommodating she was! Thank you so much, Carolynn, for being so generous with your time!.

Carolynn has been cooking for over two decades and started out on the East Coast (her old stomping grounds). Cooking followed a natural career progression for her. In her words, "It was one of the only careers that welcomed the quirky, the tattooed, the punk rock kids!" I totally agree with her and think that her statement holds true today more so than ever! Carolynn is also quite proud of her 1969 VW Squareback—perfect for all the surfing trips she never has time to take!

As far as tattoos go, her favorite ones are always her most recent ones. She was particularly fond of a piece by Robert Ryan—and we couldn't agree more! For tattoo advice, Carolynn feels that people shouldn't always worry so much about the reason for the tattoo—just do it for the art itself!

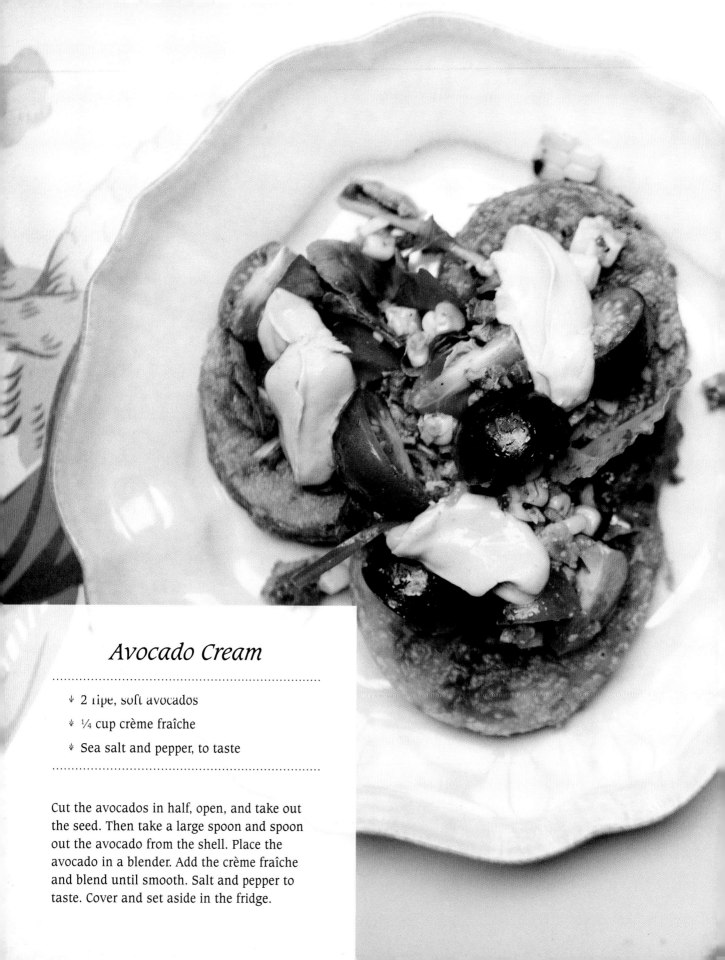

Avocado Cream

..

- ↓ 2 ripe, soft avocados
- ↓ ¼ cup crème fraîche
- ↓ Sea salt and pepper, to taste

..

Cut the avocados in half, open, and take out
the seed. Then take a large spoon and spoon
out the avocado from the shell. Place the
avocado in a blender. Add the crème fraîche
and blend until smooth. Salt and pepper to
taste. Cover and set aside in the fridge.

CAROLYNN'S FRIED GREEN TOMATOES

SERVES 4–6

- 1 cup vegetable oil, for frying, divided
- 2 ears of sweet corn, kernels shaved off husk
- 3 medium-sized green tomatoes, sliced into ¼-inch slices
- 1 cup chickpea flour
- Salt to taste

In a frying pan, heat up a tablespoon of the vegetable oil on medium-high heat and lightly sauté the corn until it starts to brown/char. Take off the heat, place the corn in a bowl, and set aside.

Heat the rest of the vegetable oil in a small saucepan until it hits 370–390°F. Lay down a couple of layers of paper towel on a plate. Dredge the tomato slices in the chickpea flour and deep fry, one by one, until golden. Let the oil heat up again between tomatoes if you are doing multiple batches. Place the fried tomato slices on the paper towels to let some of the excess oil get absorbed. Very lightly salt each of them.

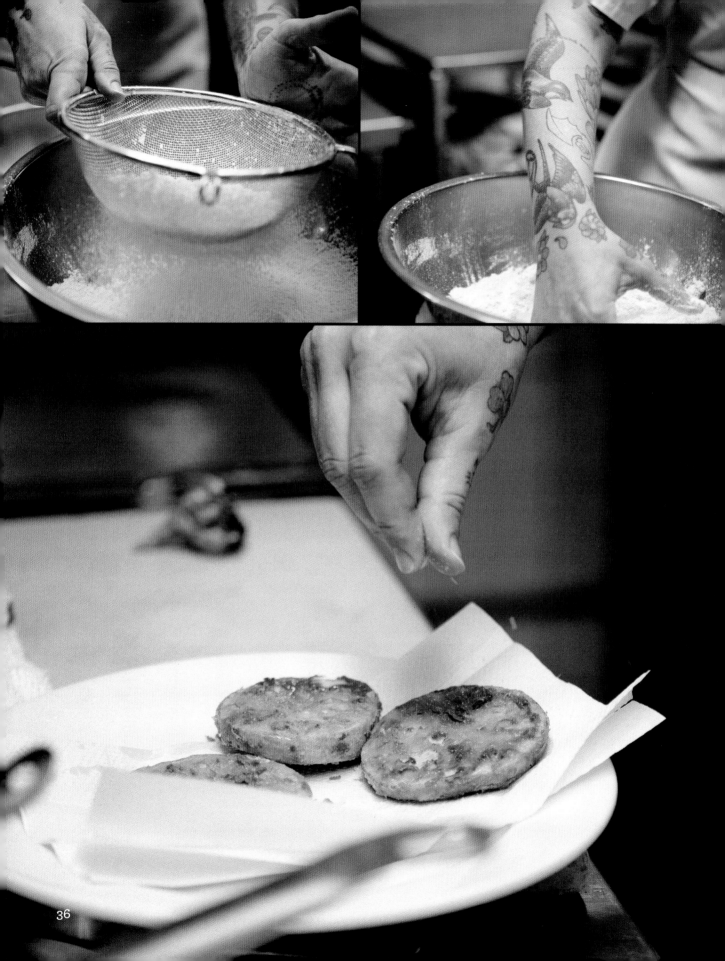

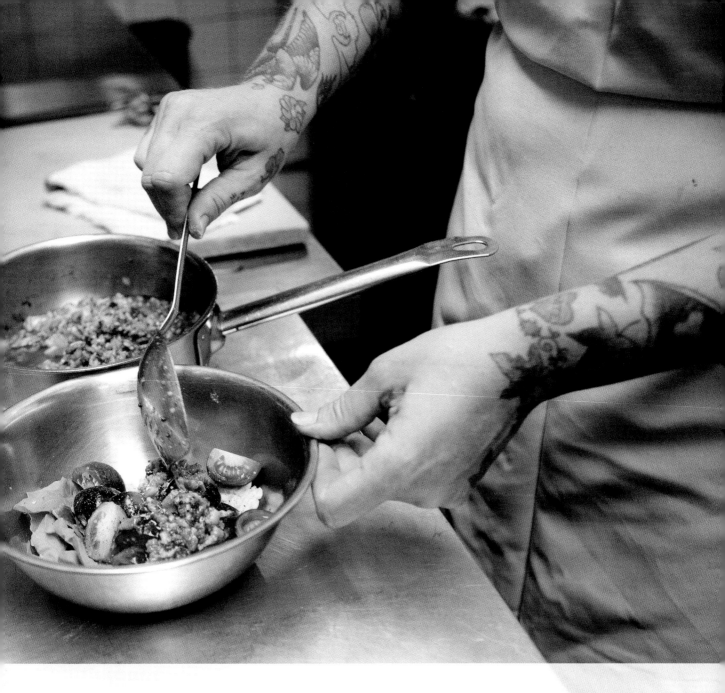

Bacon Vinaigrette

..

- 9 ounces bacon, fried to desired crispiness and cut into small, bite-sized pieces

- 4 tablespoons fat from the bacon

- ½ cup apple cider vinegar

- 2 teaspoons brown sugar

- 1 teaspoon whole Dijon mustard

- Salt and pepper to taste

Heat a large frying pan over medium-high heat. Brown the bacon to desired crispiness, between 4 and 6 minutes. Drain all but 4 tablespoons of fat and set bacon aside. Heat up the 4 tablespoons of fat in the frying pan over medium-low heat and whisk in the vinegar, sugar, and mustard. Slice the bacon into bite-sized pieces and add to the dressing. Salt and pepper to taste.

Assembling the Salad

- 1 bunch of frisée
- 6 purple plum tomatoes, quartered
- ½ red onion, small dice

Toss the frisée, tomatoes, corn, and onion in a bowl with the bacon vinaigrette. Place on a small plate for each serving. Cut the tomatoes in half and arrange on top of the frisée. Add a dollop of the avocado cream on top of the tomatoes. Enjoy!

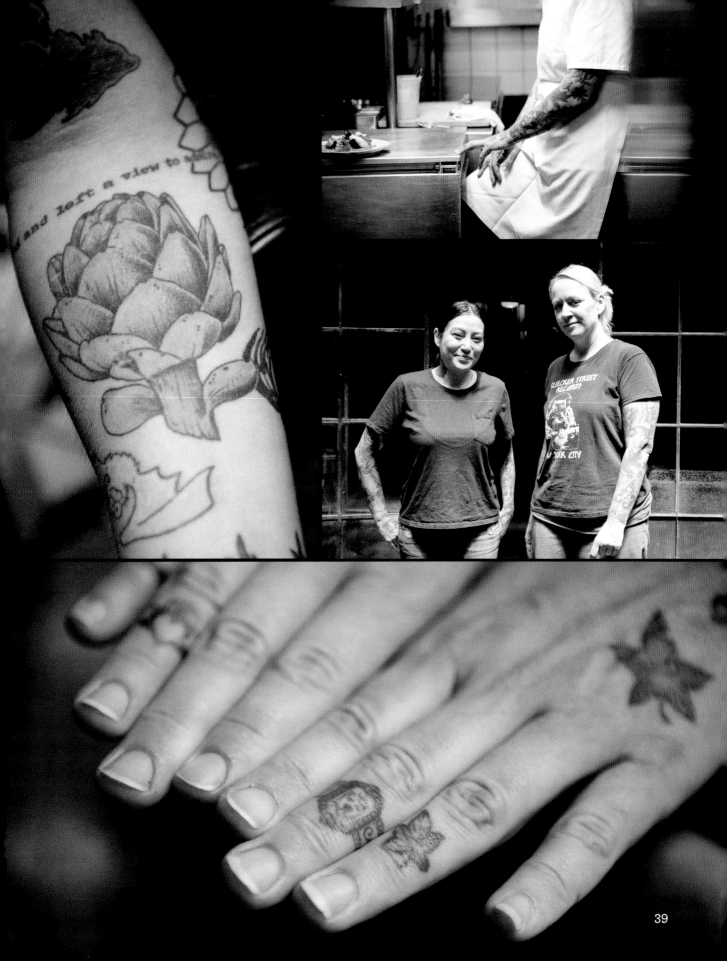

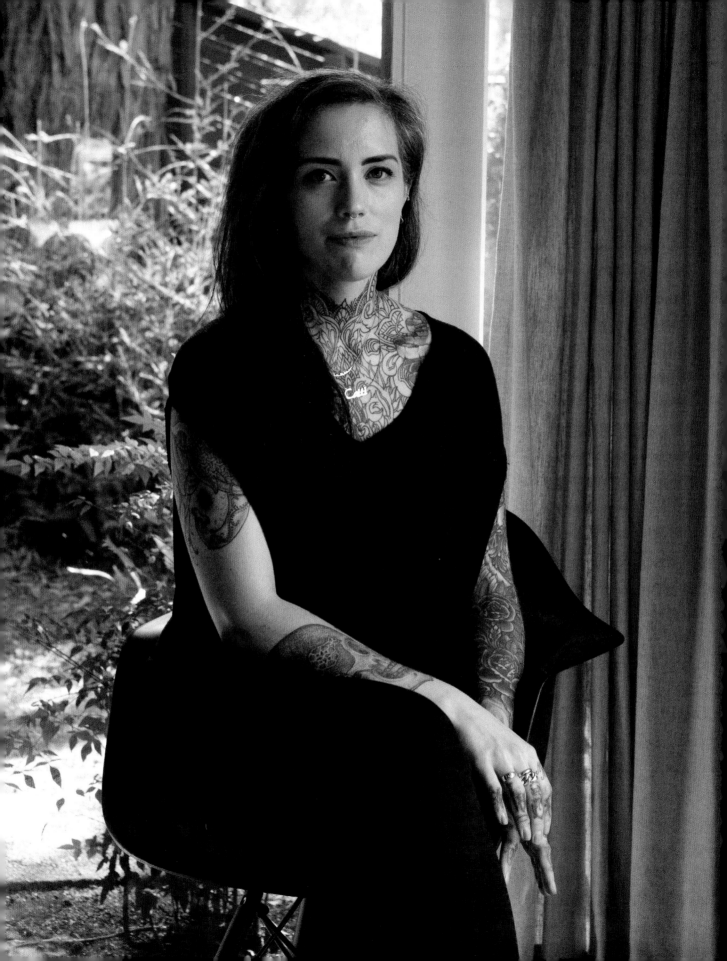

CATS

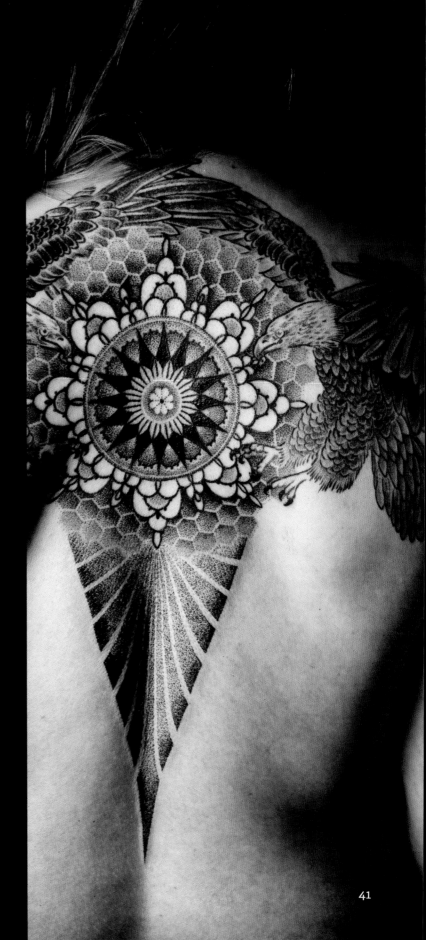

I love Cats! We always have a great time when we meet up, which is never as often as I would like. It's ironic how the distance between different parts of the Bay Area can feel like you are living in different states! Cats is from Liverpool, England, and has been tattooing for over six years. I met her while she worked at 2 Spirit Tattoo in San Francisco but, sadly for the Bay Area, she and her fiance Roxx have moved to the LA area. Cats and Roxx are animal lovers and have two amazing dogs and two beautiful horses. When not tattooing, most of her free time is spent with Roxx and their lovely animals! Recently, Cats and Roxx have switched to a sugar-free diet, evident in the recipe she submitted. While this may seem like a challenging diet, Cats has experience with specific nutritional diets. Of all the dietary lifestyles she has tried, Cats felt that the raw diet was the most difficult to maintain. Through these various experiments in the dietary spectrum, Cats firmly believes that moderation is key. This recipe for mini lemon cupcakes is a great starting point for those who want to try to go sugar free, gluten free, and even vegan. These cupcakes are super easy to make and taste great!

CATS'S MINI LEMON CUPCAKES
(FLOURLESS AND SUGARLESS)

SERVES 6-8

* 3 cups unsweetened shredded coconut
* 1 lemon, zested and juiced
* ¼ cup maple syrup
* ½ teaspoon sea salt
* ½ teaspoon baking soda
* ½ cup frozen blueberries
* 24 fresh blueberries

Preheat oven to 350°F. Place coconut in a blender and blend for 5 minutes. In the meantime, zest a lemon, juice the lemons, and measure the maple syrup, salt, and baking soda. After the 5 minutes, add the lemon juice and maple syrup. Blend for another 5 minutes. After the second 5 minutes, fold in the salt, baking soda, and frozen blueberries. Line each mini cupcake mold with a paper cupcake liner. Fill each cupcake mold with cupcake mix until they are about ¾ full. Place in the oven for 25–27 minutes or until golden. Take out of the oven, top each muffin with 1 blueberry each, and let cool for 15–20 minutes. Enjoy!

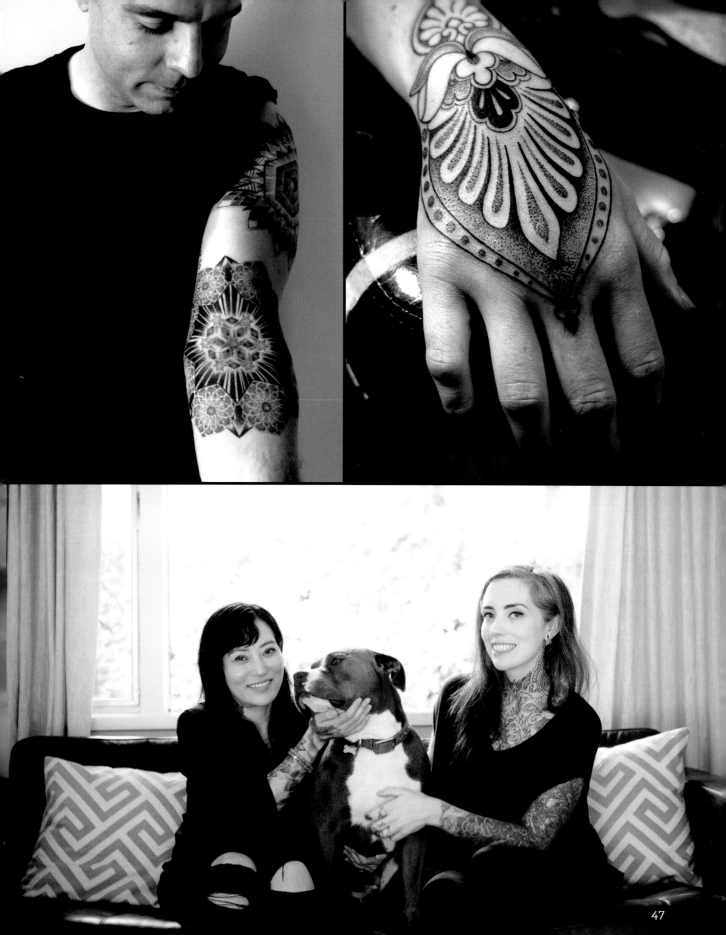

CHAD
KOEPLINGER

Chad Koeplinger is one of the biggest foodies I know! He is also an incredible tattooer and one of the people I thought of first when putting this cookbook together. He embodies the "knives and needles" lifestyle. He loves to travel, and coupled with this is his love for incredible eateries in exotic locations. He has made it his mission to eat at every Michelin-starred restaurant in the world. He is originally from Michigan, and his tattooing has taken him all over the world and helped make his mission a realistic goal.

Chad Koeplinger can literally tell you where to eat in almost any city in the world. He has had sushi straight from Jiro's hand, street market food in Vietnam—he is by far the most traveled tattooer I know! When we last spoke, he was raving about Montreal and the food scene there. His recommendation in Montreal is Joe Beef.

For this book, Chad cooked a South Indian coconut chicken curry, one of his latest obsessions. The spices and coconut milk were in perfect harmony with each other, and the chicken was tender and full of flavor. The dish filled the kitchen with a marvelous aroma. He paired the sweet and spicy dish with purple rice, making for great plating. It really was a feast for all the senses! Clearly Chad has learned a thing or two in all his eating escapades. The recipe is easy to make and very forgiving, so just jump in and go for it!

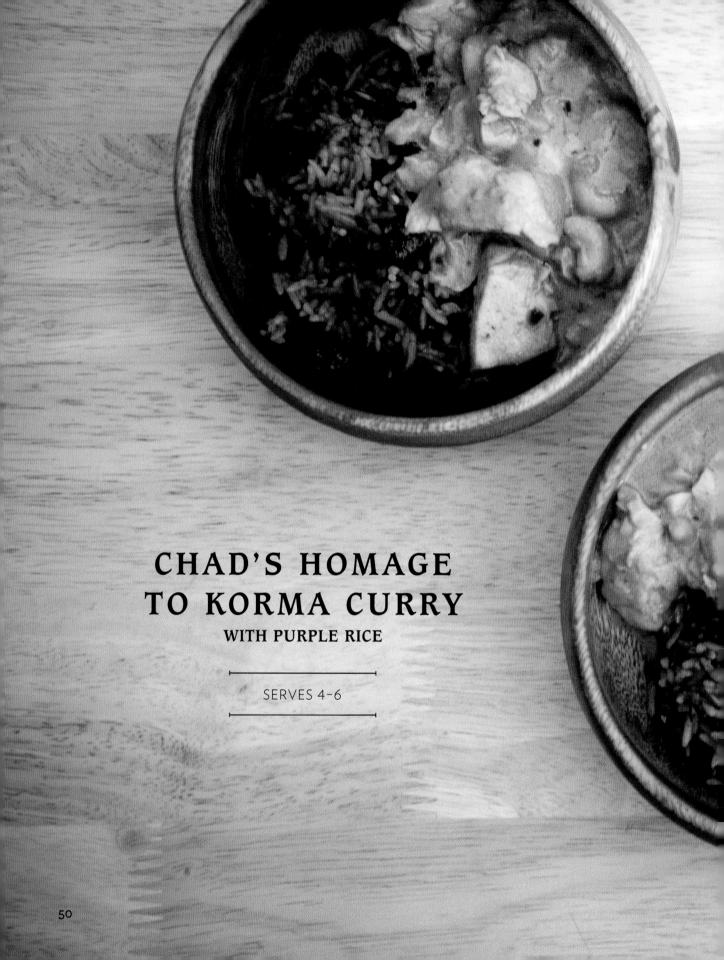

CHAD'S HOMAGE
TO KORMA CURRY
WITH PURPLE RICE

SERVES 4–6

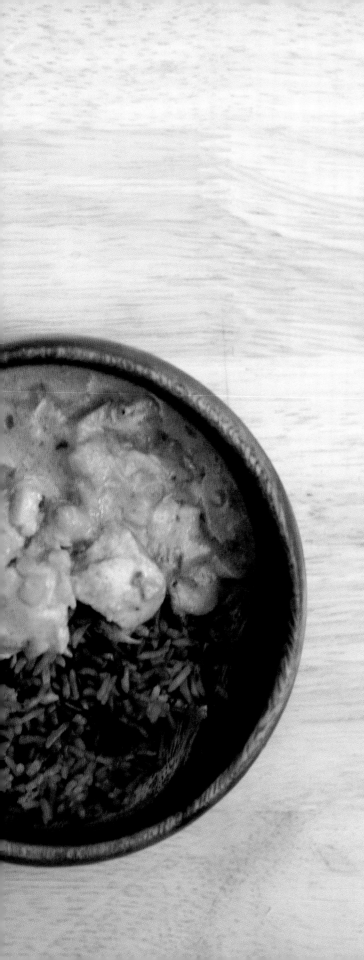

- 4 cups purple rice
- 6 cups water
- 1 tablespoon clarified butter or ghee
- 1 pound boneless, skinless chicken breast, cut into bite-sized pieces and lightly dusted with salt and pepper
- 1 yellow onion, diced small
- 8 cloves of garlic, minced
- 3 2½-inch pieces of ginger root, grated or minced
- 22 cardamom pods, slightly smashed
- 10 cloves
- 3 bay leaves
- 2 teaspoons turmeric
- 2 teaspoons garam masala
- 2 teaspoons cardamom powder
- 2 teaspoons crushed red pepper
- 2 teaspoons madras curry powder
- 2 teaspoons chili powder
- 2 tablespoons almond flour
- ½ pint heavy whipping cream
- 1 13.5-ounce can of coconut milk
- 2 cups cashews, divided
- Chicken stock to taste
- 1 cup plain yogurt
- Salt and pepper to taste

Don't let the ingredients intimidate you; this recipe is not as difficult as it looks. Enjoy and try it out—you won't regret it!

Rice

Wash the purple rice under cold water in a bowl. Strain out the water and put the rice in a rice cooker. If you do not have a rice cooker, a medium saucepan with a lid will do. For every 1 cup of rice, put in 1¼–1½ cups of water. If you are using a rice cooker, just turn it on. If you are using a saucepan, cover with the lid and bring rice and water to a boil on medium-high heat. Turn the heat to low after 8 minutes from the time you put the rice on the stove. Let the rice simmer on low for another 12 minutes, keeping the rice covered at all times. Take the rice off the heat and let it sit there, still covered, for another 15 minutes.

Curry

Heat the ghee in a medium/large saucepan over medium-high heat.

Cut the chicken into bite-sized pieces and place in the pan. Brown the pieces on all sides.

Add the onion, garlic, and ginger and sauté until onion starts to caramelize (become translucent).

Add the rest of the spices plus the almond flour and let them sauté for a minute. Next, pour the heavy whipping cream and coconut milk through a sieve and add it to the pan.

Stir until all the spices, almond flour, and liquids are incorporated.

Add half of the cashews. Bring the curry to a very light simmer over medium-high heat, then turn it down to low and let it lightly simmer for 30 minutes. Add chicken stock a little at a time if the curry starts to get too thick for your taste. After 30 minutes, take the curry off the heat and fold in the yogurt. Spoon over the rice on a plate, garnish with the rest of the cashews, and enjoy!

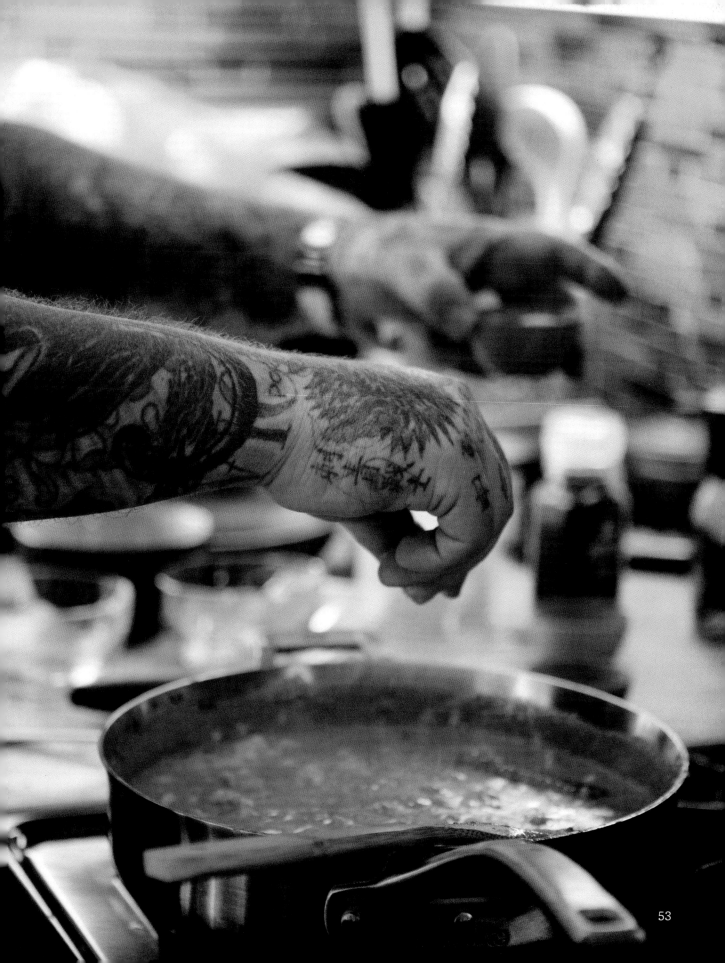

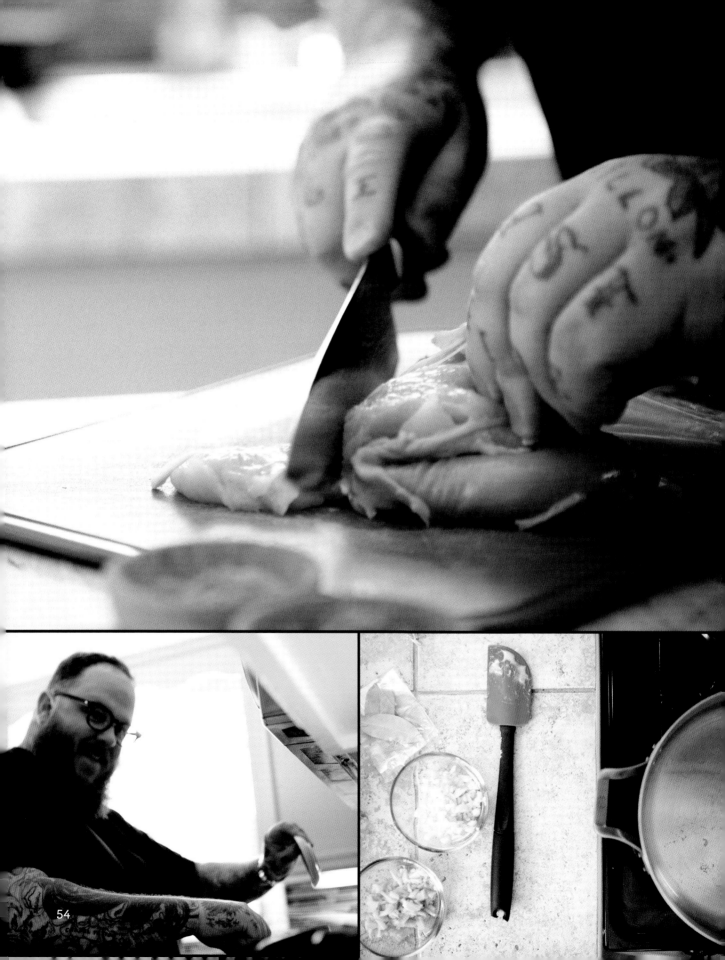

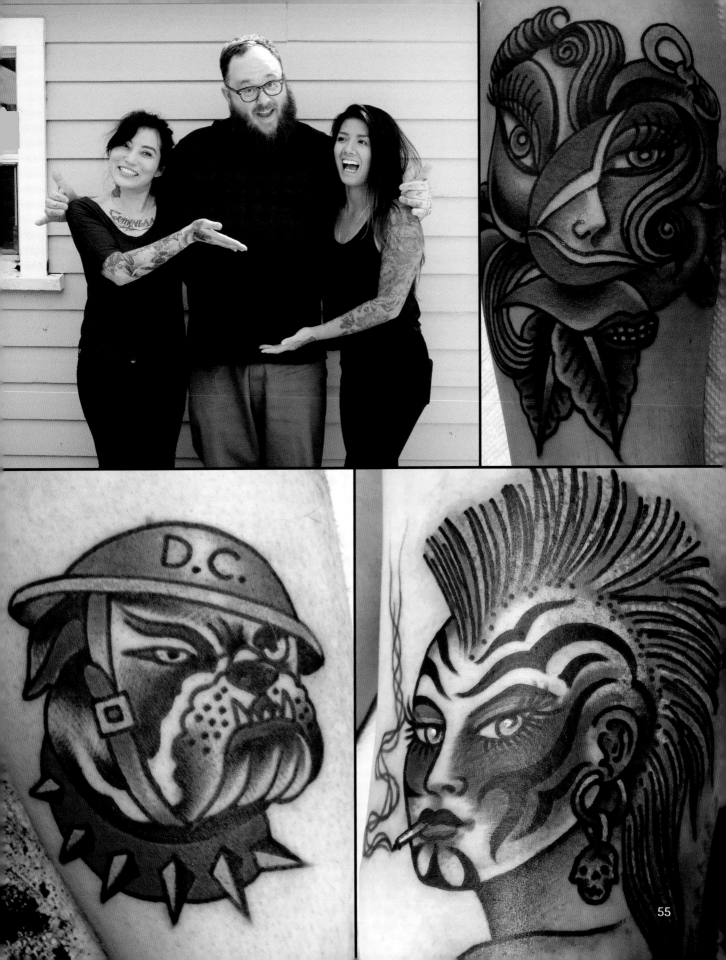

55

C hris Brand has an analytical mind and is a true artist through and through. He loves to get down to the nitty-gritty of whatever he is doing, eating, seeing, or hearing. It was no surprise that Chris would be a foodie and understand the nuances of a well-cooked dish. His culinary knowledge and attention to detail are reasons Chris is fun to eat with, and why I had to have him in this book. He is a well-known ramen connoisseur and has tried his hand at noodle making recently. I'm excited to try some of his ramen someday!

Chris Brand has quite an artistic resume. He has been tattooing since 1999 and is currently splitting his professional time between Good Time Charlie's Tattooland and his private studio located within Deer's Eye Studio in Los Angeles, California. His love affair with tattoos began when he was a child. Chris would often look through National Geographic publications, mesmerized by photos of tattooed Native Americans. He would draw and redraw these tattoos repeatedly. Chris works in many mediums now and is a founding member of the UGLAR art collective. UGLAR creates murals, sculptures, and exhibits and has even produced a published book showcasing their artistic repertoire. Chris Brand has also received the honorific Japanese tattoo title Horishiki from the esteemed Japanese tattoo master Horitomo.

As far as cooking advice, Chris keeps it simple: keep your knives sharp and use good oils! Well said, Chris, well said!

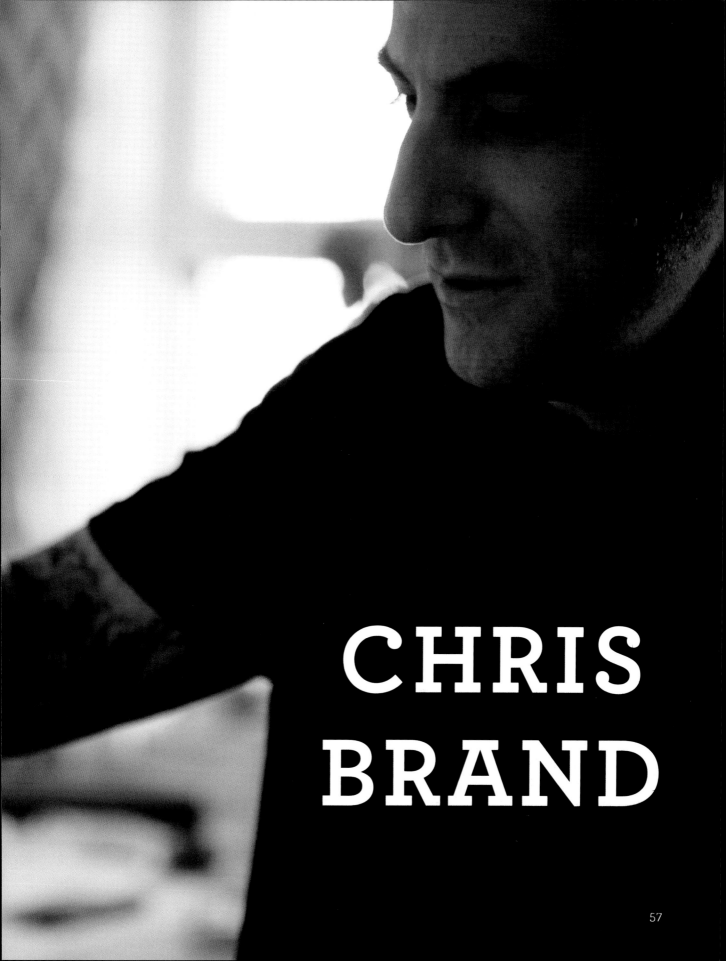

CHRIS
BRAND

CHRIS'S BACON & SQUASH TORTELLINI

SERVES 4–6

DOUGH

- 1 cup flour (well packed)
- ½ teaspoon kosher salt
- 1 large egg (white and yolk)
- 3 yolks
- 3 grams olive oil

Dough Method

Incorporate dry ingredients in a large mixing bowl and mound the mixture onto a flat surface with a well in the center. Think of a bird's nest. Add the eggs and egg yolks. Whisk the eggs into the flour mixture little by little, keeping the walls of the well intact to contain any mess. When most of the flour is incorporated with the egg, squeeze off the excess dough on the fork, add the olive oil, and start kneading the dough with your hands until it forms a smooth ball.

It will take a while, and you might think the dough is dry, but it is okay. The dough will form after about a half hour of kneading. If you are in a hurry, you can throw the dough into a mixer with a dough hook and let the machine do the kneading for about 10 minutes. If you use the mixer, you can add the oil then. After the first kneading, the dough will bind together but look lumpy and will crack on the surface when you stretch it. It still needs more kneading to completely bind the gluten together. So take the dough out of the mixer and continue kneading by hand.

To knead, place the dough on a hard surface. Fold the farthest edge from you toward you and then roll it away from you, putting pressure on the dough with the heel of your hand. Keep folding and rolling the dough while keeping it in a round-ish shape. Get into a rhythm and Zen out for a bit. Knead until the dough feels completely smooth and doesn't crack when you pull it apart. There is no specific time on this—you will just have to feel. When the dough is smooth and stretchy, form it into a ball and wrap with Saran wrap. Let it rest at room temperature while you make the filling. Let it rest a minimum of a half hour.

After the filling is done, take either a rolling pin or pasta roller and roll out the dough. Once the dough is rolled out, gently lay it out on a hard surface.

You can lightly flour each side of the dough to keep it from sticking. Take a circular dough cutter (cookie cutter or even a small ramekin) and cut out the tortellini. A circle 1¾–2 inches in diameter is a good size for tortellini. Stack the circles under a glass or bowl so the dough does not dry out.

Tips for Rolling Out Dough

Rolling pin: Cut the dough into 4 quarters. Roll out each quarter separately. Keep the other quarters wrapped in Saran wrap to keep them from drying out. Take the first quarter and lay it on a large surface. Flatten the dough and, starting in the center and moving out, roll away from you, then center again and roll toward you. Flip the dough and roll again just like before, starting in the center. Keep turning the dough to get an even square or round shape. It will take a while and some arm muscle. Roll until the dough becomes thin—as thin as you can get it. You should see a light-yellow/caramel tint to the dough, and it should be thin enough to be slightly transparent. Repeat with all of the dough quarters.

Pasta roller: Pasta rollers are definitely easier. I recommend using one if you make a lot of pasta. Cut the dough into quarters. Take one quarter to roll out and keep the others wrapped in Saran wrap so they don't dry out. Flatten one quarter into a rectangular shape and feed it through the widest setting on the pasta-rolling machine. Refold it into the original shape and run it through again. Repeat a few more times. Go to the next setting down and feed the dough through a couple of times. Work your way down to the narrowest setting. The final product should be a very thin and long sheet of pasta: thin enough to be slightly transparent and a light-yellow/caramel color. You may have to cut the sheet into pieces, since it will get very long. If your pasta machine does not get the dough thin enough, you can carefully hand roll the dough after you cut the circles out. Try to keep the shape or recut them after you get your desired thickness.

FILLING

- 3 tablespoons brown butter
- 2 cups roasted squash or pumpkin
- Olive oil
- Kosher salt
- Dash ground cinnamon
- Dash ground nutmeg
- Fresh thyme, stemmed
- 3 cloves garlic, minced
- 1 tablespoon chicken stock
- ½ tablespoon apple cider vinegar
- 1 cup Parmesan cheese, grated
- ½ cup goat cheese (soft)
- 1 tablespoon raw honey
- 2 or 3 strips thick-cut bacon, diced and cooked

Filling Tortellini

Have a small bowl of water by you to use to help glue the tortellini together. Put the filling into a sandwich bag and tie off the opening. Cut a corner of the bag to squeeze the filling into the tortellini. Do the same with the goat cheese. Take a circle of the dough and squeeze about a teaspoon or less of filling (depending on how small you make the circles) in the middle of the circle. Do the same with the goat cheese, but squeeze only a small dollop. It is easy to overfill them, but try not to, since they will leak and possibly fall apart when you cook them. Dip your finger in the water and wet the edge of one half of the circle. Fold the circle in half and gently make sure the edges are lined up and sealed.

Then take the two corners of the tortellini half-moon shape and gently press them together. You can either make a flatter shape by stacking the corners one on top of the other, or you can make more of a standing hat shape by bringing the corners together one in front of the other. You can use the water to help them stick if you need.

Cooking Tortellini

Bring salted water to a rolling boil over high heat. When it reaches boiling, bring the heat down to medium-high and add the tortellini. Remove the tortellini as they rise to the surface. Add finished tortellini to the sauce and gently toss.

Filling Method

Preheat the oven to 400°F. Line a baking sheet with aluminum foil. Cut the squash in half and scoop out and discard the seeds. Place the squash onto the baking sheet, with the cut side facing up. Salt and pepper them to taste, about a teaspoon each, give or take. Roast the squash in the oven for about 25–45 minutes, or until tender. When a fork breaks apart the squash easily, the squash is done. Take out of the oven and let it cool. Once it is cool, scoop out the meat with a spoon until you have roughly 2 cups. Puree the squash, brown butter, olive oil, cinnamon, nutmeg, apple cider vinegar, chicken stock, and thyme in a blender or mash by hand.

Put a sauté pan over medium-high heat. Add the bacon and cook to desired crispness. Drain fat into a jar you can throw in the garbage, and set the bacon aside. When it's cool, chop the bacon into tiny pieces. Add chopped bacon to the squash mixture.

SAUCE

- White wine
- ½ cup filling without the bacon
- ½ cup chicken stock
- 2 tablespoons brown butter
- 2 tablespoons olive oil
- 2 tablespoons walnut oil
- 2 cloves garlic, minced
- 2 cloves shallots, minced
- ⅛ cup fresh sage
- Kosher salt to taste
- Pepper to taste
- 2 Meyer lemons, zested and juiced
- 2 cups arugula, roughly chopped
- 3 lemons, cut into wedges

Sauce Method

Cook down. Add in squash slowly with chicken broth. Incorporate more chicken stock, sage, and a dash of white wine.

Cook the pasta, add it to the sauce, and toss gently. Plate it and squeeze half a lemon per two servings. Top with walnut oil, lemon zest, cheese, and extra herbs.

GARNISH

* Walnut oil, to taste
* Lemon, 1 slice for each plate
* Zest of lemon, sprinkled over plate to taste
* Sage, sprinkled over plate to taste

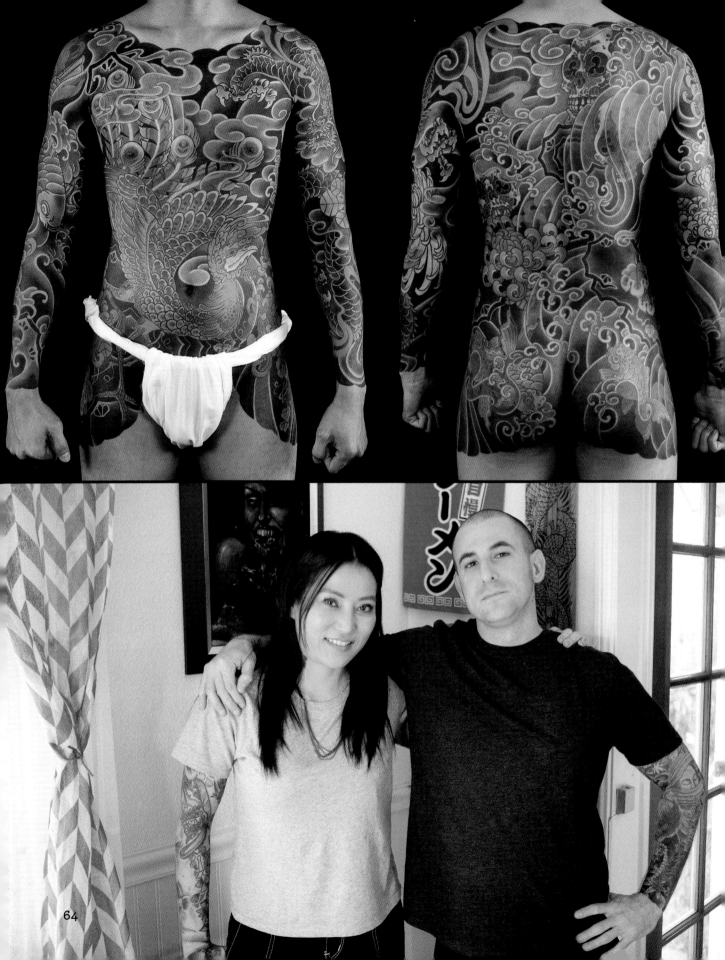

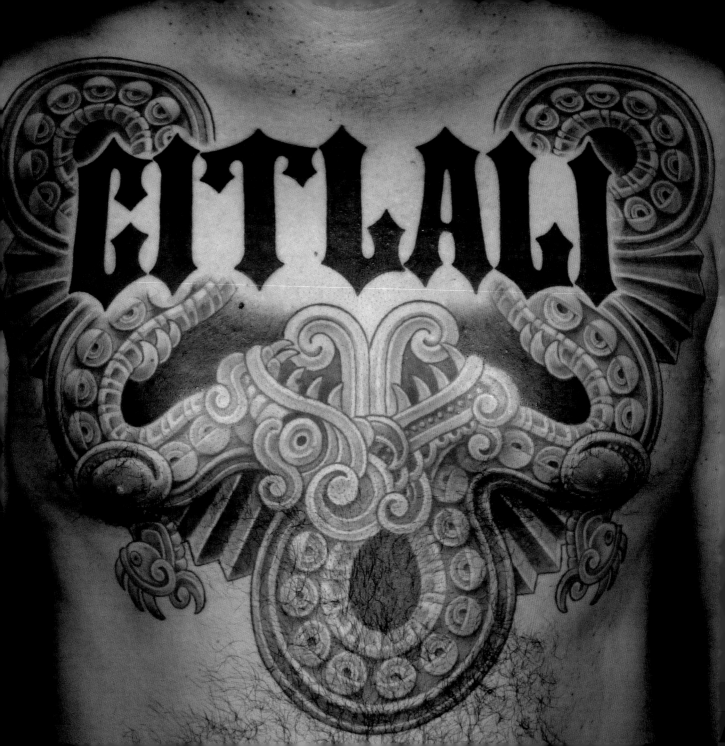

CHUEY QUINTANAR

I am honored to have Chuey Quintanar in this book for a few reasons. First, Chuey is awesome! Second, his recipe is from Oaxaca, Mexico, where his mother's side comes from. Why am I stoked on Oaxaca? Because of its diverse agricultural climates, the traditional dishes of the region are famous throughout Mexico. Chuey told me that in Mexican culture, men usually do the butchering and cooking of meats. The women prepare the rest of the food, while the kids usually are sent to the store to buy the drinks! However, today, Chuey did everything himself!

Chuey first started tattooing when he was fourteen with a homemade tattoo machine. He eventually started working in tattoo shops six years later. He now co-owns and operates Deer's Eye Studio in Los Angeles, California. Chuey has some good advice on getting tattooed: "Do your research. Figure out what you want to get, and search for the best artist that does the style you are looking for. As with

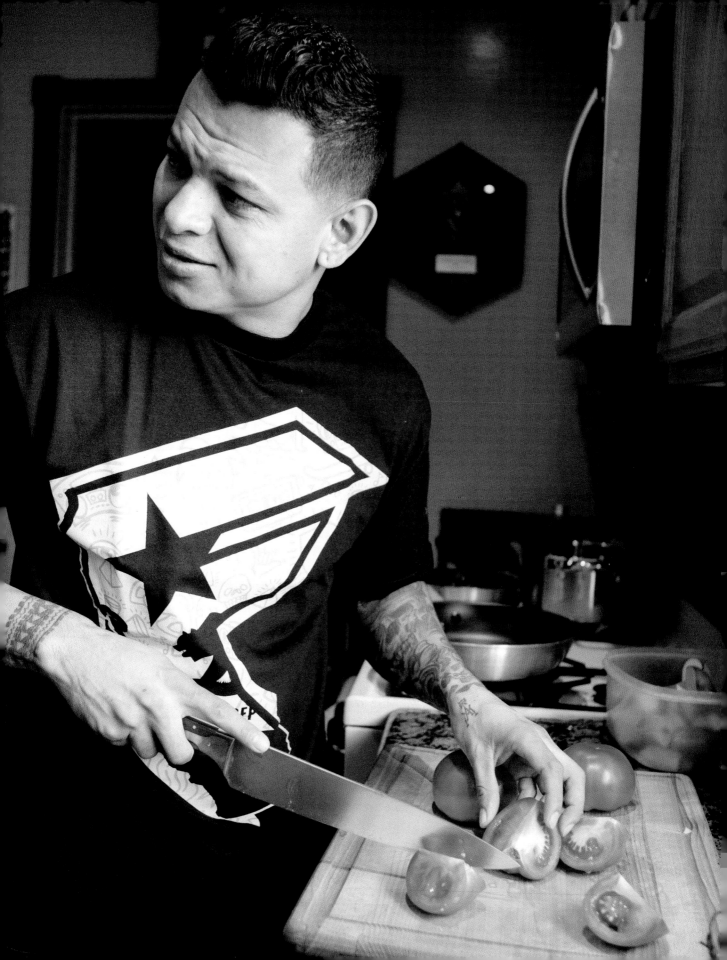

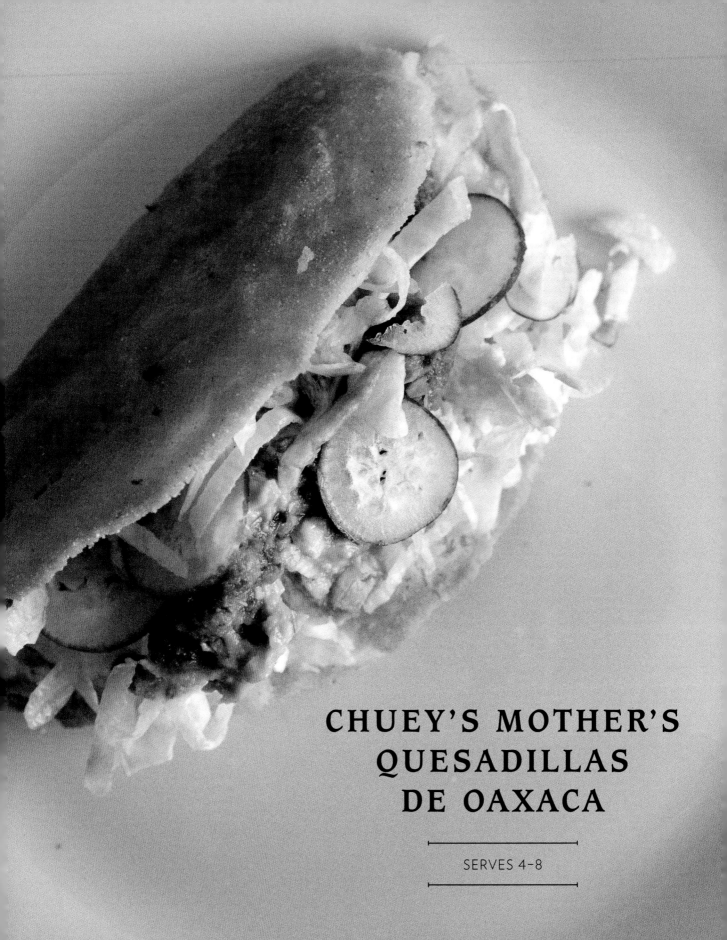

CHUEY'S MOTHER'S QUESADILLAS DE OAXACA

SERVES 4–8

- 3 russet potatoes, peeled
- Butter, salt, and pepper to taste
- 1 ball queso Oaxaca/quesillo
- 1 box Maseca corn flour
- 1 bunch epazote, if desired
- Vegetable oil for frying
- 1 10-oz package queso fresco
- Salsa to taste
- Lettuce, shredded

For the Filling

Boil potatoes. When done, mash with butter and use salt and pepper to season.

You can make both cheese quesadillas and cheese and potato quesadillas.

For the cheese, use Oaxaca-style cheese, shredded.

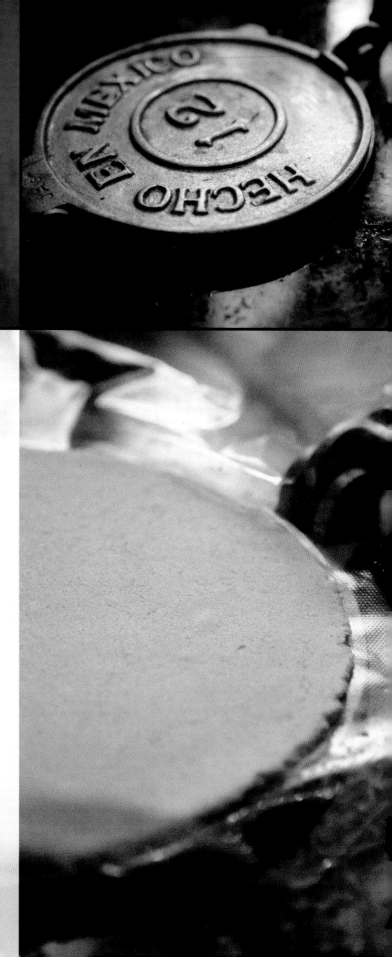

For the Quesadillas

You can use corn flour (Maseca brand) and follow the directions on the back of the package, depending on how many you want to make.

(YOU WILL NEED A TRADITIONAL TORTILLA MAKER FOR THIS RECIPE. YOU CAN FIND ONE AT A LOCAL MEXICAN GROCERY STORE.)

Once you've made the dough, roll it into a small ball (about the size of your palm) and place it in the tortilla maker. Make sure to line the tortilla maker with plastic so that the dough won't stick. Press the dough, and once it looks like a thick tortilla, place ingredients inside, such as cheese and epazote (a Mexican fresh herb) or cheese and potato. Once the ingredients are placed, close the tortilla like you would a taco, making sure that the sides are sealed.

Once you have the quesadillas assembled, fry them in vegetable oil at medium heat until golden brown. When done, take them out of the pan and place them on a paper towel to help drain the extra oil.

Top the quesadillas with guacamole, salsa, shredded lettuce, and fresh Mexican cheese (queso fresco); you can also use sour cream.

For the Guacamole

- 2 avocados
- ½ lime
- 1 tomato, diced
- 1 onion, diced
- 1 garlic clove, smashed
- ¼ cup cilantro, diced
- Salt and pepper to taste

Smash the avocado with a fork until creamy. Add lime juice and salt and pepper, then mix. Then add the tomatoes, onions, garlic, and cilantro and gently mix.

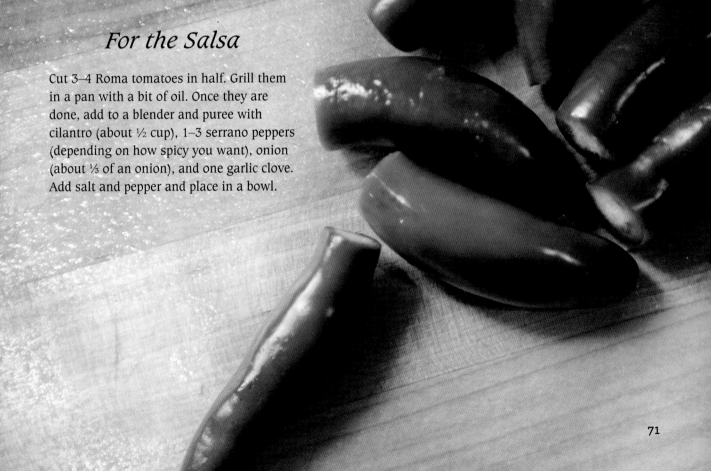

For the Salsa

Cut 3–4 Roma tomatoes in half. Grill them in a pan with a bit of oil. Once they are done, add to a blender and puree with cilantro (about ½ cup), 1–3 serrano peppers (depending on how spicy you want), onion (about ⅓ of an onion), and one garlic clove. Add salt and pepper and place in a bowl.

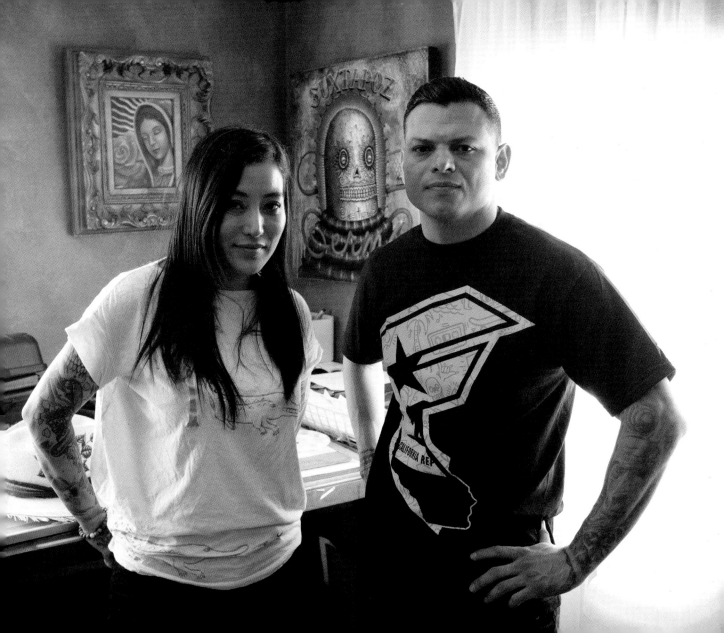

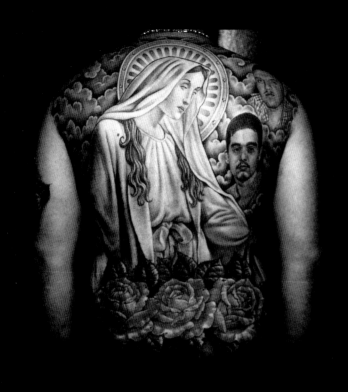

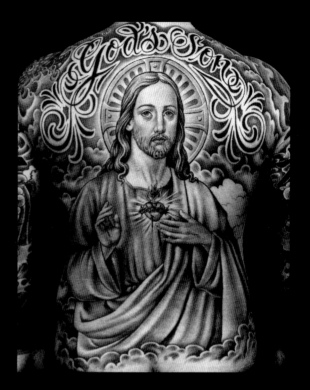

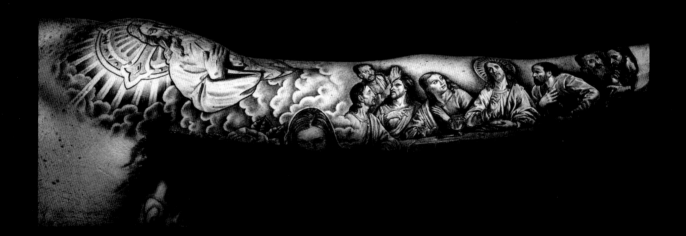

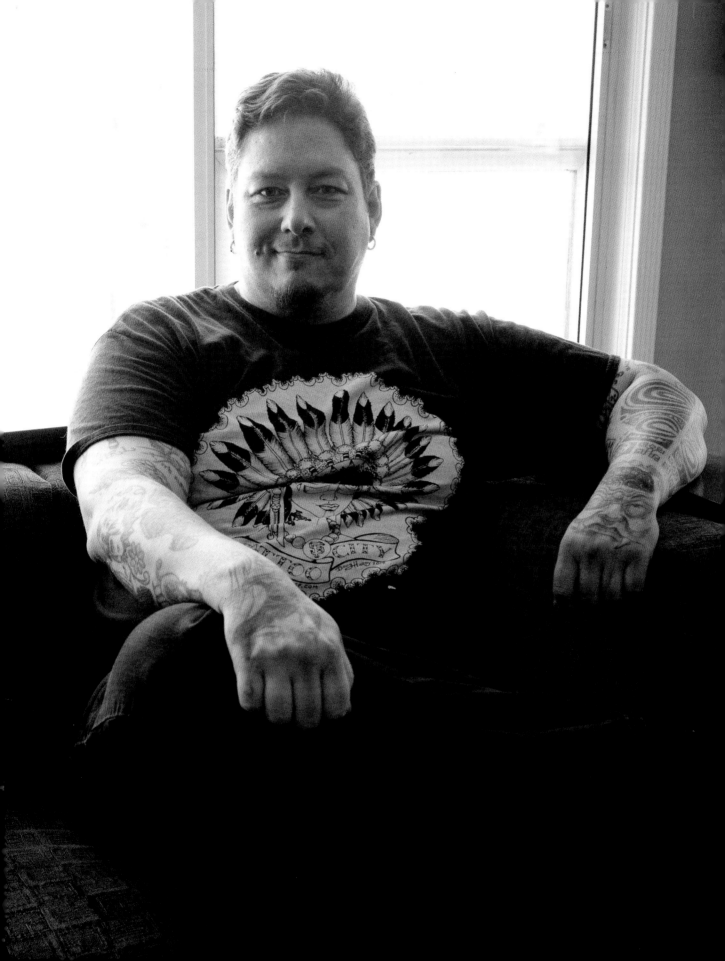

DOUG HARDY

Doug Hardy started tattooing over two decades ago at China Sea Tattoo in Honolulu. The shop was legendary, owned by Sailor Jerry Collins and then passed on to Mike Malone, who apprenticed Doug. Tattooing surrounded him as a child, and it always had a mysterious draw on him. It was destined to be his career! Doug now works at his father's shop, Tattoo City, in San Francisco, California.

Doug has a culturally eclectic family; he grew up eating a mix of Mexican and Italian cuisines. His last meal request would be his mother's quesadillas, his grandfather's menudo with hominy, and his stepmother's pizza—"It's a last meal, might as well make it count!"

Doug's advice on cooking steak is to get a good crust going by searing on high heat, using butter or oil for a few minutes on each side. Then slide the steak into the oven for a few minutes until the center warms to your desired temperature. He suggests taking meat or fish off the heat before you think it's quite done, to ensure that you do not accidentally overcook it. You can always throw it back on the fire! Another important rule is to make sure to always go for quality over quantity! Doug's recipe is a truly enjoyable, decadent classic. There is something very satisfying about cooking a proper steak, and Doug certainly does a great job!

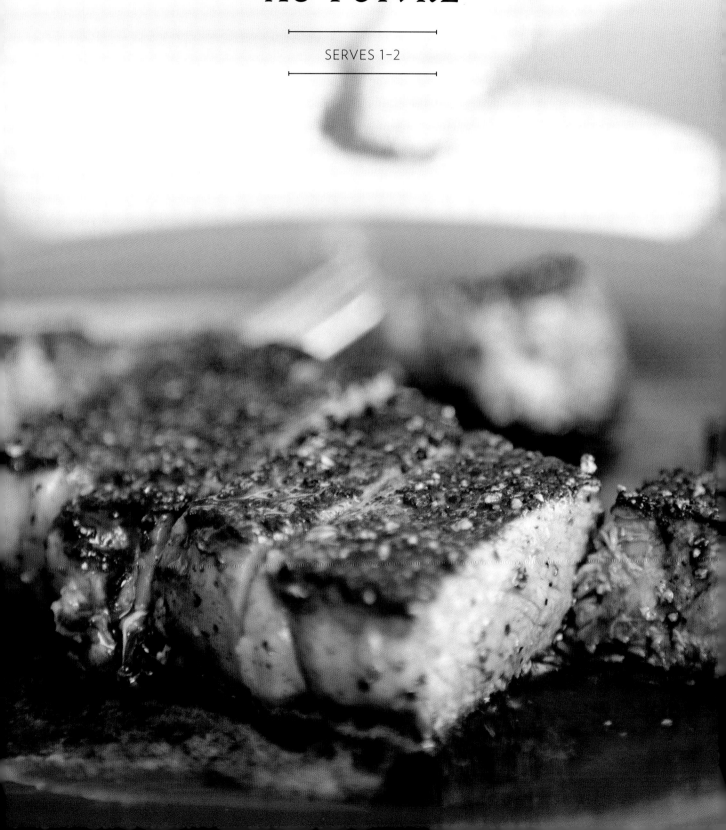

DOUG'S STEAK
AU POIVRE

SERVES 1–2

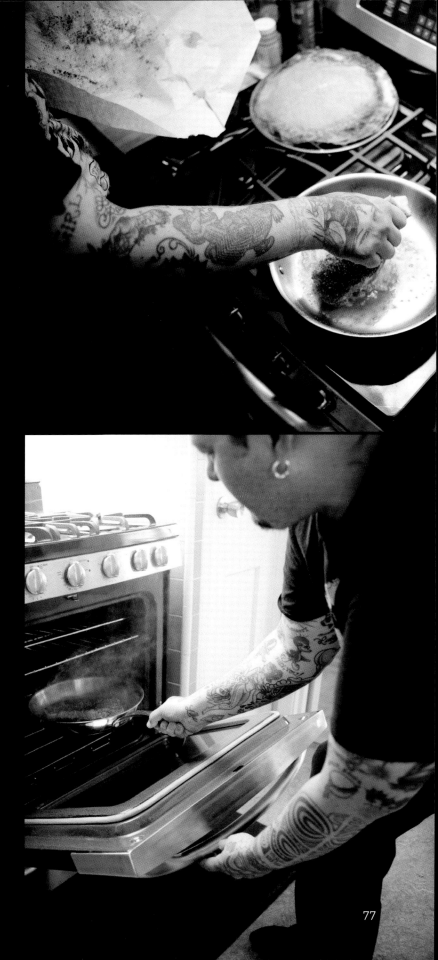

- 1 high-quality, 1-inch-thick sirloin, room temperature (you can use any cut of steak, however)

- 1 teaspoon sea salt

- 2 teaspoons fresh, very coarsely cracked peppercorns

- 3 tablespoons butter, divided into 3 1-tablespoon portions

- 2 tablespoons shallots, finely chopped

- 3 tablespoons cognac, if desired

- ¼ cup heavy cream

Preheat oven to 450°F. Salt the room-temperature steak, then press the peppercorns into the steak. (You can use any color and mix of peppercorns. To crack them, simply put the peppercorns into a sandwich bag and carefully smash them with a skillet or beef tenderizer mallet.) Coat it well with the pepper and set aside. Heat up a skillet or frying pan (do not use nonstick) over medium-high heat and add 1 tablespoon of the butter. When the butter starts to smoke (seriously, just starts to smoke, don't let it burn too much!), gently lay the steak on the pan—you should hear a good sizzle. Sear each side so that there is a nice, dark-brown crust on each side, about 1–2 minutes per side. Transfer the pan into the oven for 3–5 minutes for medium rare. If you do not have an oven-safe frying pan, transfer the steak to a baking sheet to put in the oven. When the steak is cooked to your desired temperature, remove it from the pan and set aside to let the steak rest and the juices settle. Take the pan, drain off excess fat, and put it over medium-low heat. When it starts to get hot, melt

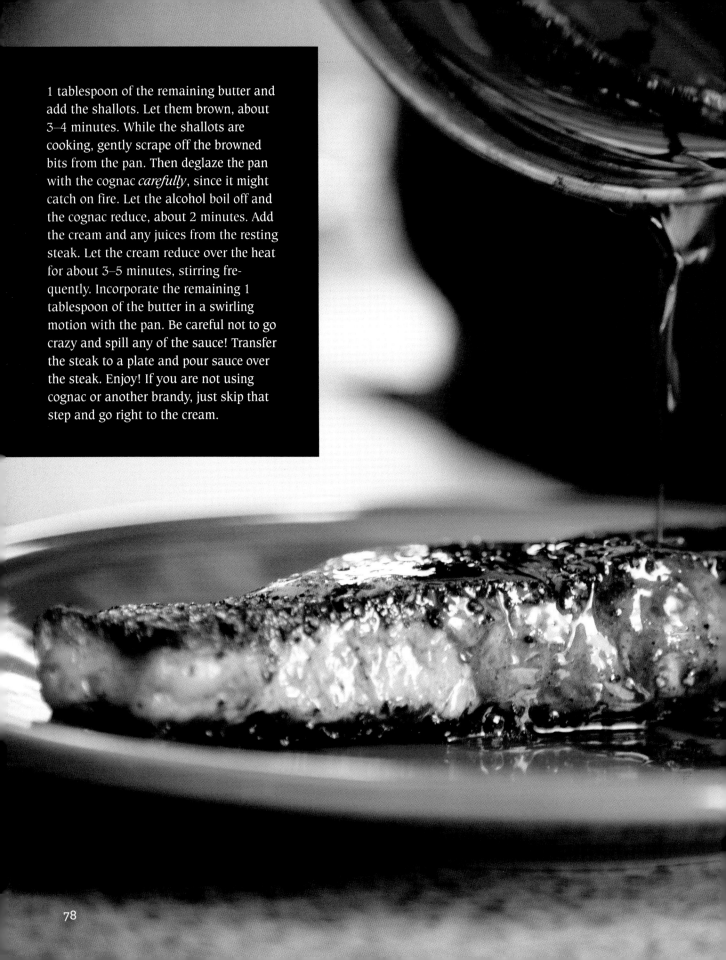

1 tablespoon of the remaining butter and add the shallots. Let them brown, about 3–4 minutes. While the shallots are cooking, gently scrape off the browned bits from the pan. Then deglaze the pan with the cognac *carefully*, since it might catch on fire. Let the alcohol boil off and the cognac reduce, about 2 minutes. Add the cream and any juices from the resting steak. Let the cream reduce over the heat for about 3–5 minutes, stirring frequently. Incorporate the remaining 1 tablespoon of the butter in a swirling motion with the pan. Be careful not to go crazy and spill any of the sauce! Transfer the steak to a plate and pour sauce over the steak. Enjoy! If you are not using cognac or another brandy, just skip that step and go right to the cream.

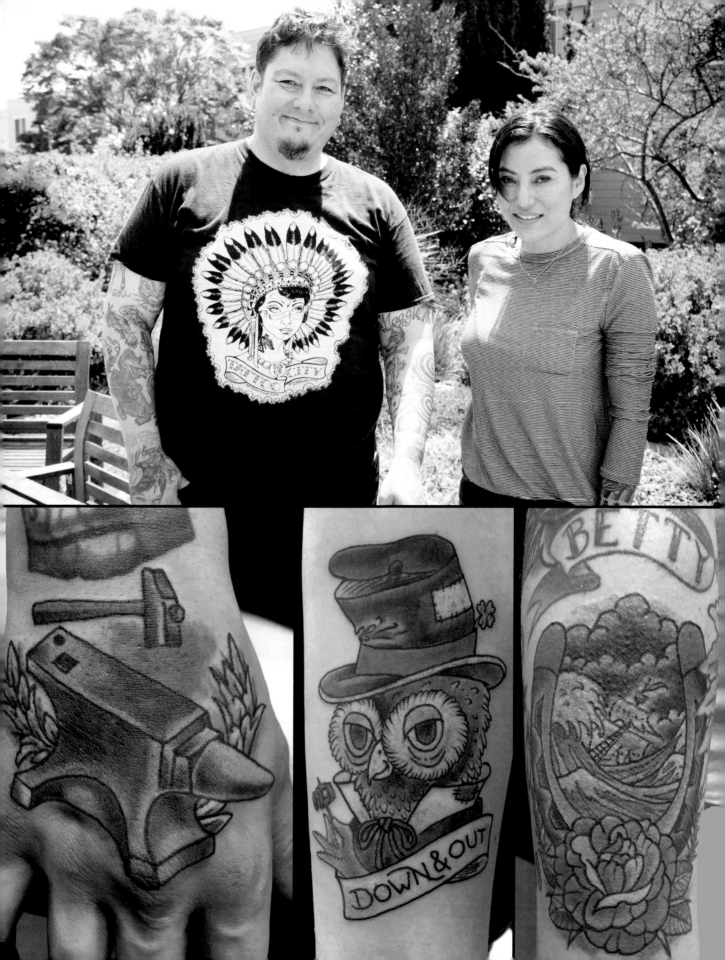

DREW FLORES

I get the opportunity to see Drew Flores all the time, and it is a real treat to see him at work, witnessing all of his talent and hard work come to life on skin. Drew has been tattooing for over seven years and works at State of Grace Tattoo in his hometown of San Jose, California. When asked, Drew will tell you he loves to work on Japanese-themed tattoos. Drew also loves cooking and eating—creating new tastes and experimenting with different ingredients is something that really excites him. As far as influences on his palette, he cites his grandmother's cooking as a major force. From what I have witnessed at shop barbecues, Drew is a grill master! He has taught me a lot about grilling over the years, and his main advice for perfect meat grilling is to keep your wristwatch on! Like any foodie, Drew loves to eat out and is up on all the good spots to eat in the Bay Area. He is a good source for advice on the newest hotspots or older hidden gems. Another one of Drew's passions is fishing, specifically for bass. Fishing is calming for Drew: it's his time to unwind and Zen out. Drew's life revolves around fishing, cooking, tattooing, and spending time with his sons. He's given us a dish they love— huevos rancheros with homemade salsa roja. It is spicy, savory, and sublime!

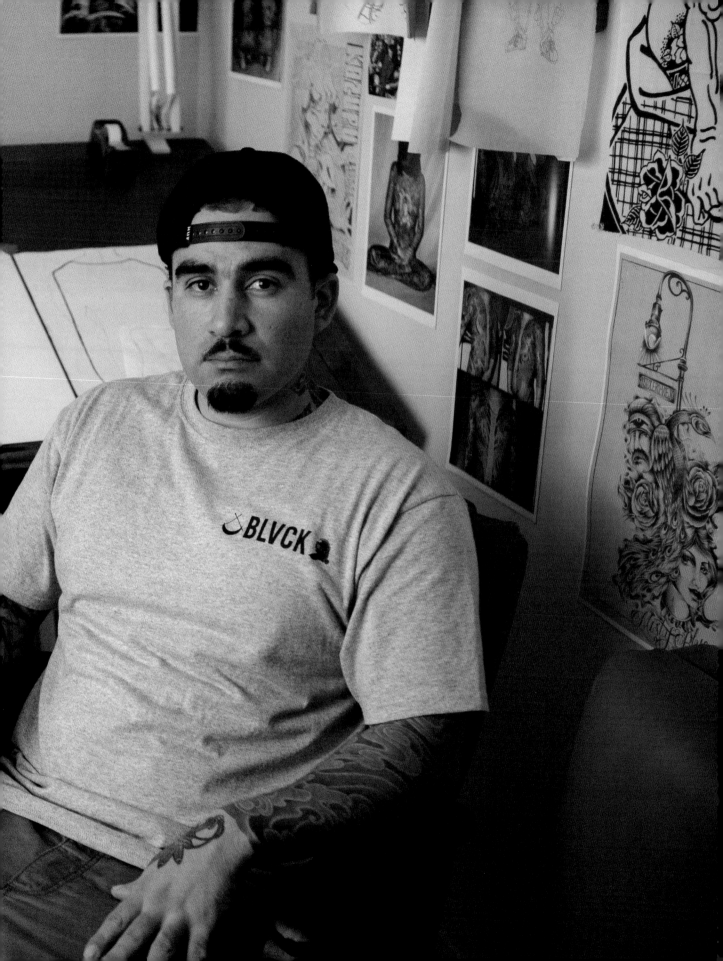

DREW'S HUEVOS RANCHEROS

WITH HOMEMADE SALSA

SERVES 4-6

4–5 ounces cheddar cheese, shredded

4–5 ounces Monterey Jack cheese, shredded

4 russet potatoes, sliced ¼ inch thick

Olive oil

6 jalapeños, roasted

8 tomatoes

4–6 garlic cloves, minced

2 yellow onions, chopped or thinly sliced

Cilantro

8–10 eggs

Salt and pepper to taste

Take the blocks of cheddar and Monterey Jack cheese, shred into a bowl, and set aside. Cut the potatoes into thin wedges. Heat up a deep frying pan with a little olive oil over medium-high heat. When the pan starts to get hot, place the potatoes in the pan and cook until tender.

While the potatoes are cooking, roast the jalapeños and tomatoes directly on the gas range. You can hold them with a pair of tongs. Or if you have a chili roaster, please use that. If you do not have a gas stove, you can roast them in the oven or toaster oven with a temperature of 450°F. Place them on the shelf level closest to the heat. When they are soft and the skin blackens, wrap them in Saran wrap for 2–3 minutes to let the steam finish roasting them. After they're done, take them out of the Saran wrap and place them in a blender. Add the garlic, onion, and cilantro to the blender and puree. Pour salsa into the frying pan with the potatoes and place over medium-high heat. When the salsa starts to simmer, crack the eggs on top of the salsa. Cover and let the eggs and salsa simmer for about 3–5 minutes. When the eggs look the desired firmness (whites should be white, and the yolk is up to you), top the whole thing with the grated cheese. Let the cheese melt. Serve with toast or on its own and enjoy!

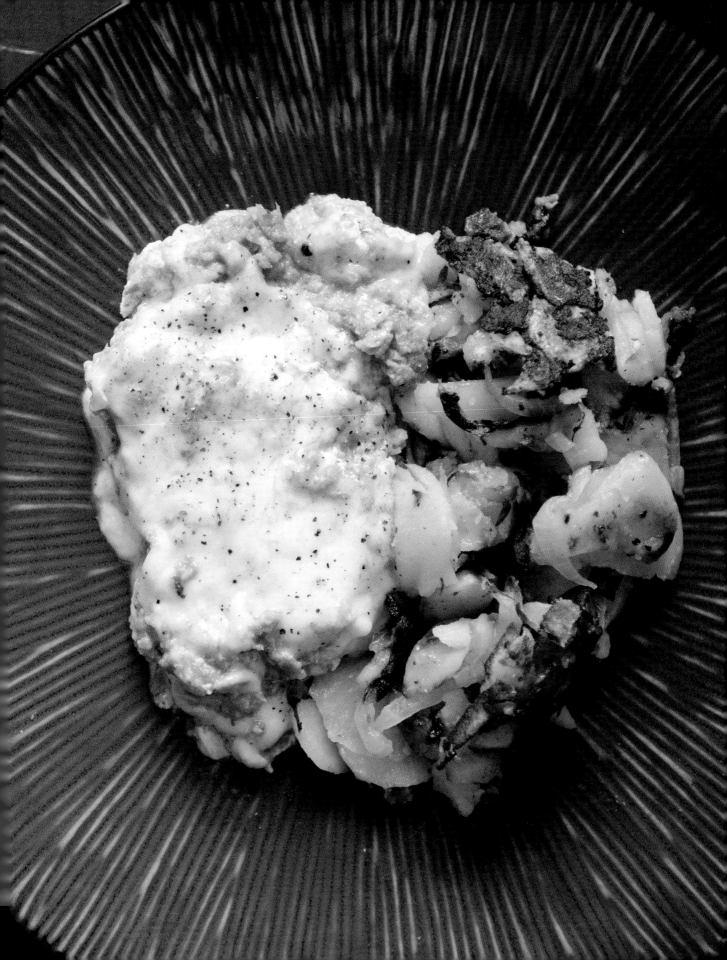

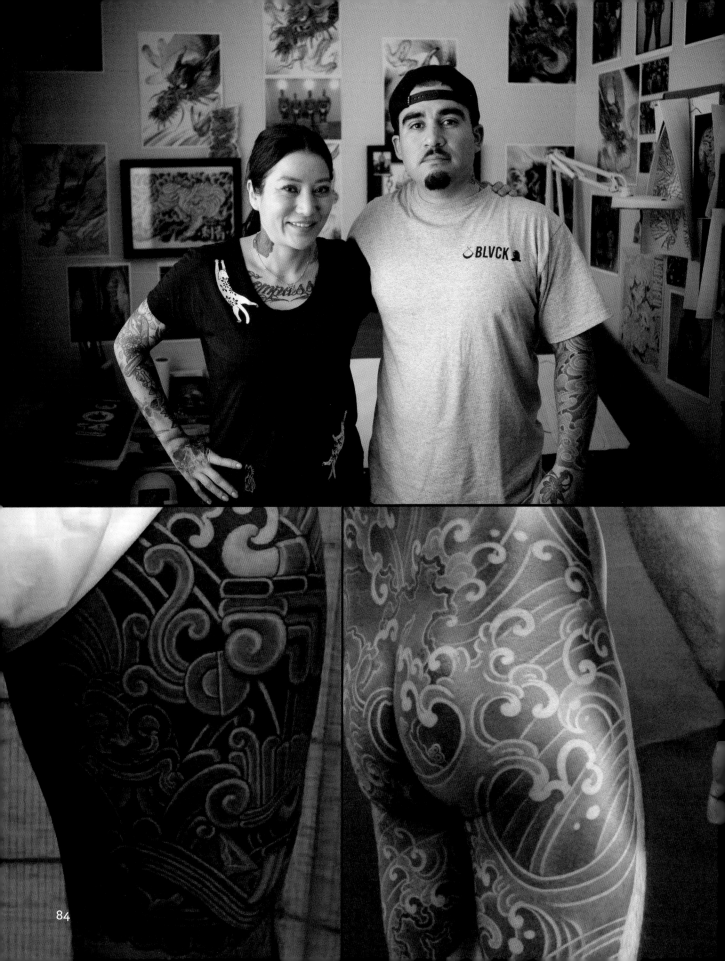

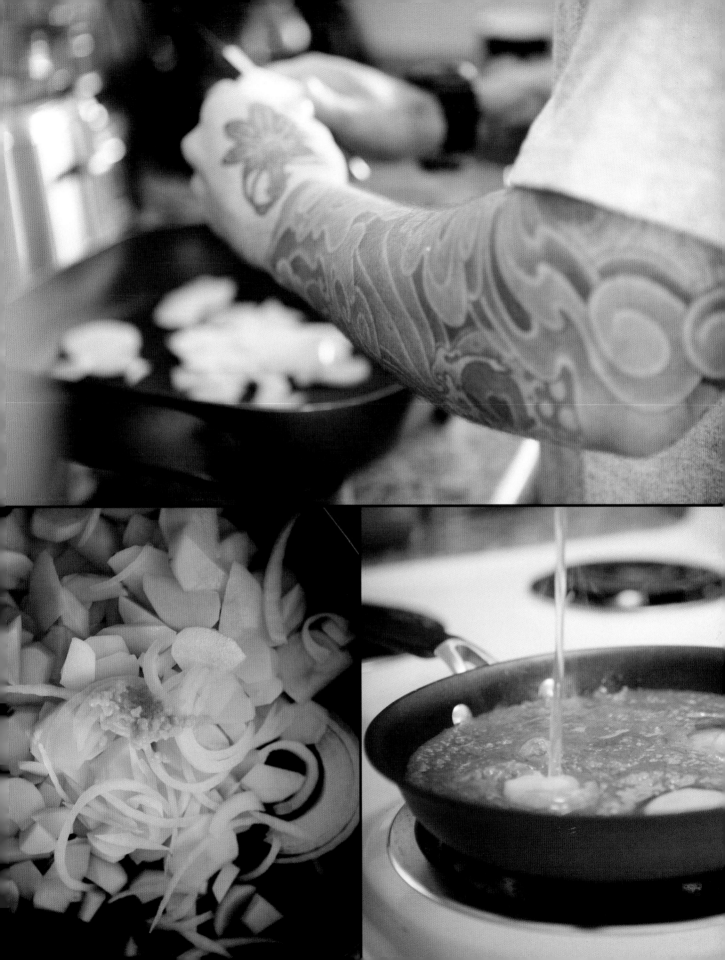

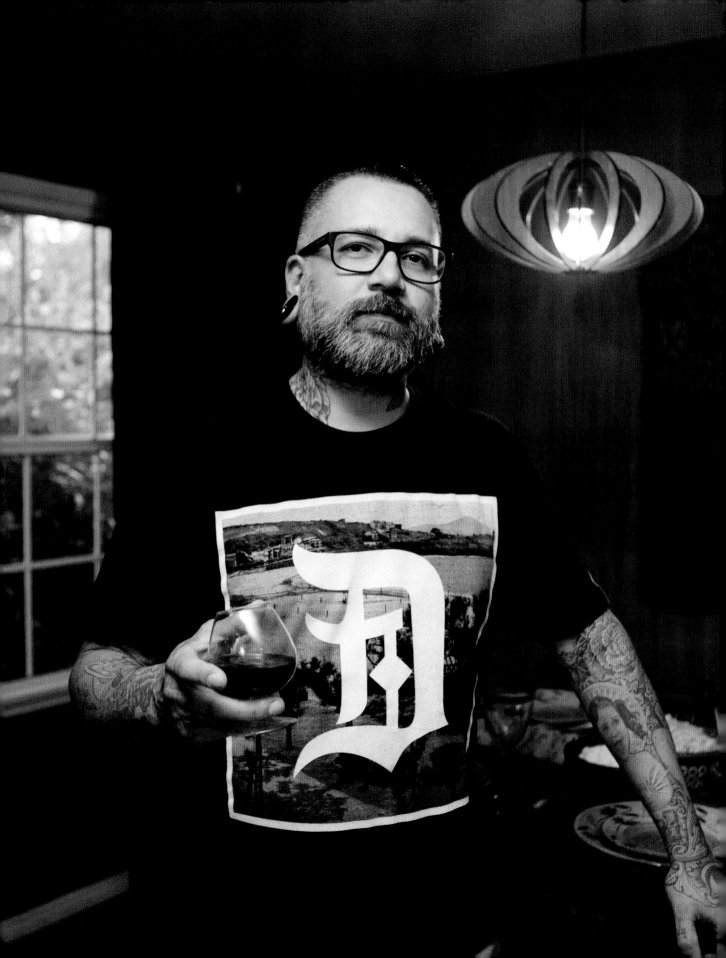

ERIC GONZALEZ

E ric definitely came prepared for this book! He got his whole family involved to make his intricate and delicious meal. The experience was amazing—Eric and his family are so warm and welcoming. John and I instantly felt at home. Watching Eric and his family cook together was like watching a well-oiled machine. Everyone had a defined job and pitched in to help Eric put this veritable feast together. When all was shredded, fried, pureed, and set, everyone sat down and we all ate together. It was a truly memorable, wonderful evening.

Eric Gonzalez, along with Chuey Quintanar, is the co-owner of Deer's Eye Studio in Los Angeles, California. Eric has been tattooing for a number of years and counts some very well-known musicians among his clients—he's tattooed Lady Gaga extensively. This isn't surprising at all, since Eric is himself a very talented musician. I've even heard rumors of an album in the works!

The recipe Eric and his family cooked is an old family dish from his mother's side. The hard work really paid off, and the food was delicious! Thank you Eric and family!

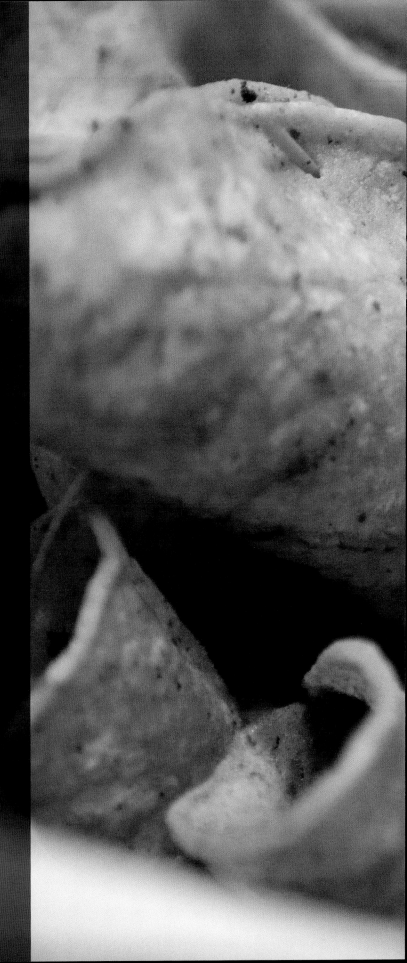

5-pound whole chicken (give or take a pound), roasted, deboned, and meat shredded

Thyme or rosemary to taste (optional)

2 tablespoons butter, clarified/melted

Paprika to taste (optional)

6–8 russet potatoes; peeled, boiled, and mashed

2–4 tablespoons butter, room temperature

Vegetable oil, enough for deep frying

20–30 small corn tortillas

6–8 tomatillos, roasted and peeled

6–8 jalapeños, roasted and peeled

6–8 tomatoes, roasted and peeled

1 yellow onion, peeled and quartered

1 bulb of garlic, peeled

1 bunch of cilantro, stemmed

Queso Oaxaca (Mexican cheese, similar to a string cheese) to taste

Mexican crema to taste

1 head of romaine lettuce, shredded

6–8 avocados, pitted and mashed

4–5 limes, juiced

1 large red onion, sliced very thin

1 cup white vinegar

⅛–¼ cup sugar

Salt and pepper

60–90 toothpicks

ERIC (& FAMILY)'S CHICKEN & POTATO TACOS

SERVES 6–10

Roasting Chicken

- 5-pound whole chicken, roasted
- 2 tablespoons butter, clarified
- Salt and pepper, to taste

Preheat the oven to 425°F. Unwrap the chicken and remove the gizzards, which should be in the cavity of the chicken. Discard the gizzards. Rinse the chicken under cold water, even rinsing the inside of the chicken. Place the chicken breast side up on a roasting pan lined with aluminum foil. You can stuff the chicken cavity with herbs like thyme and rosemary if you desire, but that is not necessary for this use. Brush the butter over the skin of the breast, and salt and pepper. You can add some paprika if you like. Roast the chicken for about 1½ hours, or until the juices run clear when you cut in between the leg and thigh. Remove the chicken and let it rest covered with foil for about half an hour. When it's cool, shred the chicken meat into a bowl and set aside.

Potatoes

- 6–8 russet potatoes, peeled and boiled
- Salt and pepper, to taste
- 2–4 tablespoons butter, if desired

Set a medium to large pot on medium-high heat. Salt the water, about 1–2 tablespoons. Peel the potatoes and place them into the water. Boil the potatoes until tender. They should break easily with a fork. Strain the potatoes, place them into a bowl, and mash until they are pureed. Add a little butter if you want! Salt and pepper to taste. Set aside.

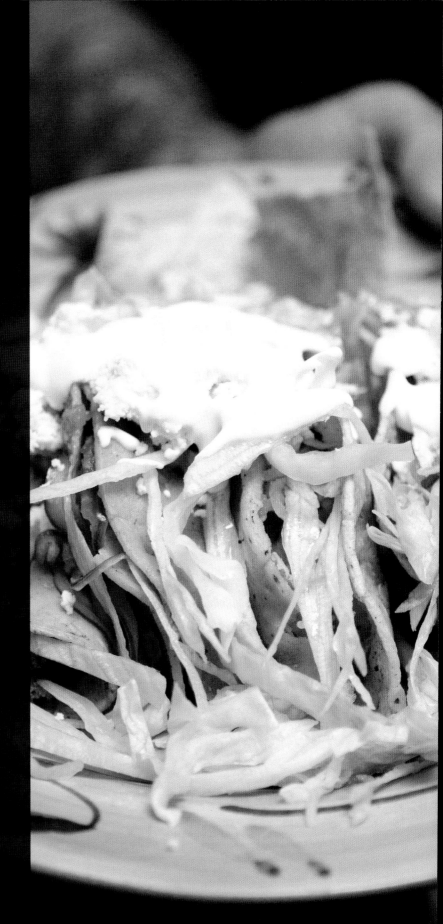

Guacamole

..

- ⚘ 6–8 avocados
- ⚘ 4–5 limes
- ⚘ Salt and pepper, optional

..

Cut each avocado in half and take out the pit. Scoop out the avocado with a spoon and place in a bowl. Cut the limes in half and juice them with a fork, or squeeze them with tongs. Add the juice to the avocados and mash the avocados until pureed. Salt and pepper if you want. Set aside as well.

Salsa

..

- ⚘ 6–8 tomatillos, roasted and peeled
- ⚘ 6–8 tomatoes, roastcd and peeled
- ⚘ 6–8 jalapeños, roasted and peeled
- ⚘ 1 yellow onion, peeled and quartered
- ⚘ 1 bulb of garlic, peeled
- ⚘ 1 bunch of cilantro, stemmed

..

Roast the tomatillos, tomatoes, and jalapeños over an open flame on the stove in a Mexican chili roaster, if possible. If you do not have this, you can roast them either in the oven or over the open flame on your stove, holding them with tongs. But please be careful! When the skin starts to char (turn black), take them off the heat, wrap them in Saran wrap, and set aside to let them finish cooking in the plastic wrap. Prepare the onion and garlic and stem the cilantro. Remove the Saran wrap and peel the skins off the tomatillos, tomatoes, and jalapeños. Throw everything into a blender and puree. Pour into a bowl and set aside.

Pickled Red Onion

❧ 1 large red onion, sliced very thin
❧ 1 cup white vinegar
❧ ⅛–¼ cup sugar, or to taste

Combine all ingredients into a bowl and let the onions pickle for at least 20 minutes.

Assembling the Tacos

Heat the vegetable oil either in a small fryer or over medium-high heat in a pot on the stove. Be careful not to burn the oil, and turn down the heat to medium-low to low when it reaches the appropriate temp. The oil will have some movement when it is hot, and you can test it by taking a small bit of tortilla and gently placing it in the oil. If the oil is ready, the tortilla will pop up to the surface quickly.

While the oil is heating, take a tortilla and stuff it with chicken and potato. Fold the tortilla in half and use 3–4 toothpicks to hold the tortilla together. Do this to as many tortillas as needed. You can do some only chicken, and some only potato. Have fun!

When the oil is hot, deep fry the tacos until the tortilla is crispy. Fry in batches, and in between batches you may have to let the oil heat up again. Line a tray or large bowl with paper towels and place the fried tacos on it. Take out the toothpicks before you eat!

The guacamole, lettuce, cheese, crema, and salsa are all ingredients the eaters can stuff into their fried tacos, so set everything out and enjoy!

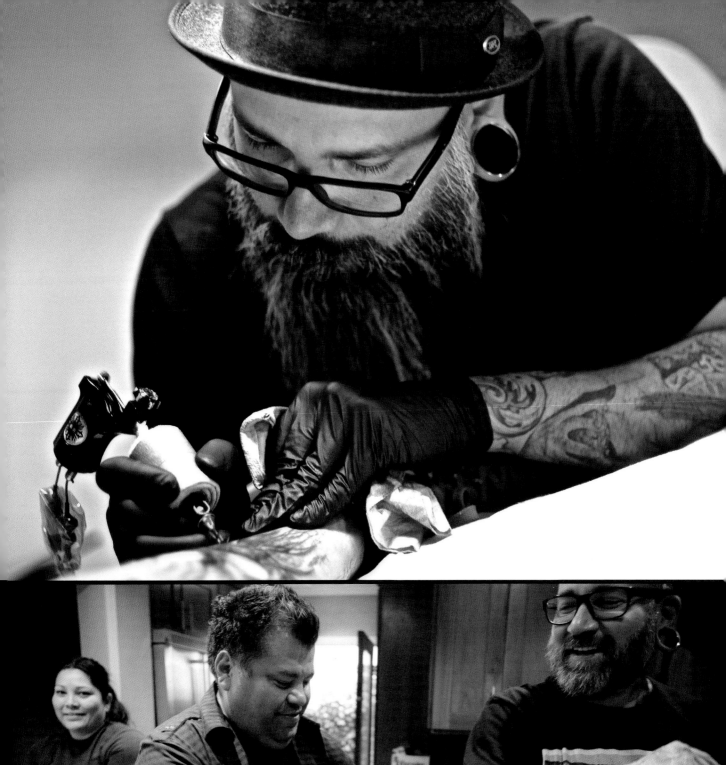

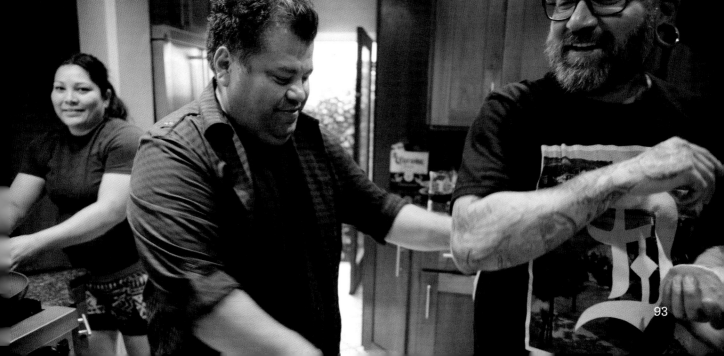

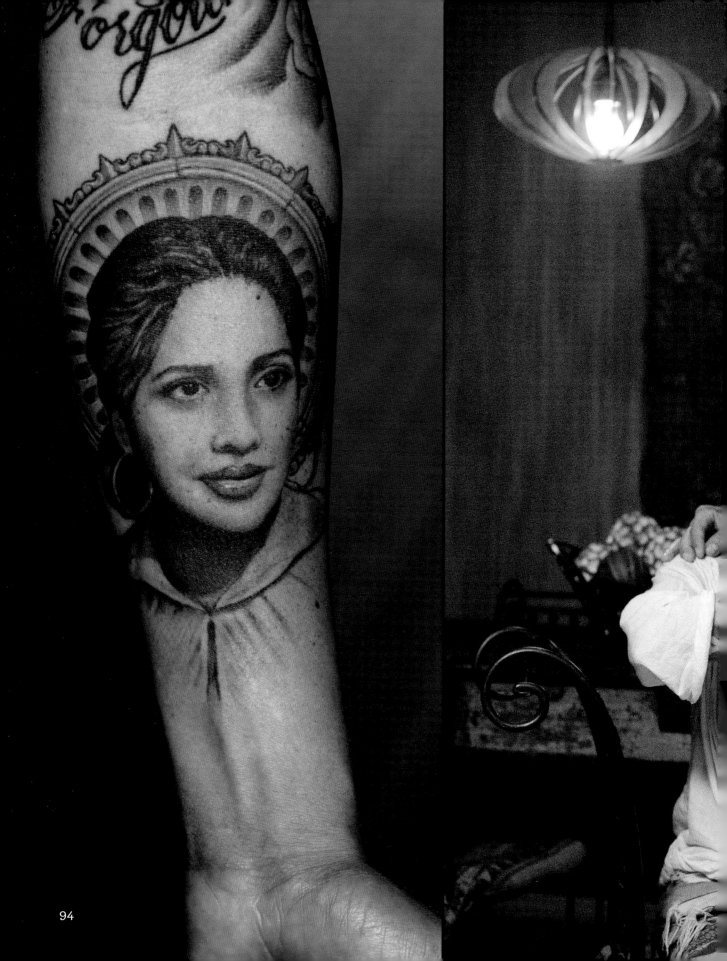

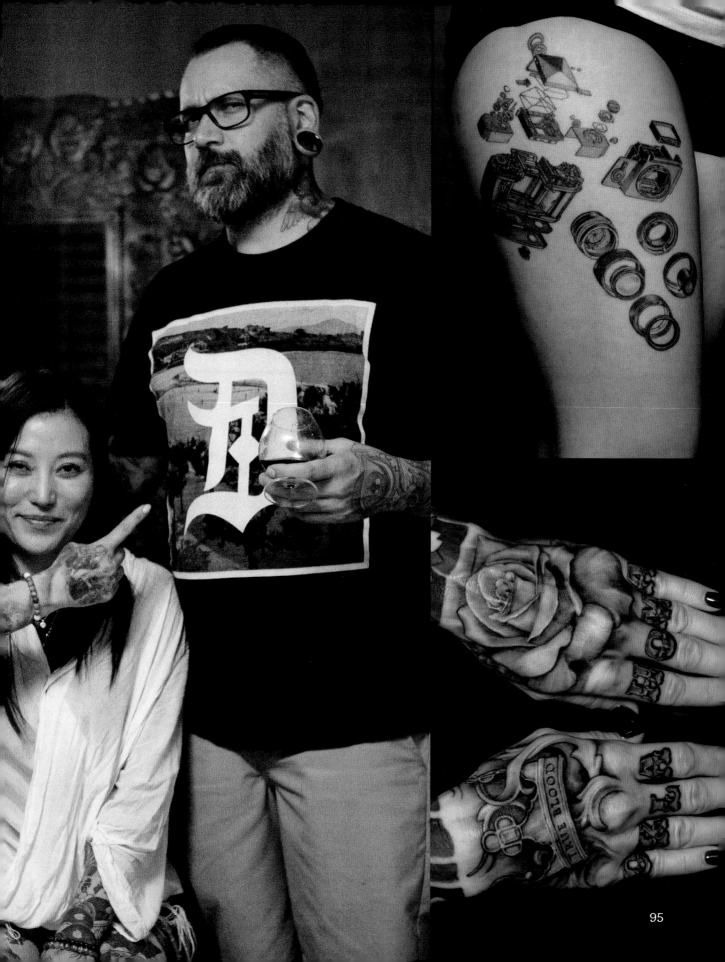

HORITOMO

Horitomo is originally from the coastal region of Mie in Kansai, Japan. His began tattooing over twenty years ago in Nagoya, then worked in Osaka, Tokyo, and Yokohama. He currently resides in San Jose, California, and works at State of Grace Tattoo. Horitomo is known among his colleagues and tattoo aficionados as one of the best Japanese tattoo artists of this generation. Horitomo is well known for his love of cats, as well as his incredible knowledge of esoteric Buddhism and Japanese folklore. You'd expect him to levitate in his spare time!

Prior to becoming a tattoo artist, Horitomo held a series of jobs: cooking, bartending, and even working at a fish market. His resume also boasts multiple design jobs for Sega Game Systems, two published books, and the creation of Monmon Cats. Monmon Cats is a new genre of Japanese art featuring tattooed cats— monmon being one of the many ways to say tattoo in Japanese. Horitomo has a subtle sense of humor, and you can really see it in his beloved Monmon Cats.

As far as food goes, Horitomo could eat Japanese curry or uni (sea urchin)—or both—any given day. He happily recounts a story where, in preparation of the New Year's shop closure, he was able to eat a whole case of uni at his fish market job! Horitomo smiles and says this was one of his happiest food memories! He also told me that cats will not eat bad sashimi, so you can actually know how fresh fish is with the help of your cat! Food, cats, and tattoos: it's what fuels Horitomo's soul! Please enjoy his recipe—it is super easy to make. One last tip from Horitomo: take your time and make sure the chicken is cooked thoroughly!

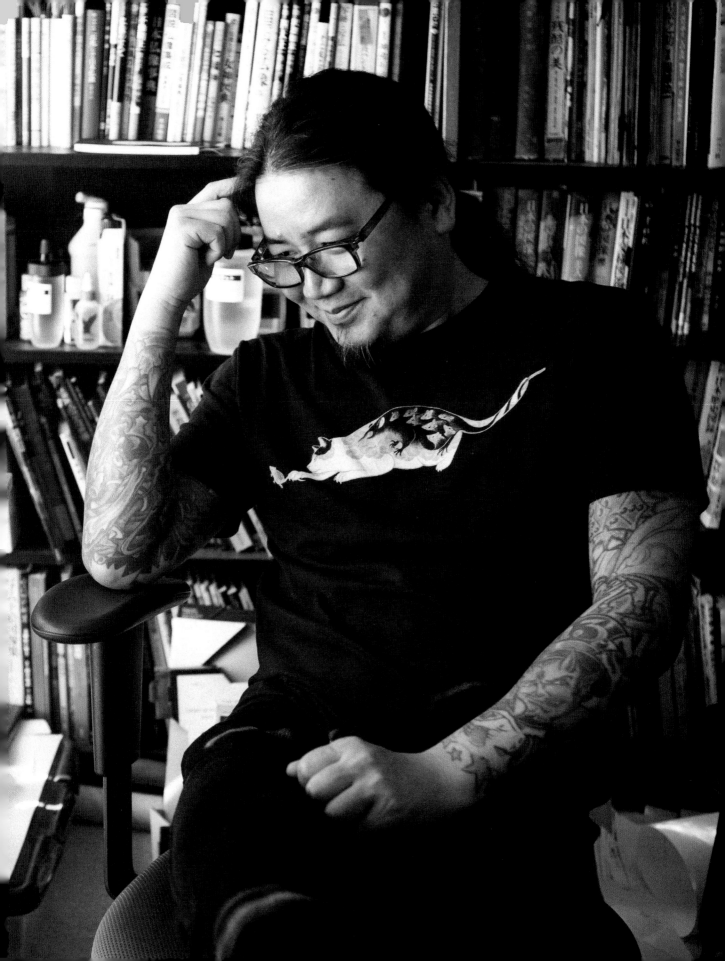

HORITOMO'S KARAAGE

SERVES 4–6

- 1 pound chicken thighs, skin on, boneless, cut into about 2-by-2-inch pieces
- 2 tablespoons minced garlic
- 4 tablespoons soy sauce
- Vegetable oil for frying
- 1 cup potato starch or cornstarch
- Lemon slices

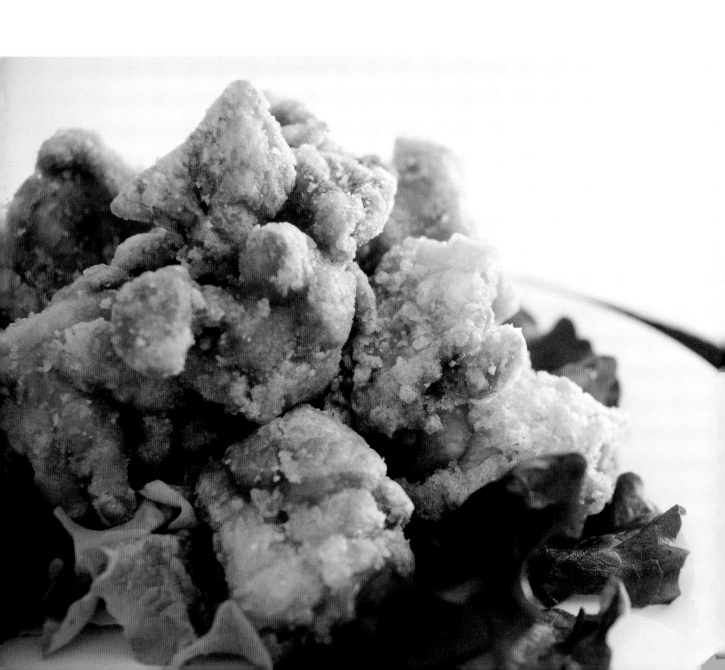

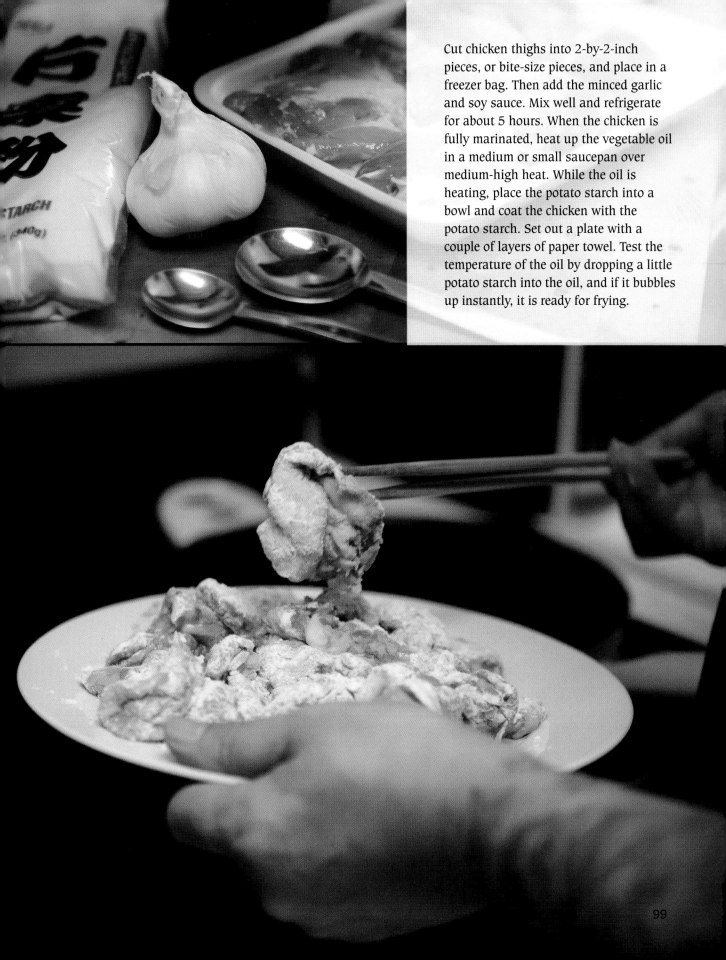

Cut chicken thighs into 2-by-2-inch pieces, or bite-size pieces, and place in a freezer bag. Then add the minced garlic and soy sauce. Mix well and refrigerate for about 5 hours. When the chicken is fully marinated, heat up the vegetable oil in a medium or small saucepan over medium-high heat. While the oil is heating, place the potato starch into a bowl and coat the chicken with the potato starch. Set out a plate with a couple of layers of paper towel. Test the temperature of the oil by dropping a little potato starch into the oil, and if it bubbles up instantly, it is ready for frying.

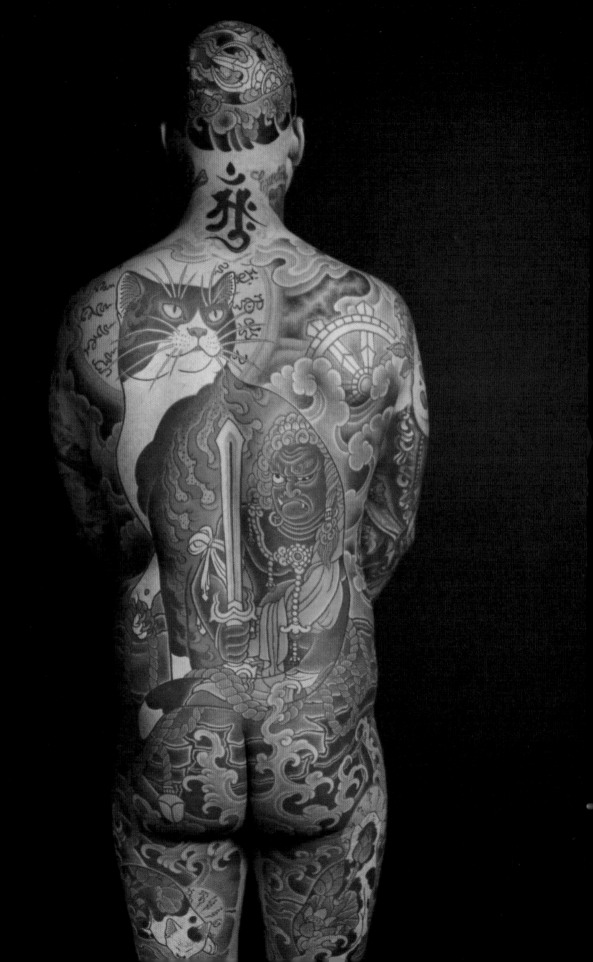

Carefully place the chicken in the oil and fry until golden, about 2–3 minutes. If you are using a small saucepan, fry the chicken in batches, waiting in between batches for the oil to heat up again. Place the fried chicken on the paper towel–lined plate to soak up any excess oil.

Serve immediately with slices of lemon. Squeeze the lemon over the chicken before you eat!

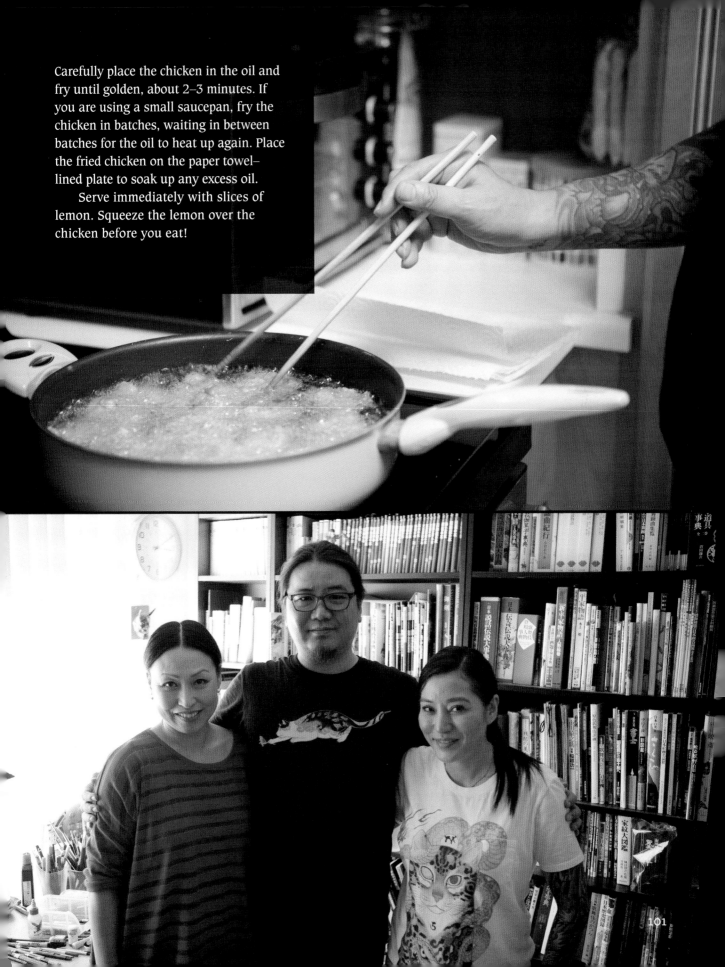

JASON
KUNDELL

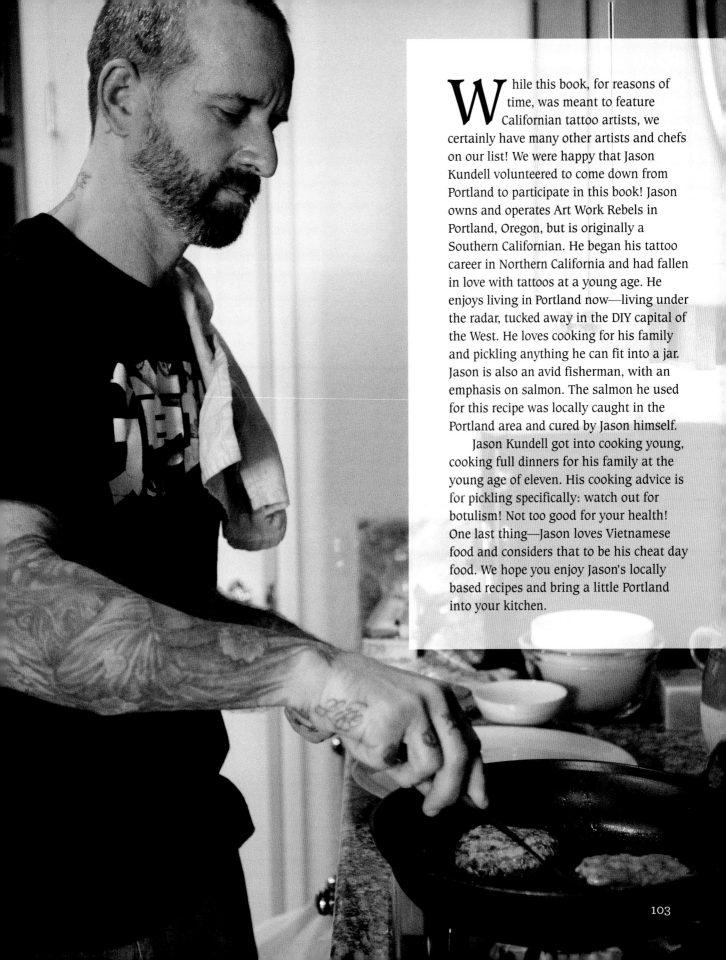

While this book, for reasons of time, was meant to feature Californian tattoo artists, we certainly have many other artists and chefs on our list! We were happy that Jason Kundell volunteered to come down from Portland to participate in this book! Jason owns and operates Art Work Rebels in Portland, Oregon, but is originally a Southern Californian. He began his tattoo career in Northern California and had fallen in love with tattoos at a young age. He enjoys living in Portland now—living under the radar, tucked away in the DIY capital of the West. He loves cooking for his family and pickling anything he can fit into a jar. Jason is also an avid fisherman, with an emphasis on salmon. The salmon he used for this recipe was locally caught in the Portland area and cured by Jason himself.

Jason Kundell got into cooking young, cooking full dinners for his family at the young age of eleven. His cooking advice is for pickling specifically: watch out for botulism! Not too good for your health! One last thing—Jason loves Vietnamese food and considers that to be his cheat day food. We hope you enjoy Jason's locally based recipes and bring a little Portland into your kitchen.

This recipe seems pretty involved for a humble salmon burger, but the taste is well worth it in the end. I prep it much like my tattoos—chipping away at it throughout the week. It's rare that I have a whole day to devote completely to cooking or drawing. I also make extra of everything. Especially the zucchini pickles to enjoy another day.
—Jason

For the Burgers

- 2-pound salmon fillet with pin bones removed
- 1 tablespoon canola oil
- 1½ tablespoons kosher salt
- ¼ tablespoon brown sugar
- ¼ tablespoon maple syrup
- 2 tablespoons coarse fresh cracked pepper
- 2 tablespoons sesame oil
- 2 tablespoons lime zest
- 2 tablespoons lime juice
- 1 egg white, beaten
- 1½ teaspoon sesame seeds
- ½ red onion, thinly sliced
- 1 bunch of watercress
- 1 heirloom tomato, thickly sliced
- 1 bag of potato buns or Parker House rolls

JASON'S PACIFIC NORTHWEST SALMON BURGER

SERVES 4–6

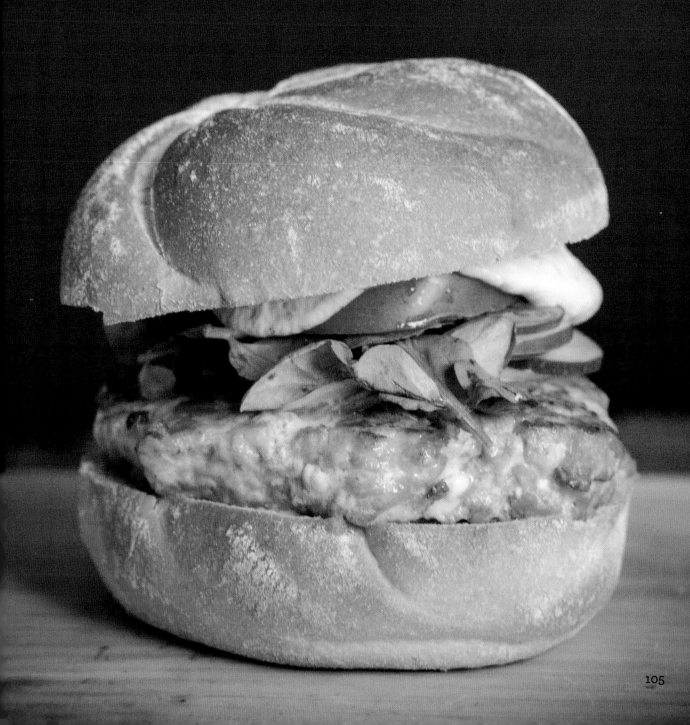

Preparing the Salmon Burgers

Combine 1½ tablespoon kosher salt, brown sugar, maple syrup, and cracked pepper in a small bowl until it's a thick, icky brown mess. Spread over the meat side of salmon only. Wrap in plastic wrap and put in the fridge for two days.

Rinse off the cure, pat dry, and put in fridge uncovered for two days.

Get BBQ ready to cold smoke by lighting a bunch of alder wood chips, then smother so you get the smoke but no heat. Cover and just leave the vent barely cracked. Put the salmon on a tray or sheet pan and smoke for 45 minutes. Once finished, skin salmon and cut away the belly. I like to serve the belly on the side with a few pickles or on a bagel with some cream cheese.

Cube the rest of the fillet and put it in a mixing bowl. Add lime zest, sesame oil, sesame seeds, lime juice, a little salt to taste, and then egg white. Combine everything with a spoon, and shape into patties with your hands (you may have to gently squeeze out a little liquid). Patties can be made ahead of time and put in fridge to help set up.

Put canola oil in large nonstick pan and turn heat to medium-high. Once the pan's hot, add burgers and cook just barely through (about 1½ minutes on each side).

Spread avocado mousse on both sides of buns, and assemble burgers with watercress, tomato, sliced onions, and zucchini lemon pickles.

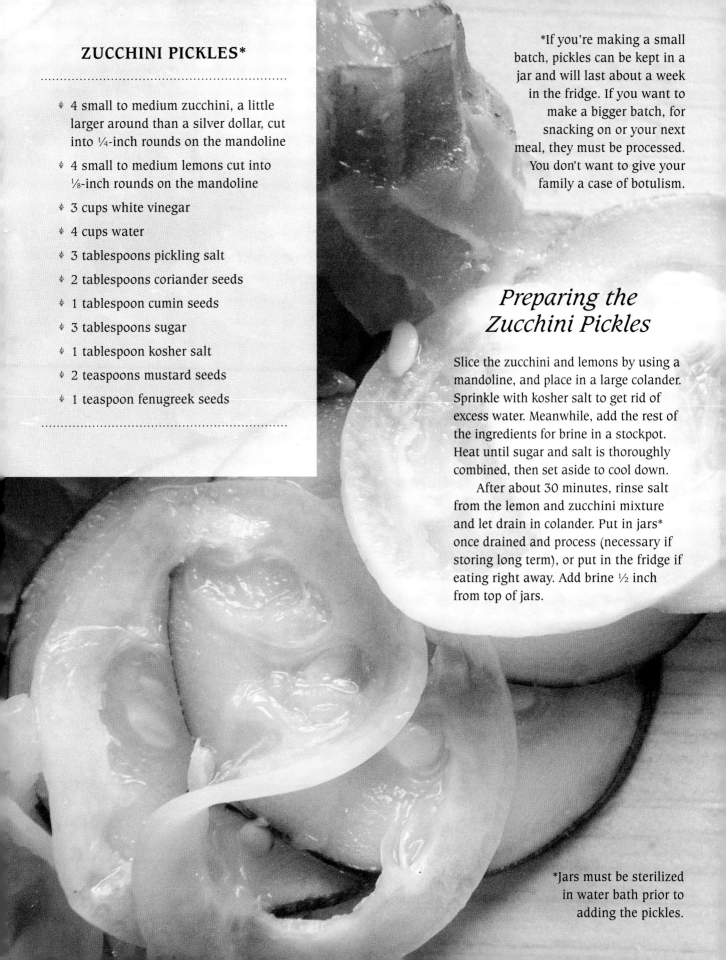

ZUCCHINI PICKLES*

..

- 4 small to medium zucchini, a little larger around than a silver dollar, cut into ¼-inch rounds on the mandoline
- 4 small to medium lemons cut into ⅛-inch rounds on the mandoline
- 3 cups white vinegar
- 4 cups water
- 3 tablespoons pickling salt
- 2 tablespoons coriander seeds
- 1 tablespoon cumin seeds
- 3 tablespoons sugar
- 1 tablespoon kosher salt
- 2 teaspoons mustard seeds
- 1 teaspoon fenugreek seeds

..

*If you're making a small batch, pickles can be kept in a jar and will last about a week in the fridge. If you want to make a bigger batch, for snacking on or your next meal, they must be processed. You don't want to give your family a case of botulism.

Preparing the Zucchini Pickles

Slice the zucchini and lemons by using a mandoline, and place in a large colander. Sprinkle with kosher salt to get rid of excess water. Meanwhile, add the rest of the ingredients for brine in a stockpot. Heat until sugar and salt is thoroughly combined, then set aside to cool down.

After about 30 minutes, rinse salt from the lemon and zucchini mixture and let drain in colander. Put in jars* once drained and process (necessary if storing long term), or put in the fridge if eating right away. Add brine ½ inch from top of jars.

*Jars must be sterilized in water bath prior to adding the pickles.

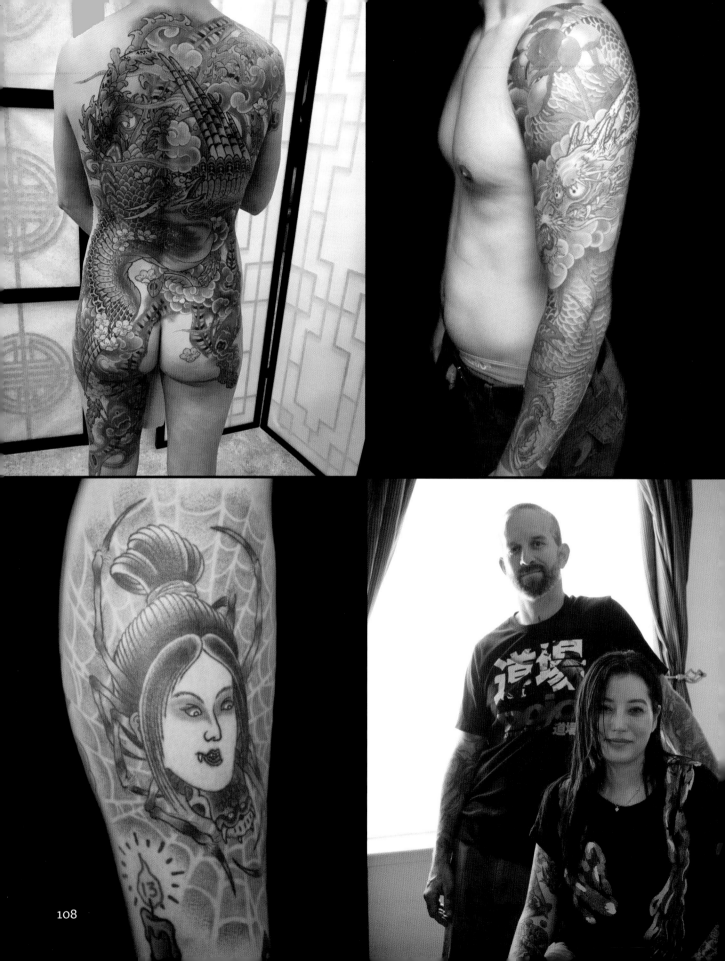

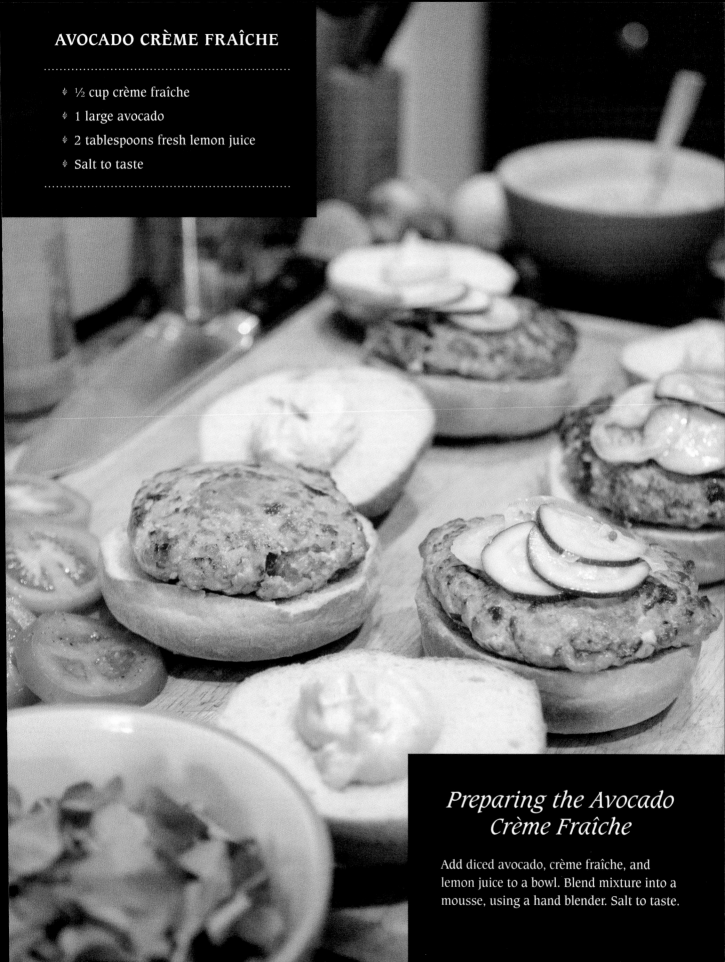

AVOCADO CRÈME FRAÎCHE

- ½ cup crème fraîche
- 1 large avocado
- 2 tablespoons fresh lemon juice
- Salt to taste

Preparing the Avocado Crème Fraîche

Add diced avocado, crème fraîche, and lemon juice to a bowl. Blend mixture into a mousse, using a hand blender. Salt to taste.

JEFF CROCI

Jeff Croci is from the Bay Area and has been tattooing for over eighteen years. He currently works at Seventh Son Tattoo in San Francisco. His father's heavily tattooed friend made a huge impression on him as a child, and this led to his fascination with getting tattooed—and his eventual career in tattooing. When it comes to food, Jeff loves Hawaiian poke—it's something he could eat on a daily basis. As far as this book goes, it was a real toss-up for Jeff between making his poke recipe or his charcuterie. I would have been fine with either one: they both sound amazing!

Jeff loves cooking for people, and this originates from his own love of eating. He likes to try making new dishes, and the most extravagant attempt to date is oxtail bourguignon.

Jeff got interested in curing after watching his mother make gravlax over the years. He loves the science of curing and figuring out what works best. His curing advice is to measure the salt correctly, watch the sodium nitrate, taste what you cook, and weigh everything in grams. One more thing I wanted to mention about Jeff is that he is an expert spear fisherman. Not only does he spear fish, he spears gigantic fish—the largest being a 302-pound black marlin! Pretty amazing! Thank you Jeff!

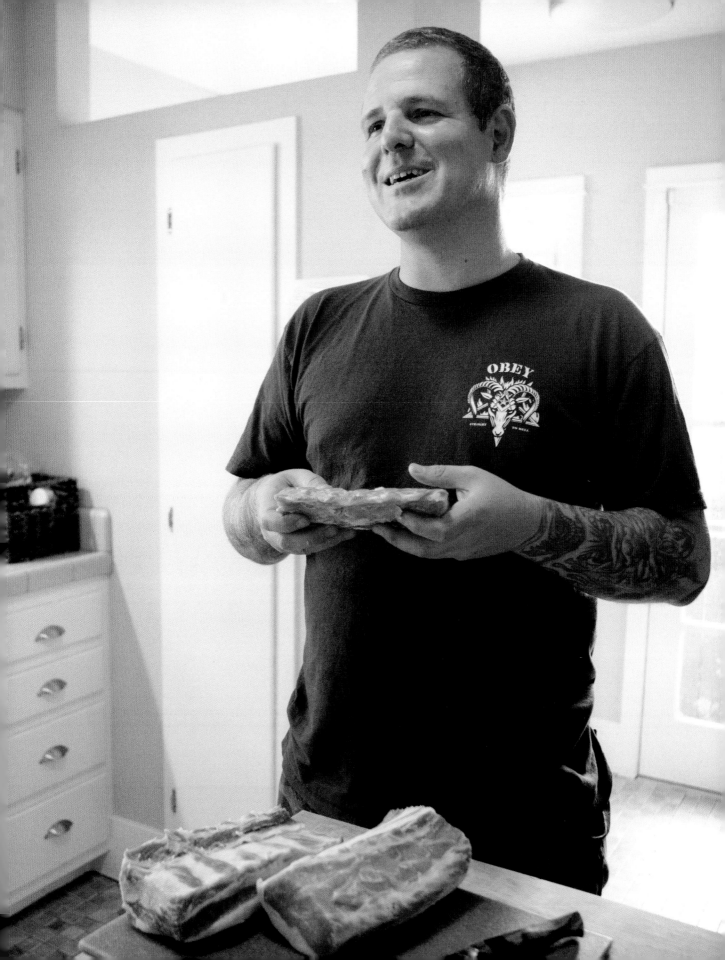

JEFF'S CHARCUTERIE
(NONTRADITIONAL LONZA)

SERVES 4–6

- 1 bone-in pork loin roast
- Kosher salt
- Curing salt, cure #2
- Fresh rosemary
- 10 juniper berries
- 1 teaspoon black pepper
- 1 teaspoon red chili powder
- 5 cloves garlic
- 4–5 inches of beef bung end cap
- Butchers twine
- Leftover skin from a salami

Carefully cut the loin away from the bone and trim the long edges to make a more tubelike shape.

Weigh the loin in grams.

Weigh the kosher salt—0.025 g salt per gram of loin (example: 1,000 g meat = 25 g salt).

Weigh curing salt, cure #2—0.0025 g per gram of loin (example: 1,000 g meat = 2.5 g cure #2).

Grind a large tablespoon of fresh rosemary, 10 juniper berries, 1 teaspoon of black pepper, 1 teaspoon of red chili powder, and 5 cloves of garlic. Jeff's preference is to use a clean coffee grinder.

Mix all the salts and spices in a vacuum food saver bag. Add the meat and coat the entire piece of meat as evenly as possible. Seal the bag with the food saver vacuum.

Let the meat cure in the refrigerator from 12 days up to a month. Turn the meat regularly to move the liquid in the bag.

After the time in the refrigerator, take the meat out of the bag and rinse about 50% of the salt/spice mix off the meat. Then pat the meat very dry.

Make sure the beef bung is 3.5–4 inches longer than the meat's length. Soak the beef bung in water for 30 minutes, then rinse thoroughly. Check for any holes. If one end of the beef bung is not naturally closed, tie one end off.

Put the meat in the bung (hahaha!).

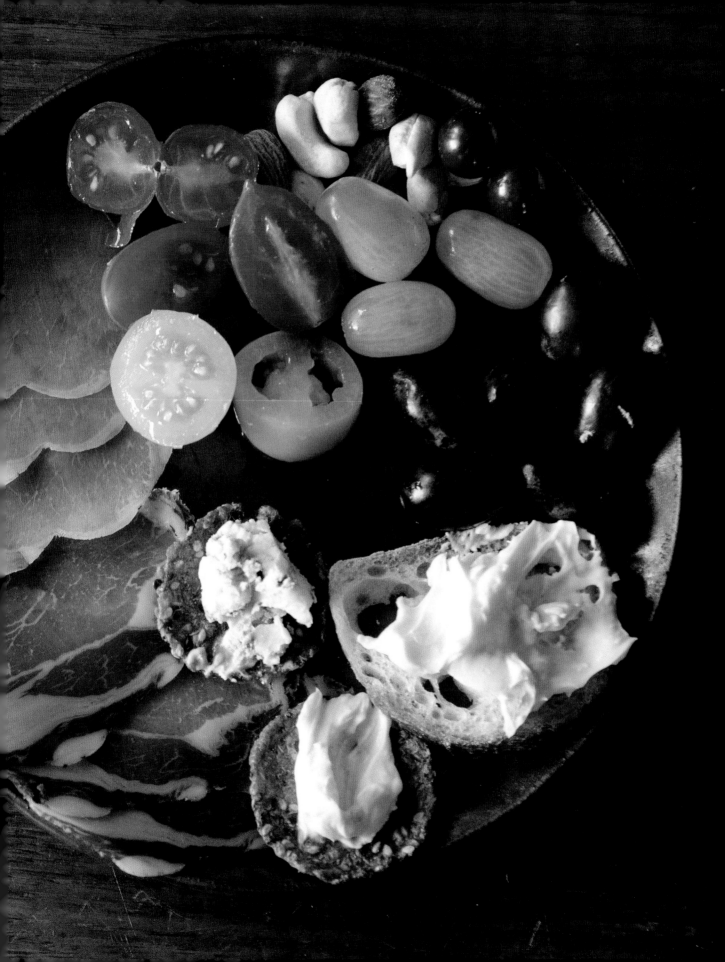

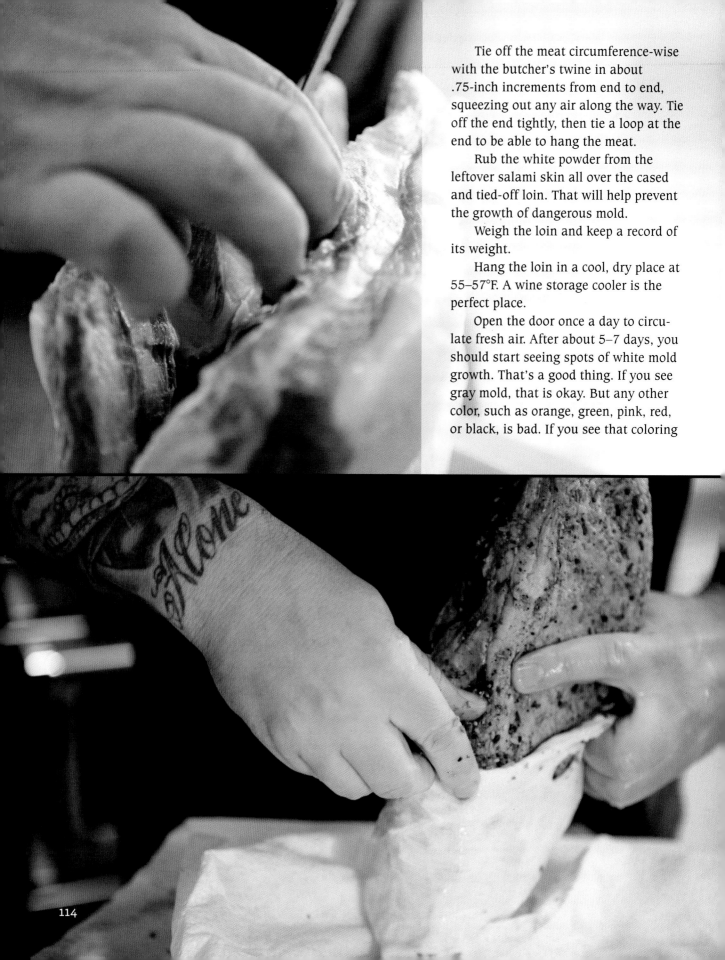

Tie off the meat circumference-wise with the butcher's twine in about .75-inch increments from end to end, squeezing out any air along the way. Tie off the end tightly, then tie a loop at the end to be able to hang the meat.

Rub the white powder from the leftover salami skin all over the cased and tied-off loin. That will help prevent the growth of dangerous mold.

Weigh the loin and keep a record of its weight.

Hang the loin in a cool, dry place at 55–57°F. A wine storage cooler is the perfect place.

Open the door once a day to circulate fresh air. After about 5–7 days, you should start seeing spots of white mold growth. That's a good thing. If you see gray mold, that is okay. But any other color, such as orange, green, pink, red, or black, is bad. If you see that coloring

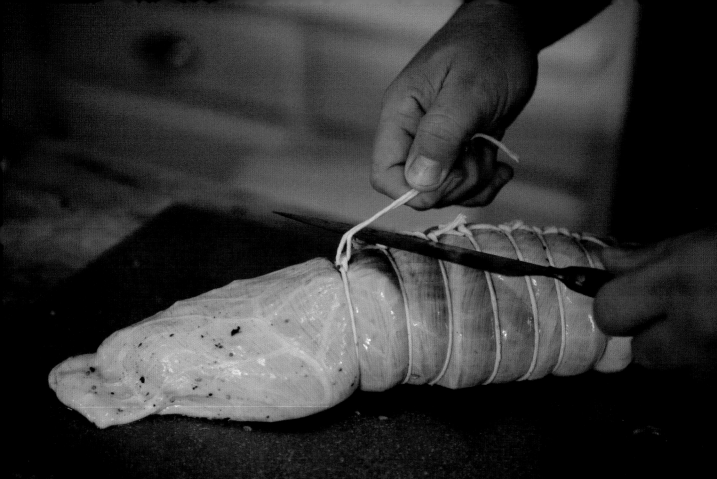

at all, wipe the loin with distilled vinegar and paper towels.

Be patient. At about a month, check the weight. Your goal should be a slow loss of weight—about 35–40% of the initial weight at the time of hanging.

When you reach the desired weight loss, cut one end open and cut 0.5 inch off. The meat should have a nice pink color and spicy meat smell. If it smells like rotting meat, cut the entire casing off and look for anything that looks rotted. If you don't see anything on the outside, cut it open and look for pockets on the inside that are rotting. If you find rot, cut it off and throw it away.

If you have measured the salt correctly and kept the temperatures within the 55–57°F range, it should be good and taste great.

Slice paper-thin and serve with some nice cheeses and crostini. Enjoy!

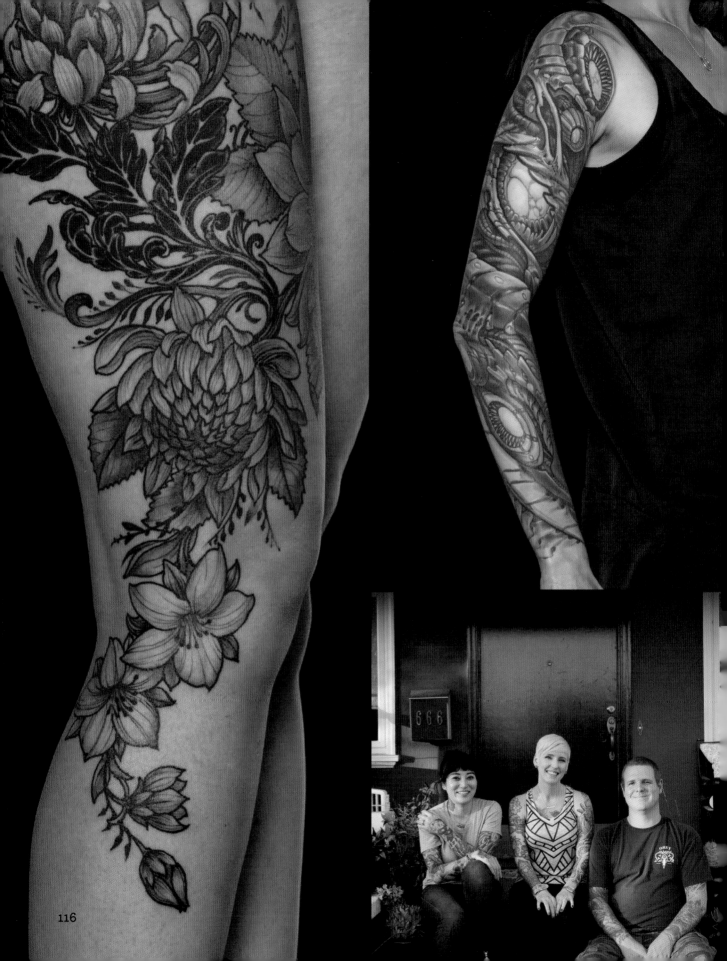

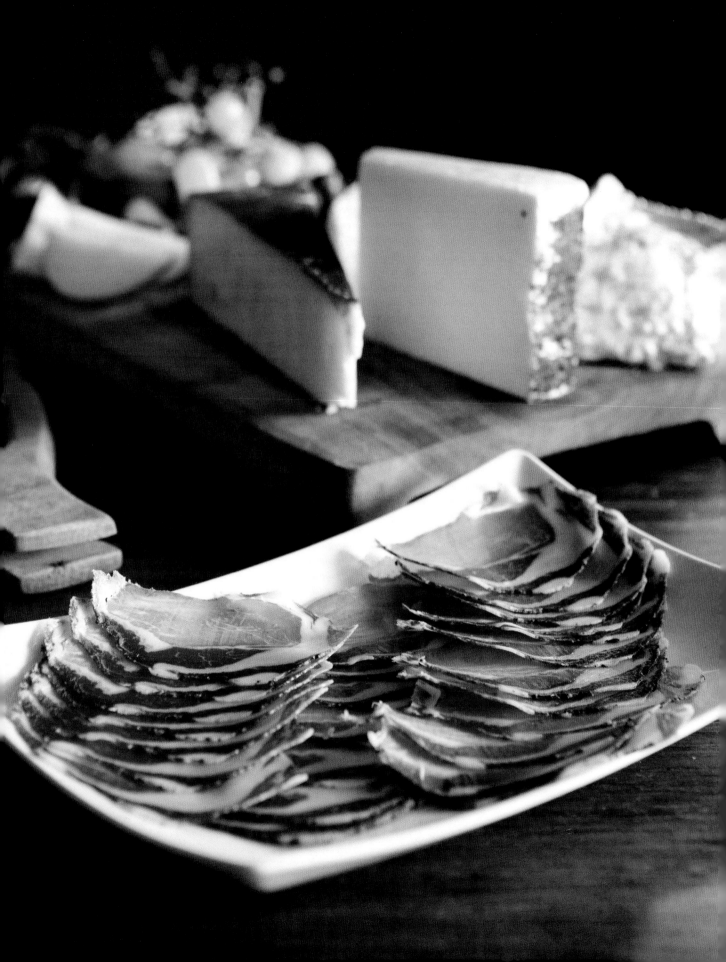

JEN LEE

I was ecstatic when Jen Lee was stoked to participate in this cookbook. I love Jen, and we always have a good laugh when we run into each other. I was also really looking forward to seeing a different side of her! Jen Lee has been a tattoo artist since 1995. She currently works alongside Doug Hardy at Tattoo City in San Francisco. Some of Jen's cooking inspiration stems from watching her mom bake her famous Christmas cookies and birthday cakes. Her secrets to great cooking are that fresh ingredients and high-quality olive oils and/or butters are a must. On a sidenote, Jen has this crazy salt-and-pepper-shaker collection. It's pretty impressive and adds charm to her kitchen. Jen's advice for getting a tattoo is to find the right artist for you and trust them to do an amazing job at creating what you want. Prepare mentally and physically; take a shower, eat a full meal, and relax. She also hopes that you enjoy this recipe. In Jen's own words, it's a great brunch idea or a healthy morning-after breakfast in bed . . . (wink, wink)

JEN'S BRUNCH: SAUSAGE-AND-MUSHROOM-STUFFED TOMATOES WITH TOAST

SERVES 4–8

- ½ pound sausage meat, not encased
- 2 tablespoons oil (olive or avocado)
- 1 yellow onion, diced small
- 8 ounces white mushrooms, sliced
- 8 beefsteak tomatoes
- 8 large eggs
- Salt and pepper to taste
- 1 loaf French baguette
- Chives

Preheat the oven to 375°F. Take a large skillet or frying pan and heat it up over medium-high heat. When the frying pan is becoming hot, place the sausage in the pan and cook until browned, about 3–5 minutes. Transfer the sausage into a bowl and set aside. Heat up the pan again over medium heat. Pour the oil, then add the onion and mushrooms. Sauté them until the onions turn translucent and start to brown, about 3–5 minutes. Transfer the onions and mushrooms to the bowl with the sausage, and mix well. Take the tomatoes and cut off the tops. Using a spoon, scoop out the insides of the tomatoes carefully, so as not to poke any holes in the tomatoes. By the way, you can save the tomato insides for tomato sauce! Fill the hollowed-out tomatoes with the sausage filling, about ¾ full. You do not want to overfill the tomatoes, since the egg will slide off the top. Top each stuffed tomato with one egg. Sprinkle each tomato with a pinch of salt and pepper.

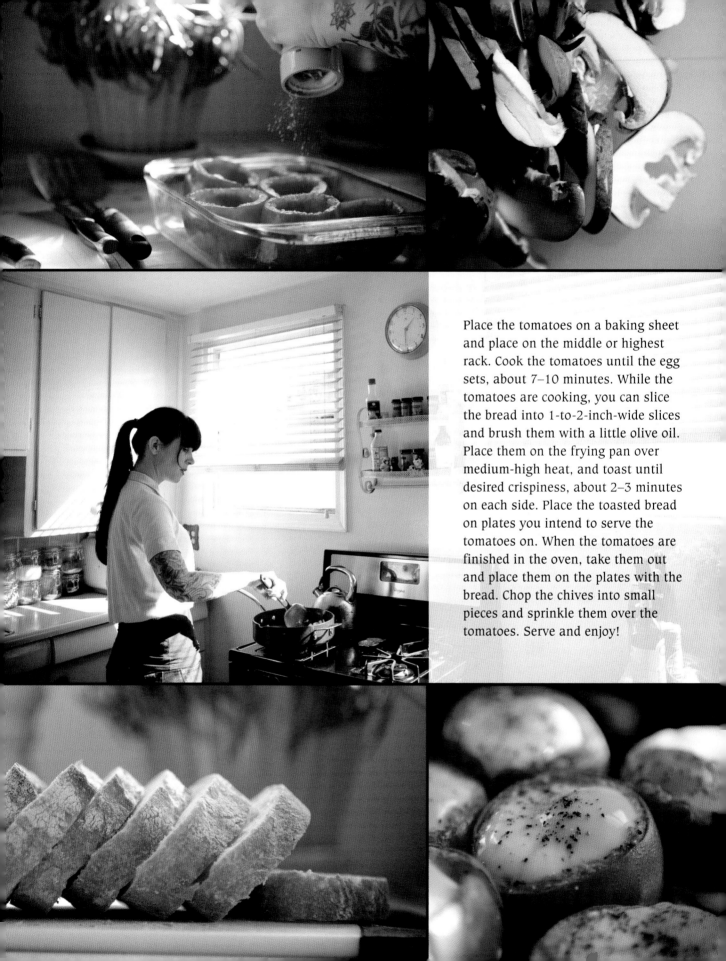

Place the tomatoes on a baking sheet and place on the middle or highest rack. Cook the tomatoes until the egg sets, about 7–10 minutes. While the tomatoes are cooking, you can slice the bread into 1-to-2-inch-wide slices and brush them with a little olive oil. Place them on the frying pan over medium-high heat, and toast until desired crispiness, about 2–3 minutes on each side. Place the toasted bread on plates you intend to serve the tomatoes on. When the tomatoes are finished in the oven, take them out and place them on the plates with the bread. Chop the chives into small pieces and sprinkle them over the tomatoes. Serve and enjoy!

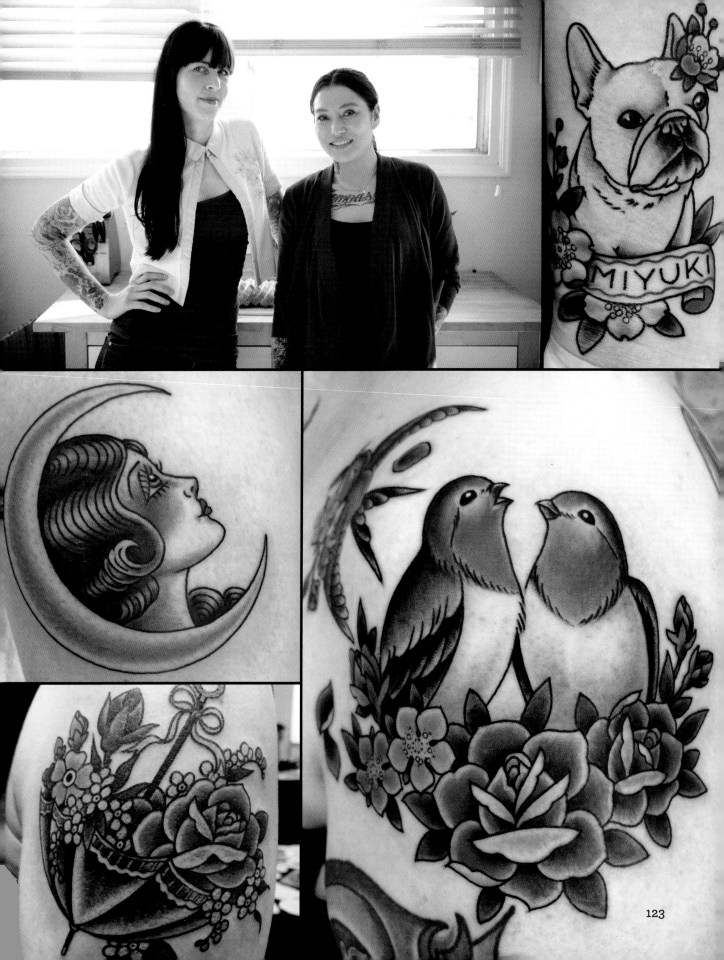

JOSE MORALES

Jose Morales is best known for his vividly colored roses and anime work. He started out tattooing neo traditional but fell in love with color realism, a style he has certainly excelled in. He stayed with us for a few days and worked at State of Grace Tattoo. In that time, the shop fell in love with him. He is humble and kind as much as he is talented. He has been tattooing for over eleven years and is of Mexican descent but was raised in Hawaii. He most certainly brings that island aloha vibe with him wherever he goes!

As far as cooking goes, Jose actually has some professional culinary experience. He was a cook for a short time before tattooing took over his life. He still loves cooking and watching *The Great British Baking Show*! Jose and his oldest son, Alic, created these "Heart Attack Mushrooms" messing around in the kitchen one day. They were such a hit that they have become a holiday tradition in the Morales household. Crispy, cheesy, rich—what more could you ask for? Mahalo Jose!

JOSE'S HEART ATTACK MUSHROOMS

SERVES 4-6

- 12 strips of bacon, flash fried in a sauté pan
- 12 giant white mushrooms, washed and destemmed
- ¼ cup mozzarella cheese, shredded
- ¼ cup cheddar cheese, shredded
- ¼ cup cream cheese
- ½ cup stovetop stuffing
- ¼ cup Italian salad dressing
- Toothpicks

Preheat the oven to 400°F.

Flash fry the bacon in small batches in a sauté pan: about 1 minute per side. Set aside on a paper towel.

Next, wash the mushrooms and remove the stems. Set aside on a parchment paper–lined baking dish.

In a medium-sized bowl, mix the cheeses, stuffing mix, and Italian dressing. Stuff the mushrooms with the mixture.

Take one strip of bacon per mushroom and wrap the outside of the mushroom with the bacon, securing it with a toothpick. Repeat with all the mushrooms, placing them back on the baking dish.

Place on the middle rack of the oven and cook for 45 minutes or until the bacon is crisp and the cheese is browned on top. Enjoy!

JOSEPH HAEFS

Joseph's presence and undeniable excitement for the world are larger than life. His pure heart of gold can only speak the truth, and that can be refreshing in this social media world we have created, where people tend to only show the highlight reel of their life. He is open and honest and shows his vulnerable side despite the inevitable criticism and commentary. Joseph is originally from Connecticut but currently lives in Las Vegas and owns the shop Reverent Tattoo with his beautiful wife, Michelle. They are a force to be reckoned with, yet their savvy business sense and teamwork comes across as unpretentious and honest. Michelle even photographed this chapter for John, since he was in Bali when we had them out here. Thank you, Michelle!

Joseph has been tattooing for seventeen years, building himself up from the wild and crazy streets of Vegas. While he has been tattooing well over a decade, he has adapted to the emerging generation of tattooers where "traditional" rules are being broken and tattooing styles are morphing in so many directions at lightning speed. In a competitive time where there are countless tattooers to choose from, he has managed to create a style of his own, making a name for himself. And his clients love him for it.

Joseph's grandmother's apples are a family recipe. It has become one of his signature dishes at gatherings and is an amazing way to end a meal! Thank you, Joseph!

JOSEPH'S GRANDMOTHER'S BAKED APPLES

SERVES 6

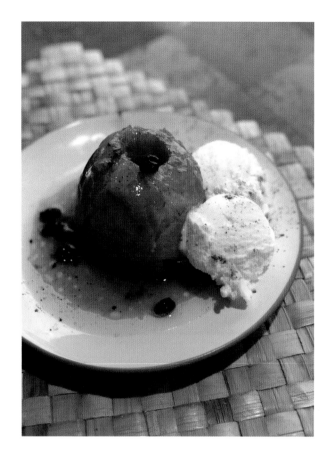

- 6 green apples, cored
- 3 sticks of chilled butter, cubed
- ⅛ cup raisins
- ¼ cup brown sugar
- 2 tablespoons ground cinnamon
- Preheat oven at 375°F

Line a baking dish with parchment paper or a Sil-Pad. Core each apple and stuff with alternating layers of butter and raisins. Place them in the baking dish and put the remaining butter and raisins over the top, along with the brown sugar and cinnamon. Place the baking dish on the middle rack of the oven and bake for approximately 45 minutes to 1 hour, or until the skin of the apples cracks and the fruit is soft. Baste with a spoon or turkey baster every 15 minutes. Serve with your favorite ice cream and enjoy!

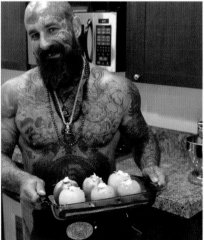
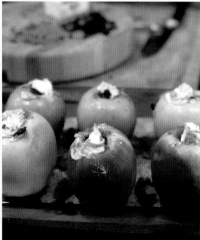

JUAN PUENTE

Juan is a household name in the tattoo community. In addition to having a solid career spent in many of the most influential shops ever, he loves meeting up with friends and going to punk shows and is generally known to be the life of any party. His warm smile is contagious, and you are always guaranteed a big hug when you see him. As rad and well known as he is, Juan is still very down to earth and humble. Reading this would probably make him blush. When he is not grilling or making his favorite treat—frosted flakes with banana (his last-meal request!)—Juan tattoos at the legendary Blackheart Tattoo in San Francisco. Juan has been tattooing since 1992 and started out at Classic Tattoo in Fullerton, California. The first tattoo he ever got was some *kanji*, tattooed on a whim from Joe Satterwhite at Tattooland in San Diego. Juan is also well known for his tattoo machines. He comes from a generation and time when machine building was a sacred craft, and he had to work very hard to achieve his awesome reputation as a machine builder. His machines are highly sought after and used by many professional tattooers worldwide—including some in this book!

Cooking with Juan Puente was a really good time, and as an added bonus, Jen Lee also joined us for the afternoon shoot. Juan's cooking advice for anyone is to cook what you like to eat and go from there. Follow your instincts and put faith in your palette. You will be able to tell if you fell short of the mark. These days it's not enough to get great taste: people are concerned about their health, and this is a challenge for many chefs today. Modern cooking is often a balance of health and taste. Juan's recipe is healthy and delicious, so try it out!

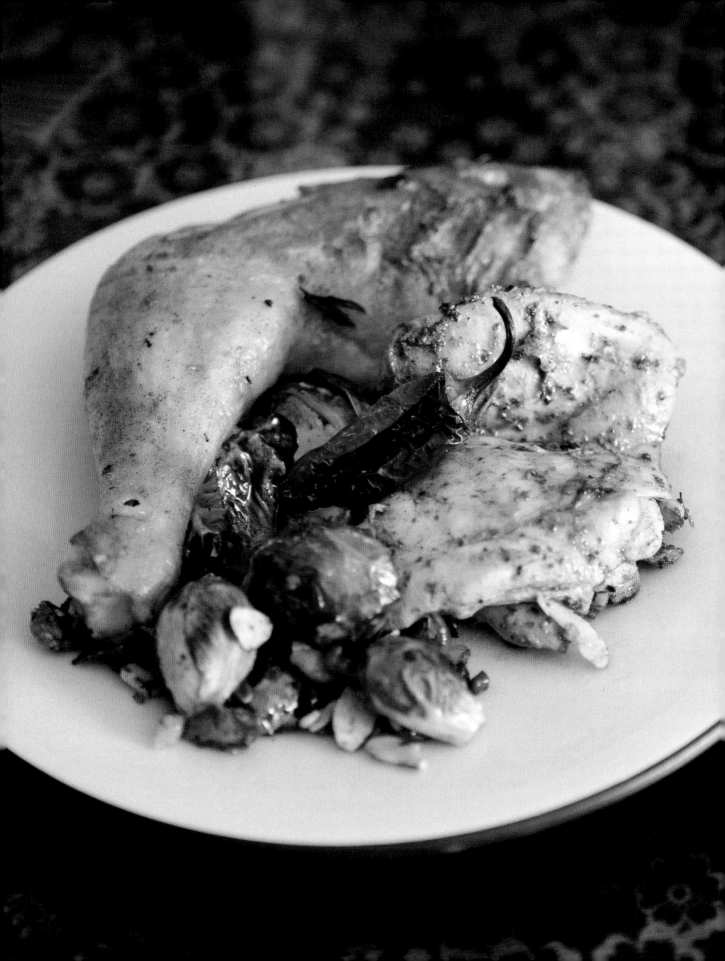

JUAN'S GRILLED CHICKEN & JALAPEÑOS
WITH BRUSSELS SPROUTS AND BACON

SERVES 4-6

MARINADE

- 6-8 chicken thighs with legs, fat trimmed off

MARINADE

- 8-10 limes, juiced
- ¼ cup avocado oil
- 4-6 cloves garlic, minced
- ½ yellow onion, peeled and sliced into 8 wedges
- 1 bulb of garlic, chopped
- ½ cup olive oil
- Salt and pepper to taste
- 6-8 jalapeños, whole

Chicken and Jalapeños

Combine the marinade ingredients in a large mixing bowl. Toss in the chicken and coat them evenly. Divide the chicken into 2-3 large freezer bags. Then divide the excess marinade between the bags. Let the chicken marinate in the refrigerator for a minimum of 2 hours and up to 12 hours.

Set up your grill and preheat. Brush and oil the grill to clean. Remove the chicken from the marinade and dab off any excess marinade. Season with salt and pepper and drizzle with a bit more oil.

When the coals start to turn white, place the chicken on the grill on the hottest area. You want to sear the chicken about 2 minutes on each side, or until golden brown. Place the jalapeños on the lower-heat part of the grill. Keep the jalapeños on the grill until the skin starts to blacken, which should be about 5-10 minutes. When they're done, take off the grill and set aside.

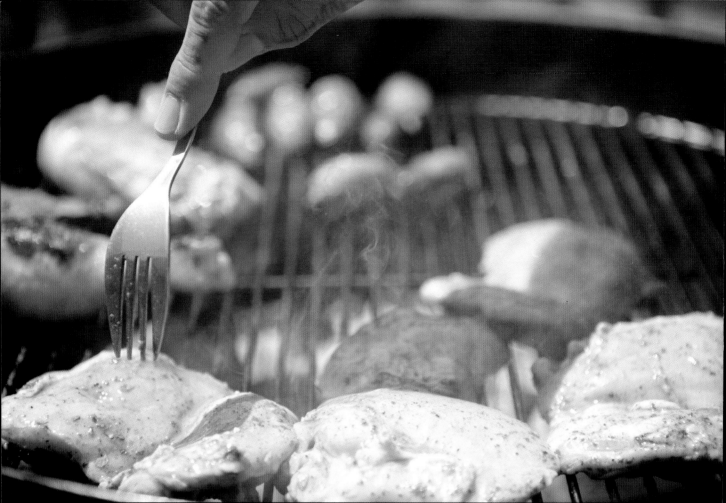

Then move the chicken over to the lower-heat area of the grill and put the lid back on the grill. Let the grill heat up to 350°F. Turn the chicken every few minutes, brushing each piece of chicken with the mixture of garlic and olive oil, using a rosemary sprig as a brush. Cook until the internal temperature in the thickest part of the chicken is 165°F, or the internal chicken meat is white and juicy.

Let the chicken rest for about 5 minutes. Last, serve with your favorite side dishes and enjoy.

BRUSSELS SPROUTS

* 15–20 brussels sprouts, halved
* 4–6 strips of bacon, chopped
* ⅛ cup shaved almonds (if desired)

Brussels Sprouts

Preheat the oven to 450°F. Wash and cut each brussels sprout in half and place them in an oven-safe baking dish. Set aside. Chop the bacon into bits and add them to the brussels sprouts. Slide into the oven until the bacon cooks and the brussels sprouts start to brown a bit, about 10–15 minutes. Take them out of the oven and sprinkle with the shaved almonds.

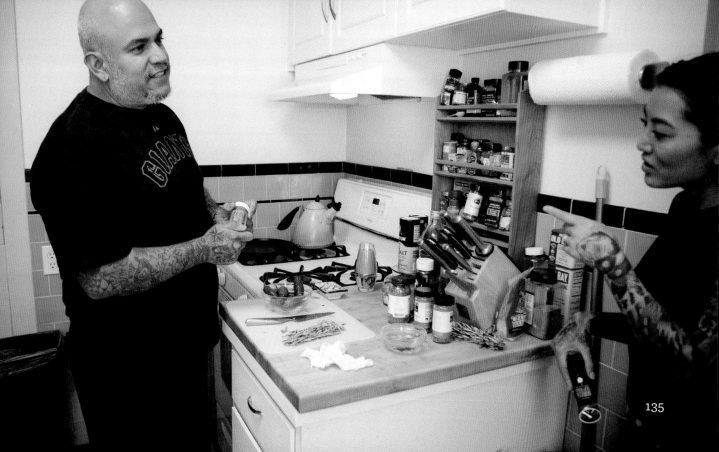

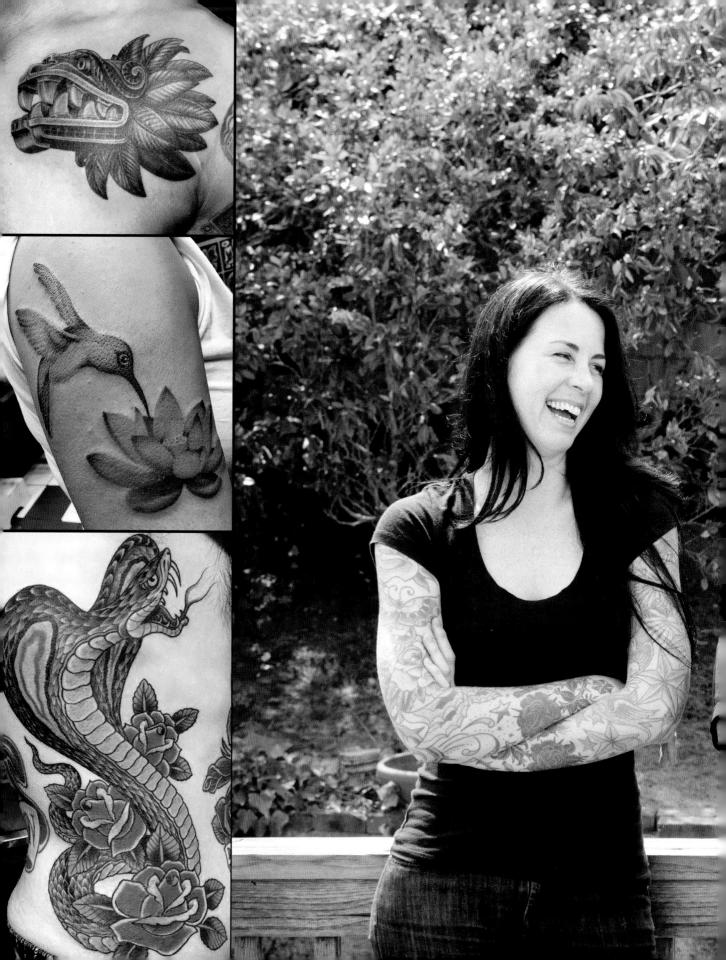

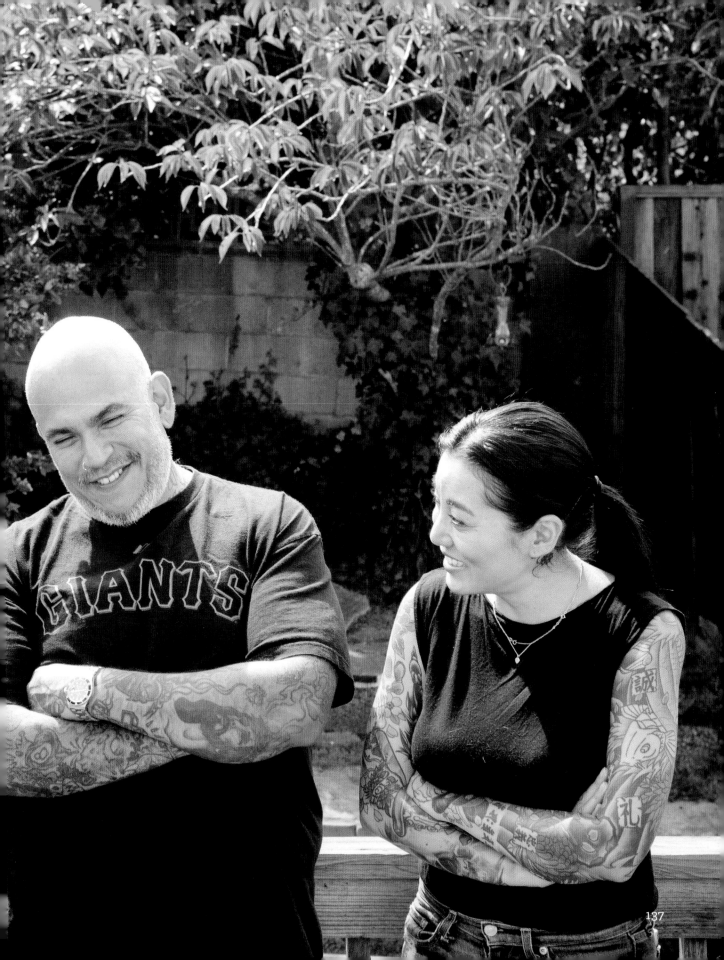

ICHI

KOJI MARU

Koji Ichimaru hails from the city of Kitakyushu, in Fukuoka Prefecture in Kyushu, Japan. That is where his illustrious career began over fifteen years ago. Koji did not always want to be a tattoo artist. At one time, he had wanted to be a hairstylist! Koji first started getting tattooed because of the Japanese rockabilly scene; he loved the Stray Cats, especially Brian Setzer. If you have ever witnessed the rockabilly scene in Japan first-hand, you would understand why Koji was so attracted to it as a youth. Thankfully, this led him to the world of tattooing!

Koji has an interesting outlook on food, since he is Japanese but has been living in Bologna, Italy, for the past seven years. Koji's wife, Alessandra, a great tattoo artist as well, is a Bologna native. One thing Koji loves about Italy is the pasta, something he loved even before he moved there. Koji fondly reminisces about childhood memories of his mother taking him to eat at the local Italian restaurant in their home-town. The recipe he shared reminds him of his mother and the pasta they used to eat together.

Though Koji gave us his recipe, he insists on not following the rules when it comes to cook-ing: follow your heart! Not surprising from someone who routinely dunks his karaage chicken in his ramen! Grazie mille, Koji!

KOJI'S AMATICIANA PASTA

SERVES 4–6

- 1–1½ pounds spaghetti
- 4 tablespoons (or to taste) olive oil
- ½ pound smoked bacon, cut into bite-sized pieces
- 1 yellow onion, chopped
- 1 24-ounce can whole tomatoes
- 1½ cups whole milk
- 3 tablespoons unsalted butter
- ½ cup Parmesan cheese, grated
- 1 bunch flat leaf parsley, chopped
- Salt and pepper, to taste

Bring a pot of salted water to a boil over medium-high heat. When the water is at a rolling boil, add the spaghetti. Boil the pasta until al dente. To know when spaghetti is al dente, take a strand out and break it in half. When there is a pinpoint dot in the center of uncooked pasta, it is done. Promptly take pasta off the heat, strain, and rinse with cool water to keep it from overcooking. Set aside. Next, place a large sauté pan on the stove over medium-high heat. Brown the bacon in the pan for about 3–5 minutes. Add the chopped onion. Caramelize the onion until it turns translucent and starts to take on a brown color: about 5–7 minutes. Next add the tomatoes and let them simmer gently for about 2 minutes; turn down the heat if you need to. After simmering for a couple of minutes, turn the heat down (if it is not already on medium-low) and stir in the milk, butter, and Parmesan cheese. Once the dairy is incorporated (the butter and cheese melted), take off the heat. Add the parsley, and salt and pepper to taste. Place the pasta in the sauce and mix well. Serve and enjoy.

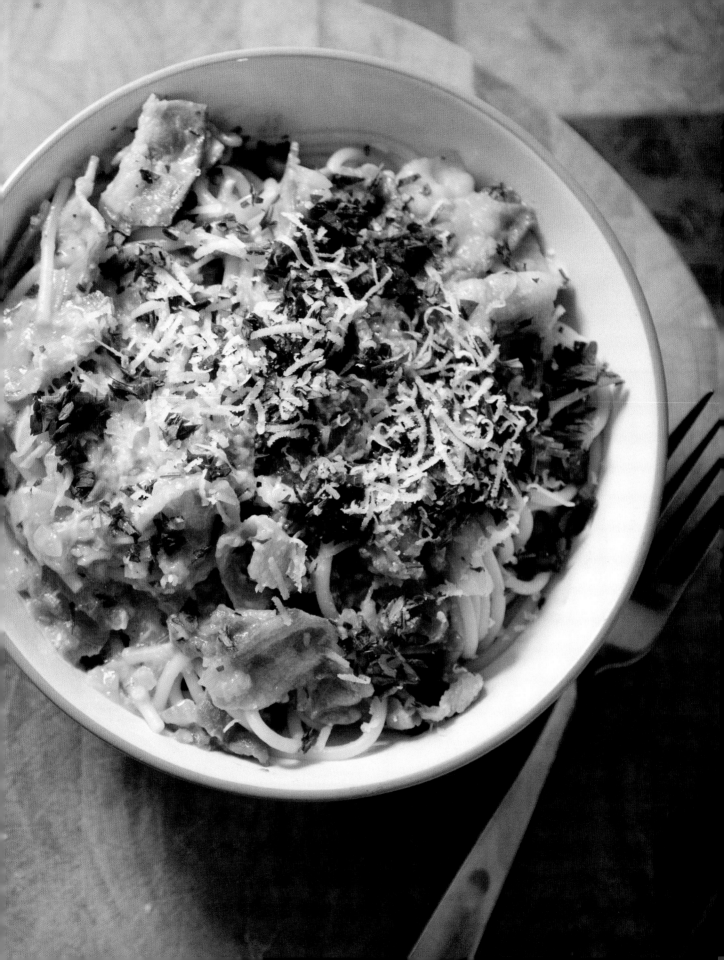

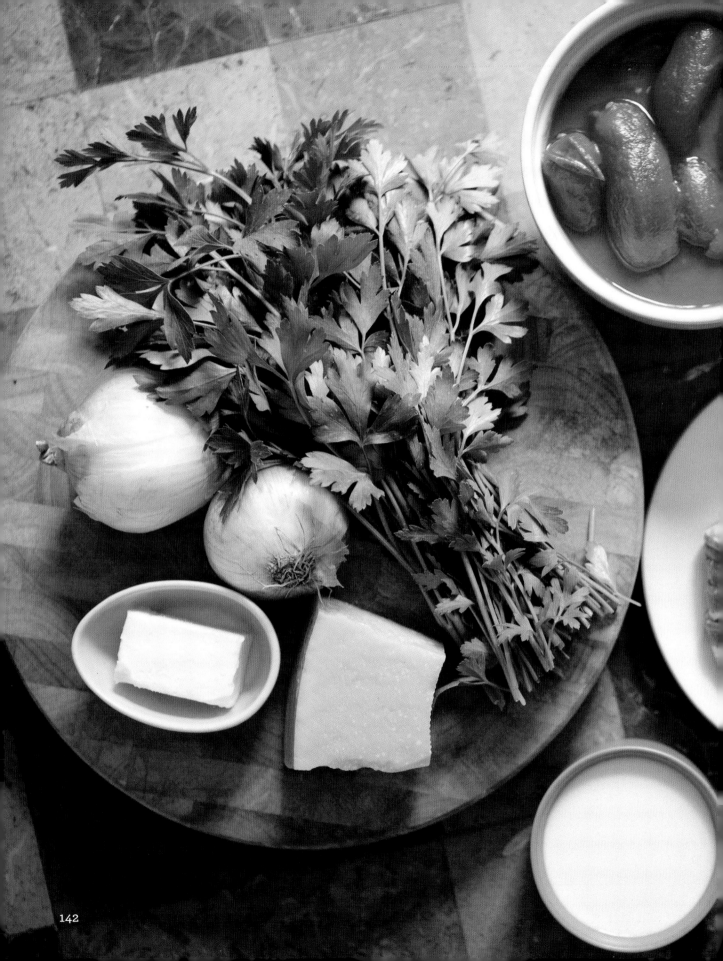

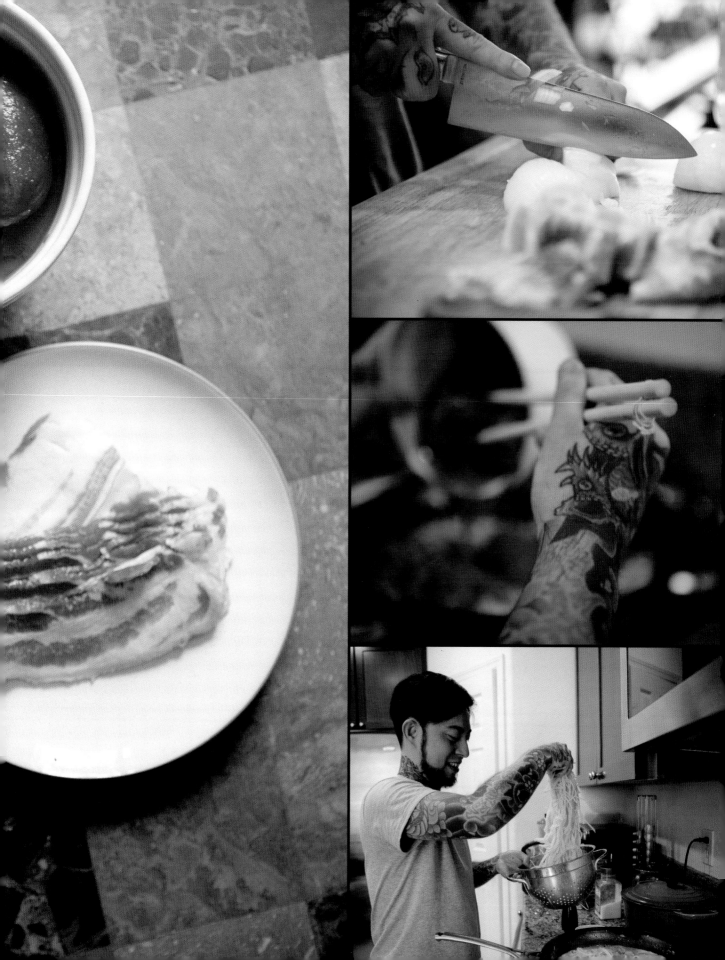

MARY JOY SCOTT

Mary Joy has been tattooing for twelve years. She hails from Woodland, a town just south of Sacramento, near Davis. Aside from being a talented tattoo artist, she is a classically trained painter and studied art in Spain. She fell in love with classical European art, specifically Spanish painters such as Francisco Goya and Diego Velásquez. Mary Joy moved to San Francisco and had the great honor of being Don Ed Hardy's last apprentice. She began working at his shop in 2005, and you can find her there today! While her artistic repertoire is vast, girls' heads are her favorite images to tattoo!

Mary Joy is so fun to hang out with—we laughed while munching on Rice Krispies treats and photographing her making her mother's famous shortbread. Being of Scotch Irish descent, baking is in her blood. She has also started a new tradition of spiced tea for her own family: her musician husband, Jack, and alchemist son, little Jack. Her mom's shortbread and spiced tea reminds her of the holidays, family time, and the cozy joy the season brings. She loves cooking for people and was happy to be able to share this family tradition with you all! Enjoy! Thank you, Mary Joy!

MARY JOY'S SHORTBREAD & SPICED TEA

SERVES 6–8 (MAKES 6–8 COOKIES OR SLICES)

- 2 cups flour
- ½ teaspoon salt
- ½ cup brown sugar
- 2 sticks of Kerry Gold salted butter (if unsalted, add ¼ teaspoon salt to each stick), cubed and cold
- 1 teaspoon vanilla extract
- PAM nonstick spray

Preheat the oven to 300°F.

In a large mixing bowl, whisk the flour, salt, and sugar.

Add the vanilla and cut the cold cubed butter into the flour mixture and knead just until the texture is crumbly. It will be dry and very crumbly. Do not overknead!

Spray shortbread molds or pie pan with PAM nonstick spray (or you can use butter).

Firmly, but gently, press the mixture into shortbread molds or a 9-inch pie pan (if a pan, the mixture should be about 1–1½ inch thick).

Place pressed shortbread on the center rack of the oven and bake for 45 minutes or until golden.

When it is finished, let it cool in the pan for about 30 minutes before eating. Enjoy!

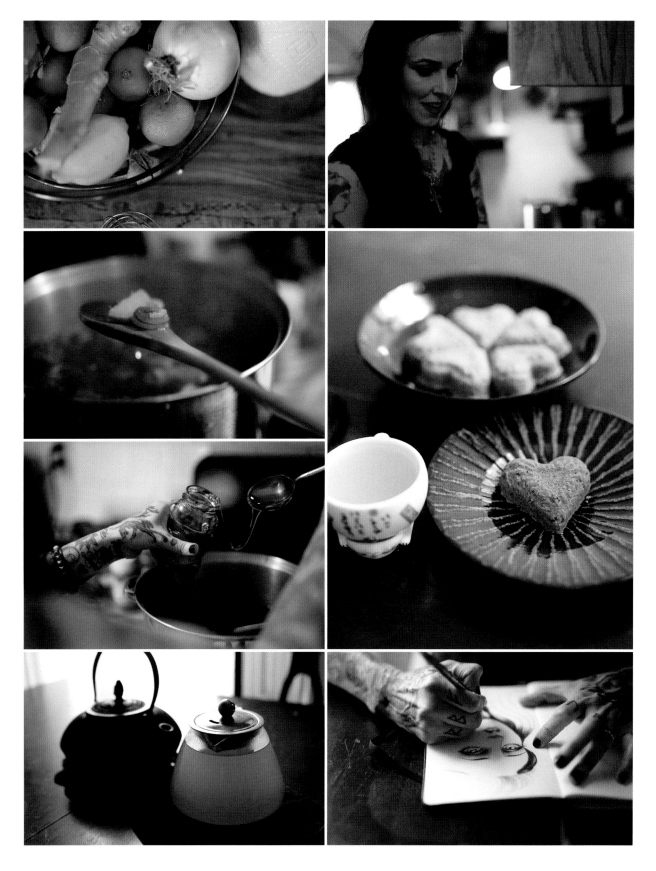

SPICED TEA

- 3 liters water
- 2 medium to large fresh ginger "hands"
- 4–6 tablespoons turmeric
- 1–2 whole cinnamon sticks
- 1 tablespoon black pepper
- 2–4 whole cardamom pods (not too many!)
- 1 cup honey
- 2 lemons, juiced

*EVERYTHING CAN BE MEASURED TO TASTE DEPENDING ON WATER VOLUME AND PERSONAL PREFERENCE

In a large pot, pour the water and add everything but the honey and lemon. Put on the stove over high heat until it starts to gently simmer. Turn the heat down to medium-low or low and let the tea simmer for 45 minutes. Strain at the end of the 45 minutes and then add the lemon and honey.

You can serve hot or cold!

MEGAN & RYAN SANCHEZ

M egan and Ryan are, as the millennial saying goes, "couple goals." So much so that she insisted that he was credited along with her! Married two years now, they complement each other just like the churros and vegan caramel sauce they made! Awesome individually, but fireworks when combined!

Megan is a San Jose, California, native who has been tattooing for ten years. She worked at Analog Tattoo in San Jose and then moved to San Francisco a few years ago to help Adrian Lee establish the Analog Tattoo and art gallery up there. She loves traveling around Japan and has future plans to visit with Ryan, eating fresh sushi being at the top of the things-to-do list!

Ryan loves cooking just as much as Megan, and his specialty is baking, chocolate cookies to be specific. They decided to make vegan churros for this book, since it celebrates both their cultures. While they are a popular traditional Mexican desert, they are reminiscent of the traditional Jewish deserts Megan enjoyed throughout her childhood. They hope you enjoy making and eating their churros just as much as they do. Thank you, Megan and Ryan!

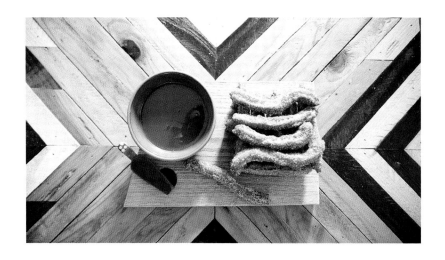

MEGAN & RYAN'S VEGAN CHURROS

SERVES 6–8 (MAKES 6–8 CHURROS)

- 1 cup flour
- ½ teaspoon baking powder
- ½ teaspoon salt
- 1 tablespoon brown sugar
- 1 cup water
- 1 tablespoon canola oil
- 1 quart canola oil for frying
- ½ cup white sugar
- ¼ cup light brown sugar
- 1 tablespoon ground cinnamon

Combine flour, baking powder, and salt, and set aside.

Combine brown sugar and water in saucepan and heat until bubbles begin to rise (but not boiling).

Add oil to dry ingredients, then hot water/sugar and mix well.

Dough will be sticky but will easily form a ball. Cover with Saran wrap and refrigerate for about 15 minutes.

After chilling the dough, spoon it into a pastry bag with a large star tip for piping.

Heat oil, around ¾ inch deep, over high heat in a large saucepan for about 5–8 minutes, then reduce to medium heat.

Pipe 6-inch churros into the hot oil, about 3 at a time or whatever you can manage without them getting stuck together. Keep turning them so they fry evenly.

Fry until golden brown—about 2 minutes.

Move to paper towel–lined plate.

Before they cool off completely, roll the churros in the sugar-and-cinnamon mixture.

CARAMEL SAUCE

- 1 15-ounce can full-fat coconut milk
- ¼ cup maple syrup
- ¼ cup packed brown sugar
- 1 teaspoon salt
- 1 teaspoon vanilla extract

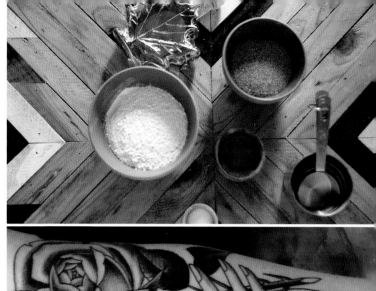

In a bowl, combine all ingredients (except vanilla) and mix together. The coconut fat may not fully combine—that's okay.

Add to shallow saucepan and heat on high while mixing continuously. Once brought to a boil, lower to medium-low heat and allow to simmer on its own while you start the dough.

Sauce should cook down slowly and turn a deep caramel brown . . . after about 25 minutes of simmer it should be thickening. Keep an eye on it at this point and add the vanilla extract. Start to stir continuously for another 5–10 minutes, until it coats the back of a spoon without running off.

Remove from heat, transfer to a bowl, and allow to cool.

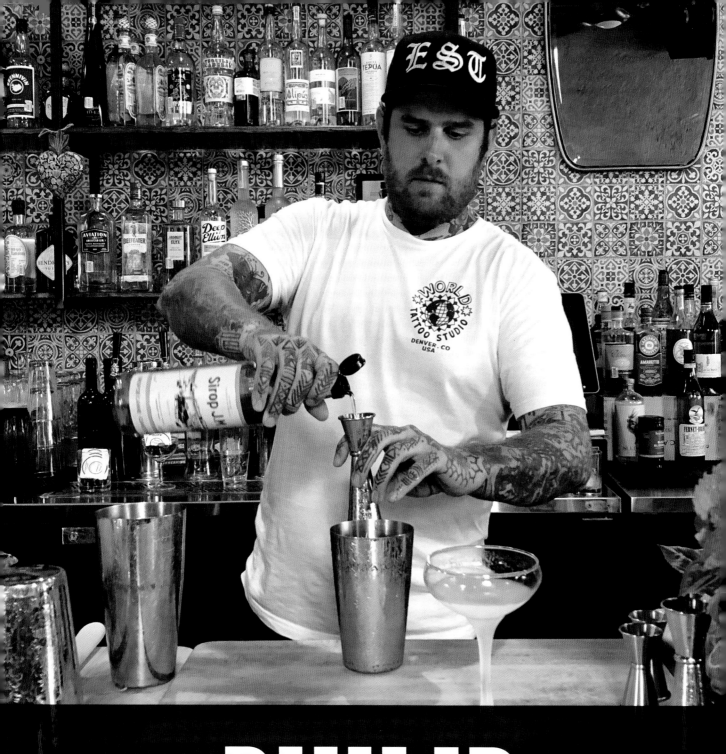

PHILIP
LAROCCA

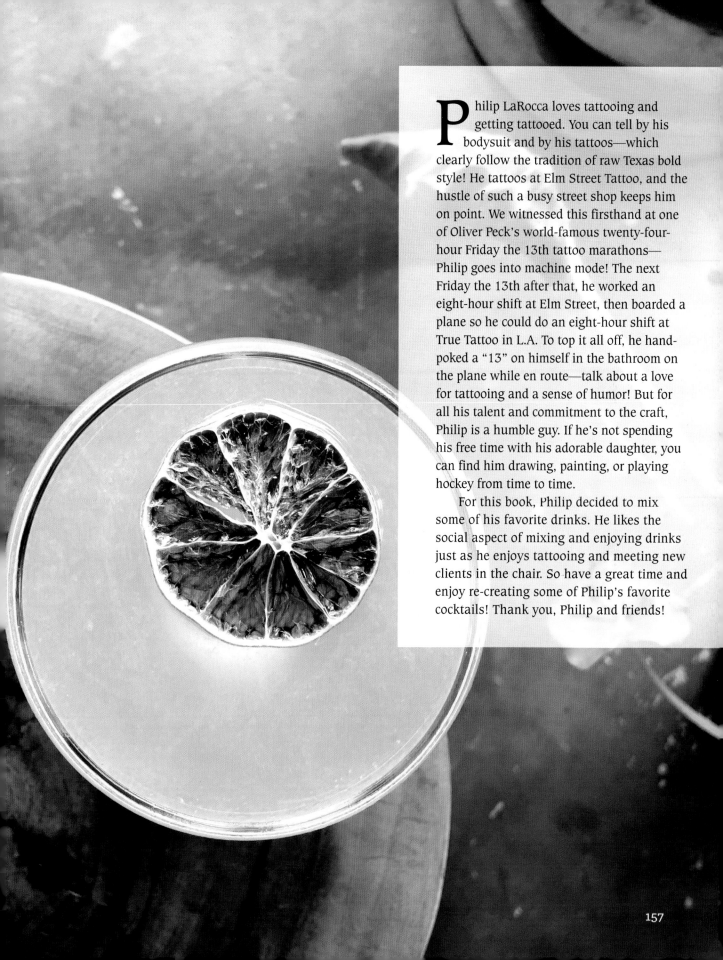

Philip LaRocca loves tattooing and getting tattooed. You can tell by his bodysuit and by his tattoos—which clearly follow the tradition of raw Texas bold style! He tattoos at Elm Street Tattoo, and the hustle of such a busy street shop keeps him on point. We witnessed this firsthand at one of Oliver Peck's world-famous twenty-four-hour Friday the 13th tattoo marathons—Philip goes into machine mode! The next Friday the 13th after that, he worked an eight-hour shift at Elm Street, then boarded a plane so he could do an eight-hour shift at True Tattoo in L.A. To top it all off, he hand-poked a "13" on himself in the bathroom on the plane while en route—talk about a love for tattooing and a sense of humor! But for all his talent and commitment to the craft, Philip is a humble guy. If he's not spending his free time with his adorable daughter, you can find him drawing, painting, or playing hockey from time to time.

For this book, Philip decided to mix some of his favorite drinks. He likes the social aspect of mixing and enjoying drinks just as he enjoys tattooing and meeting new clients in the chair. So have a great time and enjoy re-creating some of Philip's favorite cocktails! Thank you, Philip and friends!

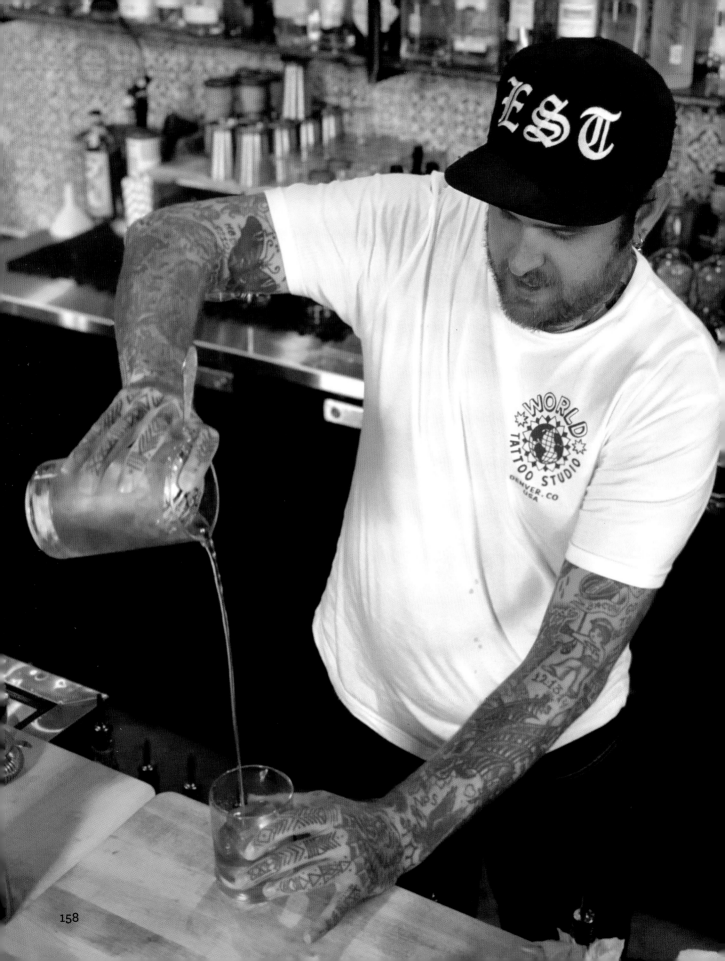

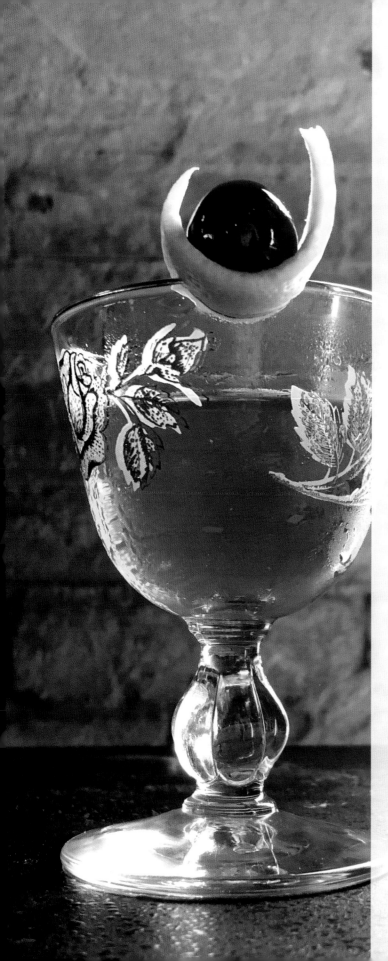

PHILIP'S DRINK RECIPES

OLD FASHIONED
- 2 ounces Old Overholt Rye Whiskey
- ¼ lemon oleo saccharum
- 2 dashes Angostura bitters

MANHATTAN
- 2 ounces Buffalo Trace Bourbon
- 1 ounce Carpano Antica Sweet Vermouth
- 2 dashes Angostura bitters

DAIQUIRI
- 2 ounces J. M. Agricole Rhum, white or gold
- ¾ ounce lime juice
- ¾ ounce 1:1 simple syrup
- 2 drops of tiki bitters

WHISKEY SOUR
- 2 ounces Buffalo Trace Bourbon
- ¾ ounce lemon juice
- ¾ ounce 1:1 simple syrup
- 1 egg white
- 1 dash Angostura bitters

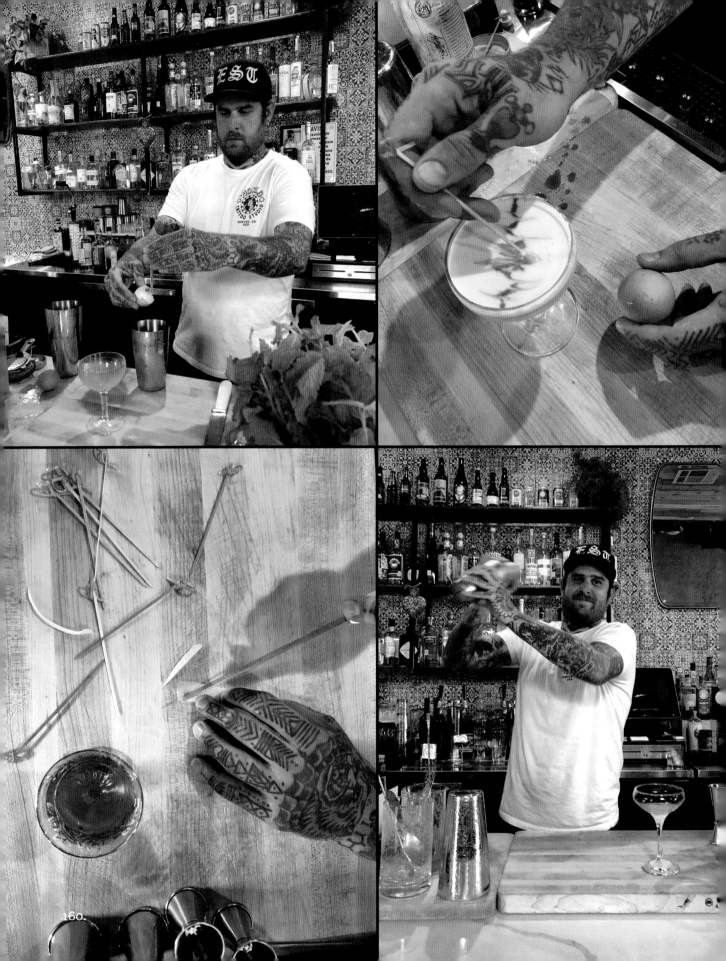

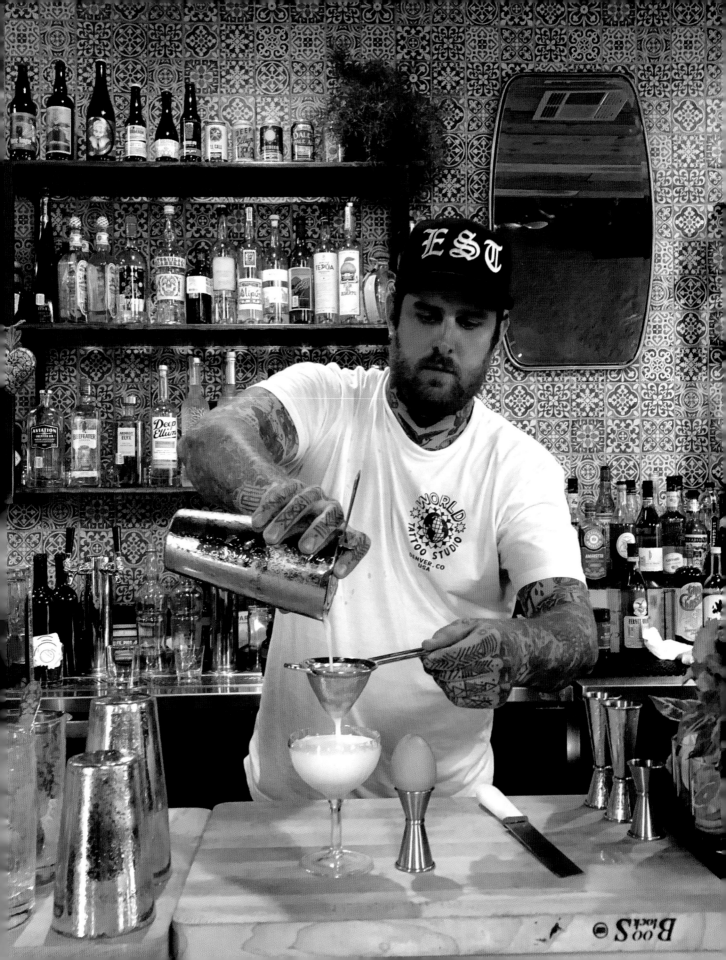

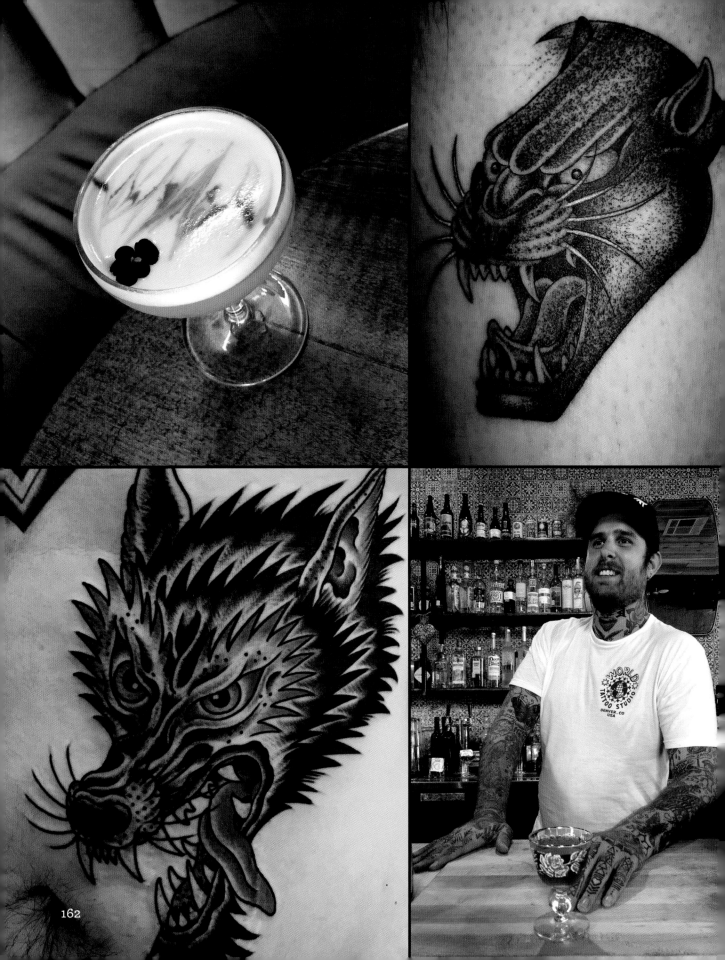

ROB STRUVEN

R ob Struven owns and operates Napa Valley Tattoo Company (formally Garage Ink), located in a beautiful house-turned-studio in the heart of Napa Valley, California. Rob himself has been tattooing for over sixteen years. Napa Valley is known as "wine country" in California and is also known for its cuisine and unique restaurant culture. It must have been crazy to grow up where fine wine and food are so embedded into the culture. When I asked Rob what some of his favorite food memories are, they are of cooking at home with his mother and brother. One special memory he has is homemade wontons on a rainy New Year's Eve. These days he loves the family recipes of his charming wife, Ginger, from her Greek heritage.

Rob and Ginger chose to cook an old family recipe, seafood chowder, paired with a sauvignon blanc from a friend's winery. Rob did the art for the label! They had gone to the market that morning, so the seafood was very fresh. Thick-legged king crab, plump shrimp, and scallops; I love the smell of seafood chowder. Rob's cooking advice is to try new things, so we hope you enjoy this recipe: it's a good one.

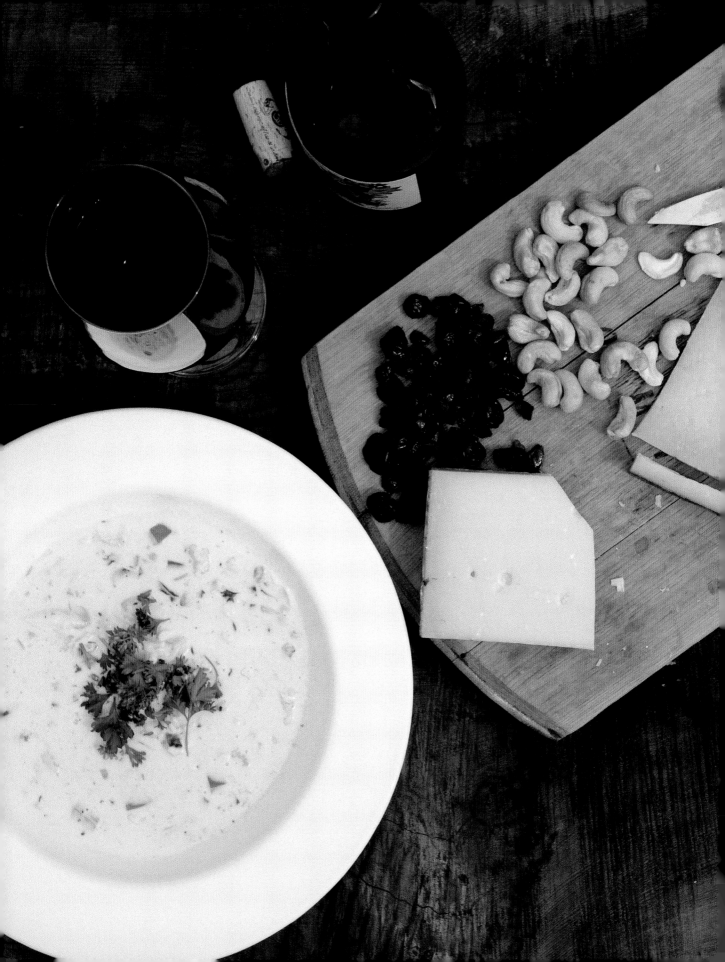

- 6 ounces bacon, sliced into bite-sized pieces
- 2 tablespoons unsalted butter
- Onion, diced small
- Carrot, diced small
- Celery, diced small
- 4 tablespoons flour
- 2 cups clam juice
- 3–4 potatoes, diced small
- Salt and pepper to taste
- ½ pound fresh crab meat
- ½ pound shrimp, deshelled and deveined
- 1 pound shucked clams
- 4 cups whole milk or half and half
- Parsley, roughly chopped

THE STRUVENS' FAMILY SEAFOOD CHOWDER

SERVES 6–8

Cook bacon until browned in a large stockpot over medium-high heat. Add butter and onions, carrots, and celery, and cook until onions turn transparent, about 8–10 minutes. Stir in the flour and then add the clam juice. Add the potatoes, salt, and pepper and bring to a simmer. Cook until the potatoes are soft all the way through. Add the seafood and simmer for another 10 minutes, then add the milk or half and half and heat through on medium-low. Do not boil! Check the level of the salt and pepper and add to taste if you need. Garnish with the parsley.

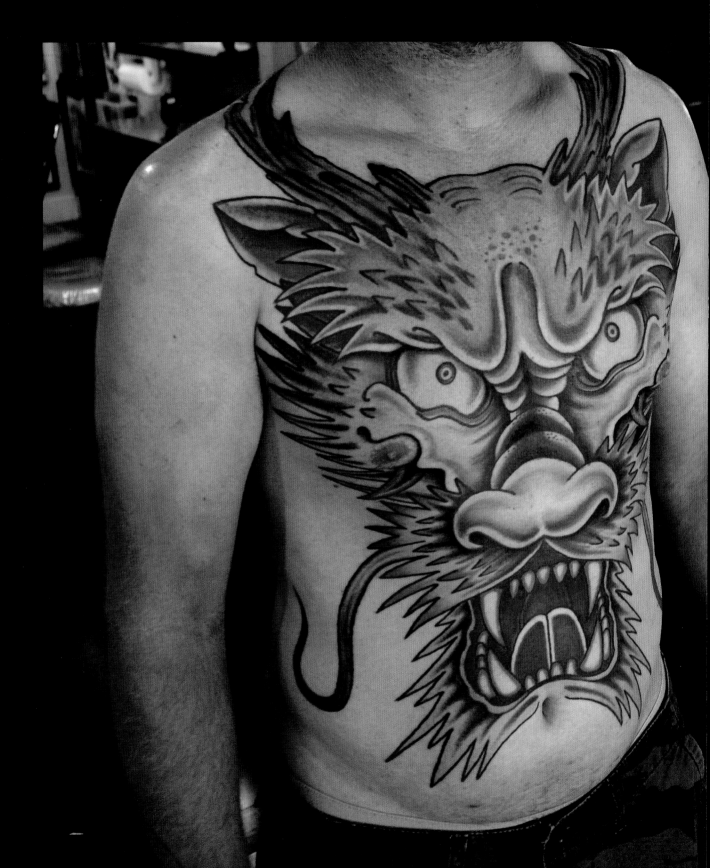

STEVE LOONEY

S ulu'ape Steve Looney has been tattooing for over twenty years and is the owner/operator of Pacific Soul Tattoo in Honolulu, Hawaii. Steve spent part of his youth in American Samoa. As his title indicates, he belongs to the celebrated Sulu'ape tattoo family from Samoa. Traditionally, men do most of the food preparation in Samoa due to the physical strength required for many of the dishes. Samoan food is organic and resourceful. In Samoa, people take full advantage of their natural resources and make use of every part of whatever it is they are cooking—from wild boars to coconuts, everything gets used!

As one of the principal ingredients for the oka dish, we had the opportunity to document Steve making coconut milk from scratch. Every part of the coconut is used; he offered us the coconut water to drink, squeezed the milk from the coconut meat after shaving it out of the shells, used leftover shavings for baking, and even burned the shells as fuel for the barbecue. Everything is very labor intensive—it's no wonder why Samoans take pride in their food! Steve and his beautiful wife, Dani, often host huge barbecues at their shop. The spread is usually like a huge banquet, done in true Polynesian style. In addition to the fresh oka, Steve's barbecued short ribs are phenomenal and his teriyaki hamburgers are legendary. I hope you enjoy Steve's dish; it's really good!

STEVE'S SAMOAN OKA
WITH BOILED GREEN BANANA

SERVES 6–8

- 2 pounds ahi tuna or marlin, diced into bite-sized pieces
- 4–5 limes, juiced
- 4 medium plum tomatoes, diced small
- ½ medium yellow onion, diced small
- 1 bunch of green onion, thinly sliced
- 1 large cucumber, diced small
- 1–2 fresh red chili peppers, crushed and macerated
- Coconut milk (if you try to make your own, 2 coconuts = 1 can)
- 6–8 very green bananas, peeled and boiled (you can also use plantains)
- Salt and pepper to taste

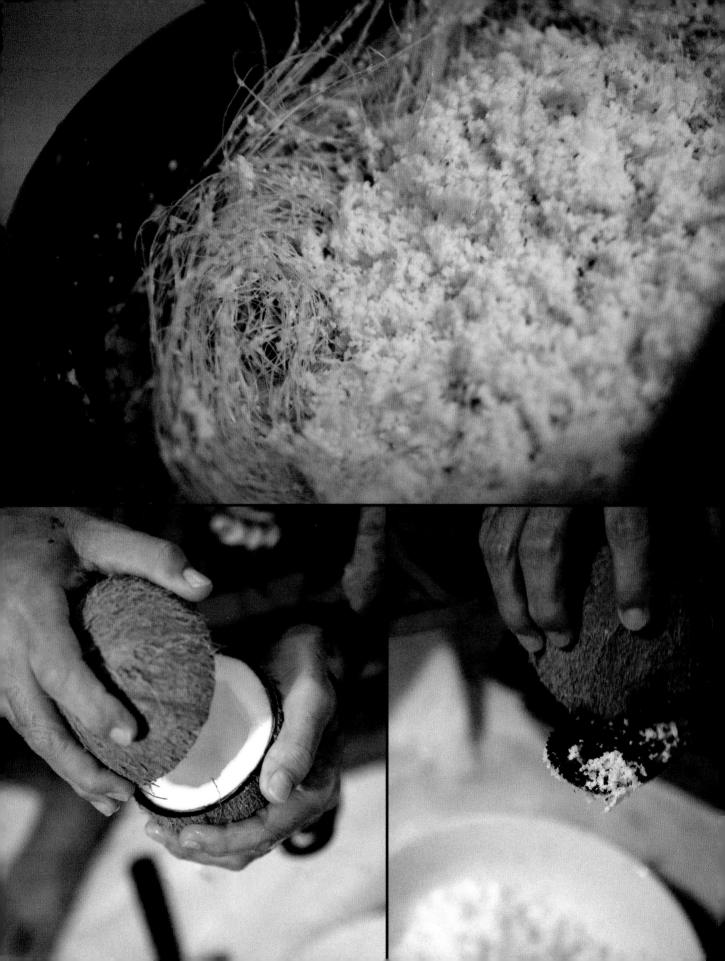

Dice the fish and marinate it with the lime juice in a medium- or large-sized bowl for about 20 minutes. Meanwhile, slice and dice the tomatoes, onions, cucumber, and chilis and add them to the fish. Incorporate the coconut milk, cover, and set aside in the refrigerator.

Put a medium-large saucepot filled with water on the stove over medium-high heat. Bring the water to a boil. Peel the green bananas and carefully place them in the boiling water. Turn the heat down to medium and boil the bananas until they are tender, about 20–30 minutes. They are done when they are easily pierced with a fork. Take them out of the water and let them cool before serving.

Serve the oka in a nice serving bowl, with the boiled bananas on the side. A good alternative to boiled bananas could be plantain chips if you want a starch with more of a crunch. Enjoy!

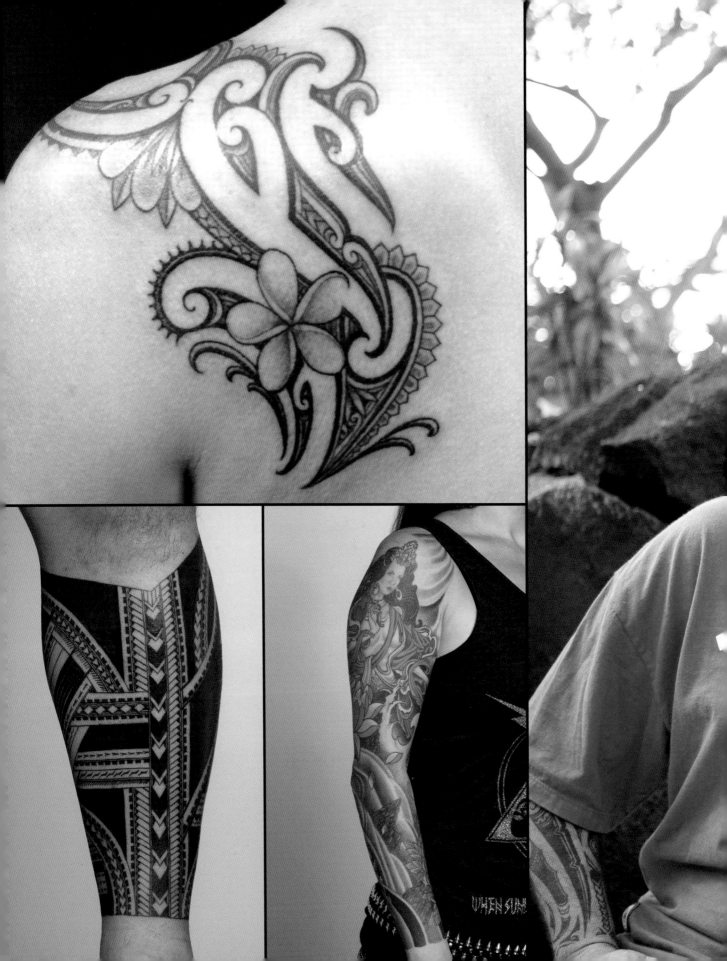

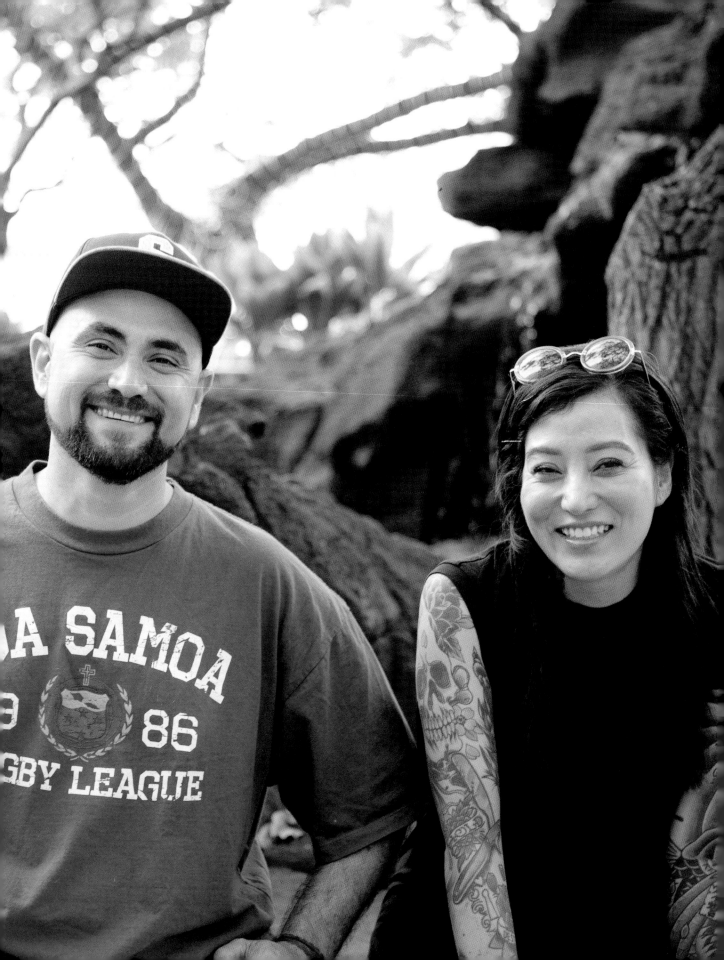

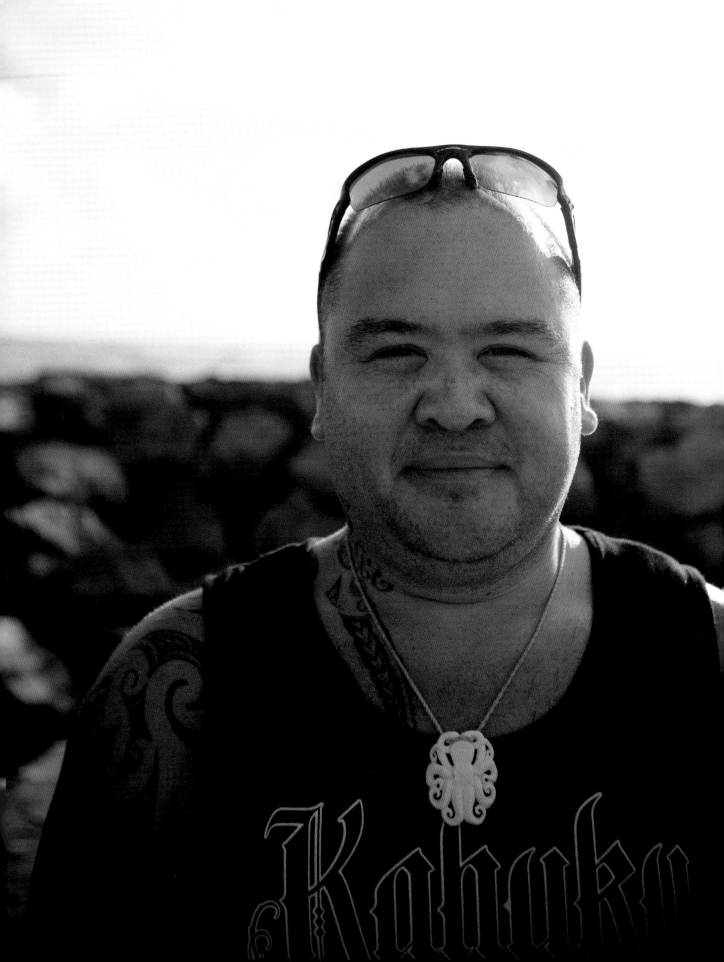

TEDDIE SCOTT

Teddie is what I would call a hybrid chef-tat-tooer: he's very skilled and has a great love for both trades. His love for cooking started early, largely due to the fact that his stepfather was a chef from Japan and the executive chef of the Turtle Bay Resort in Hawaii. He basically grew up in the main kitchen, and some of his fondest childhood memories are of being in that kitchen. His family would even use it to make food for family get-togethers! The first dish Teddie made was maki sushi. He would watch his stepfather cut fish and vegetables, and then would practice repeatedly on his own. Teddie loves feeding people, nurturing them with his delicious experiments, and spends a lot of his free time cooking. Although he grew up in a professional kitchen, Teddie never harbored a desire to cook professionally. He did try a stint as a cook during school but was afraid that the long hours, pressure, and stress required for a career as a successful chef would take the enjoyment out of cooking.

Teddie turned to other creative outlets for his artistic abilities. He went to art school in Philadelphia and studied painting and animation. He fell into tattooing almost by accident after starting his own clothing company. He was drawing designs for his clothing company, and these caught the attention of local tattoo artists. They eventually helped him learn the basics of the craft, and he fell in love with it. He has been tattooing for over eleven years now.

Teddie's cooking advice for this recipe is to steam the ribs before grilling, and also to follow your instincts. Try his guava ribs, avocado jelly, and lobster-stuffed mushrooms—they are incredible!

Guava Ribs

* 2 full racks of pork baby back ribs
* 3 tablespoons salt
* 3 cloves of garlic
* 3 slices of ginger, about ½ inch thick
* 1 apple, sliced
* Water for steamer

Add salt, garlic, ginger, and apple to water in steamer and bring to a boil. Cut the full racks in half and steam for 35–45 minutes.

Guava Glaze

* 10 ounces guava jam
* 10 ounces mango or pineapple jam
* 3 cloves garlic, minced
* ½ cup apple juice
* 3 tablespoons apple cider or rice wine vinegar
* 2 stalks of green onion, chopped
* 1 cup pure coconut milk
* 3 tablespoons Dijon mustard
* ½ cup macadamia nuts, chopped (optional)
* Salt and pepper to taste

In a large bowl, combine all ingredients and mix until smooth. Coat the steamed ribs well with guava glaze.

Grill over medium to medium-high heat on the grill. Lightly caramelize the ribs (be careful not to burn!) and reapply glaze. Caramelize after every flip (about 3 times per side) and sprinkle the macadamia nuts over the ribs on the last flip.

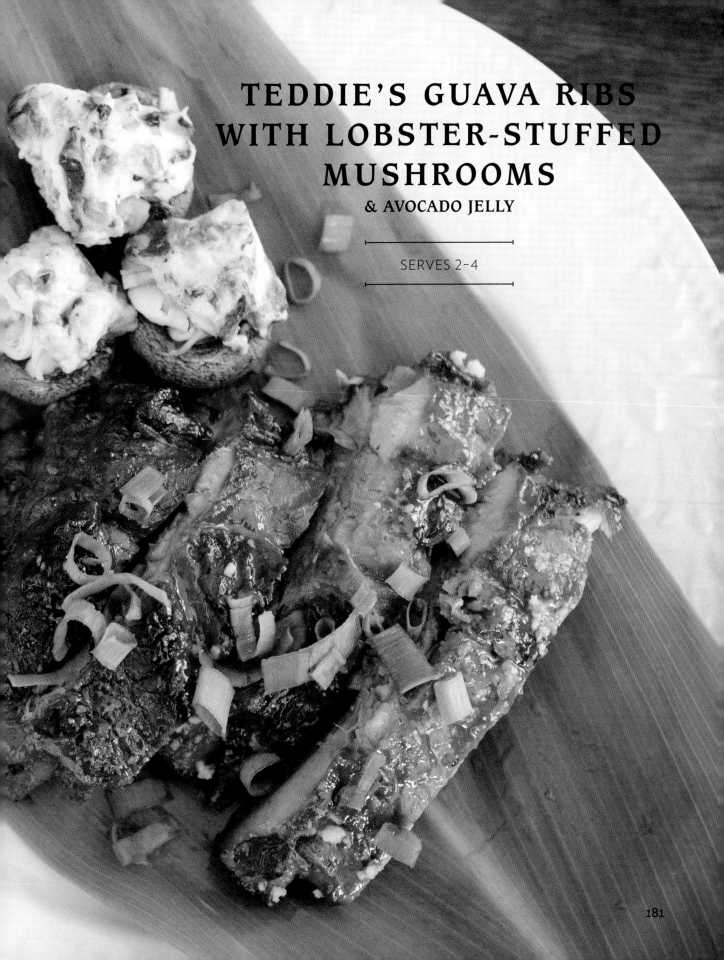

TEDDIE'S GUAVA RIBS WITH LOBSTER-STUFFED MUSHROOMS
& AVOCADO JELLY

SERVES 2-4

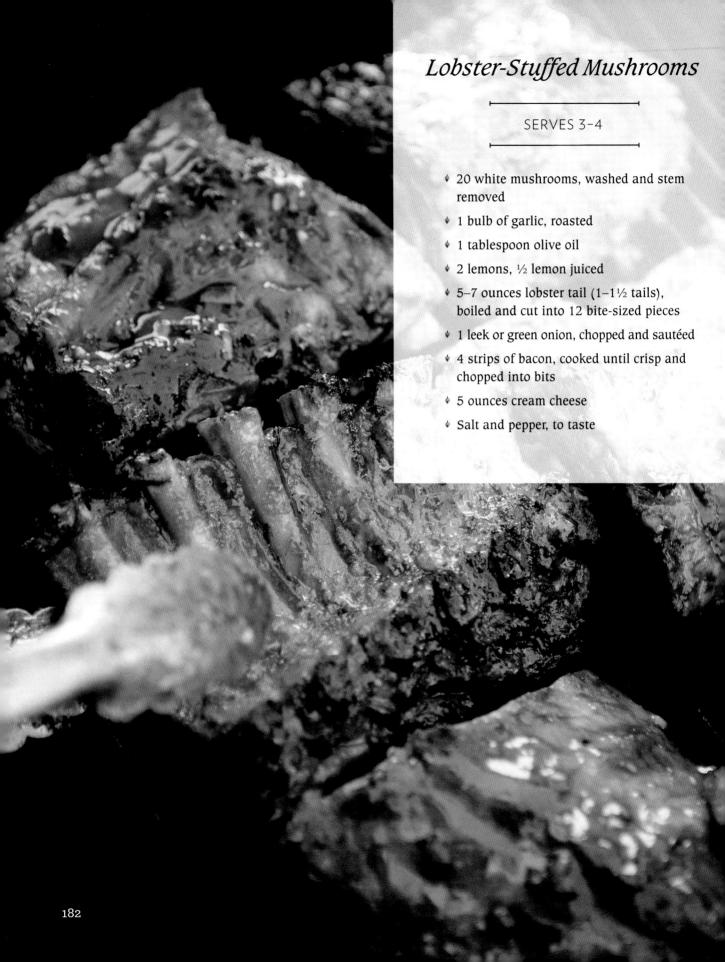

Lobster-Stuffed Mushrooms

SERVES 3–4

- 20 white mushrooms, washed and stem removed
- 1 bulb of garlic, roasted
- 1 tablespoon olive oil
- 2 lemons, ½ lemon juiced
- 5–7 ounces lobster tail (1–1½ tails), boiled and cut into 12 bite-sized pieces
- 1 leek or green onion, chopped and sautéed
- 4 strips of bacon, cooked until crisp and chopped into bits
- 5 ounces cream cheese
- Salt and pepper, to taste

Preheat oven to 400°F. First, wash and take
out the stems of the mushrooms. Set on a
paper towel and set aside. Next take the bulb
of garlic, place it on a piece of aluminum
foil, and lightly drizzle it with olive oil. Wrap
it neatly in the foil and slide it into the oven.
Let the garlic roast for about 30–40 minutes,
or until the bulb is tender and soft to the
touch. While the garlic is roasting, put a
small to medium saucepan filled with water,
salt (salty like the sea), and 1½ lemons cut
in half on the stove over high heat. Bring up
to a boil. When boiling, gently add the
lobster in shell. Boil for about 5–8 minutes.
In the meantime, prepare a bowl with lightly
salted (not as salted as the boiling water) ice
water. Strain the lobster and transfer to the
ice water immediately. Let the lobster cool
down. While the lobster is cooling, sauté the
chopped onion in a frying pan over medium-
high heat until it starts to wilt and set aside.

Next, cook the bacon over medium-high heat in a frying pan until very crispy and then chop into small bits. Also set aside. The garlic should be about done by this time, so take it out of the oven and let it cool. While the garlic is cooling, take the lobster out of the ice bath and cut the bottom with a pair of kitchen scissors. Take the meat out and cut into 20 bite-sized pieces. When the garlic is cool enough, squeeze the garlic out of each clove into a mixing bowl. Add the rest of the ingredients except for the lobster. Lightly whip the cream cheese mixture together. Place the mushrooms on a baking dish, top side down. Fill each mushroom with a piece of lobster and top with about a teaspoon of the cream cheese mixture. Place the baking dish into the oven for about 20–30 minutes, or until the mushrooms are cooked through and soft to the touch. When they are done, transfer the mushrooms to a platter and serve warm.

Avocado Jelly with Graham Cracker Crust

In a blender or food processor, mix avocado, cream, and honey. Set aside. Bring 1 cup of water to a boil. Remove from heat and add gelatin and lime Jello. Stir until gelatin is dissolved. Add 1 cup of cold water and place in the refrigerator until it reaches the consistency of egg whites. Blend the gelatin mix and avocado mix together until smooth. Pour blended mix over the cooled crust and let it set in the refrigerator for about 4–5 hours. Slice into squares and drizzle strawberry reduction over the top.

CRUST

- 1½ cups finely ground graham cracker crumbs
- ⅓ cup sugar
- 8 tablespoons butter, melted
- ½ teaspoon cinnamon (optional)

Preheat oven to 350°F. Mix all ingredients until well blended. Split and press mixture into two 8-by-8-inch baking pans. Bake until golden brown, about 7 minutes. Let cool.

Strawberry Reduction

- 12 ounces fresh strawberries
- 1 cup water
- ⅛ cup sugar

In a blender, puree strawberries, water, and sugar. Transfer the puree into a small pot and bring to a boil over medium-high heat. Reduce heat to low and simmer until liquid is reduced by half. Let it cool.

AVOCADO JELLY

- 2 cups avocado
- ¼ cup heavy cream (can be substituted with soy or almond milk)
- ⅛ cup honey
- 2 packets of unflavored gelatin
- 1 4-ounce box of lime-flavored Jello

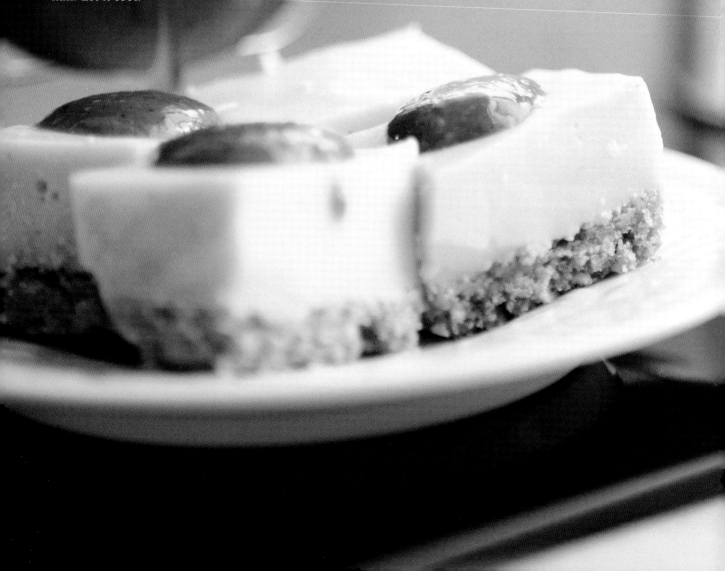

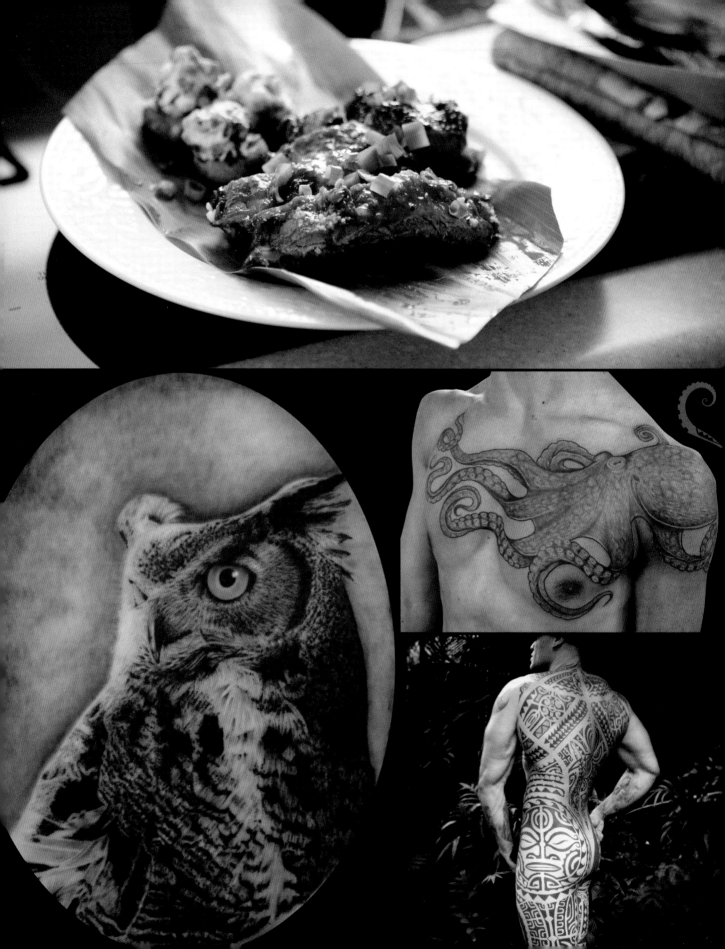

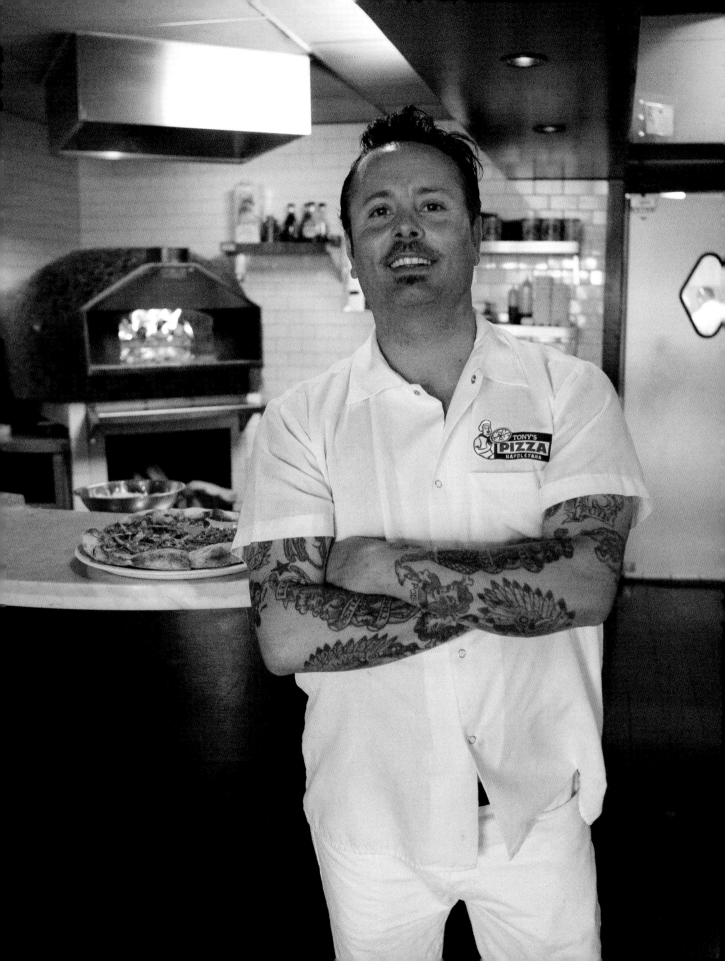

TONY GEMIGNANI

This was one of the funnest shoots we did! Tony Gemignani is super charismatic, friendly, and fun to interview—and as a world-renowned pizza chef, it's easy to see why. He has won numerous world championships in pizza making, even beating out the top competitors from Italy! Obviously, Tony is a very busy man; he owns and operates nine pizzerias in the Bay Area, and his pizzas are also at local sports stadiums. In true form, immediately following our photo shoot, he jumped on a plane to fly cross-country and cook a pizza on the morning talk show *Live! With Kelly and Michael*.

Tony has been cooking for over twenty years, starting out at a pizzeria in Castro Valley, California. He simply fell in love with cooking and has been full on ever since. He also has his own cookbook, aptly titled *The Pizza Bible*. It is a great cookbook—well thought out, and it even looks like a takeout pizza box.

One of Tony's main pizzerias, Tony's Pizza Napoletana, is in San Francisco. That location is one of tattoo legend Ed Hardy's favorite restaurants. Ed took us there for lunch a few years ago, and the food was wonderful! Tony is covered in tattoos by some of the best tattoo artists in San Francisco, including Juan Puente, Ed Hardy, and Doug Hardy. Doug has actually painted one of the restaurant doors. Tattoos run deep in this pizza community, and we were very lucky for the opportunity to have this photo shoot in this book.

Tony cooked one of his famous pizzas for us and gave us a sample of his award-winning pizza-tossing techniques. It was crazy—literally like watching the Globetrotters of pizza. Thank you, Tony, for incredible pizza and such an entertaining photo shoot!

189

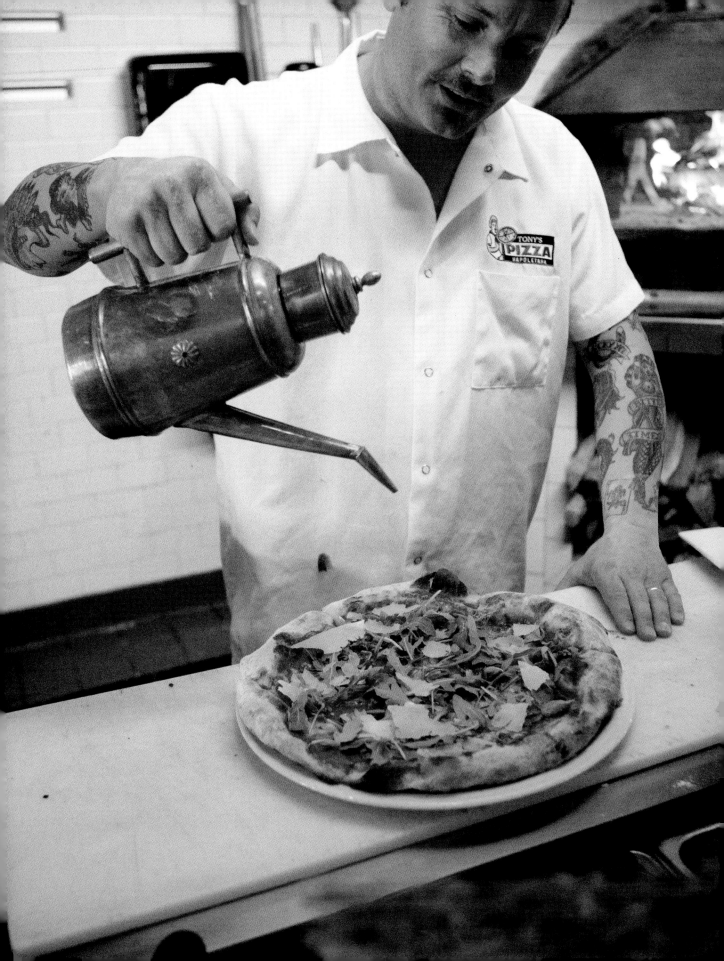

TONY'S PIZZA DIAVOLA

|———————————————————|

SERVES 1–4

|———————————————————|

New York–Style Dough with Starter

..

- ✤ 28.8 ounces All Trumps High Gluten Flour / Tony's Artisan Flour Blend
- ✤ 0.64 ounce malt (2%)
- ✤ 0.14 ounce dry active yeast (0.5%)
- ✤ 2 ounces (¹/₄ cup) warm water at 80°F
- ✤ 14 ounces (1³/₄ cups) cold water at 55°F
- ✤ Total water = 60%
- ✤ 6.4 ounces starter (20%)
- ✤ 0.64 ounce sea salt (2%)
- ✤ 0.96 ounce extra-virgin olive oil (3%)

..

Blend flour and malt together.

Mix/bloom together the yeast and warm water.

Place the cold water and warm water / yeast mixture into the bowl. Start the mixer and add 80% of your flour and malt.

After 1 minute of mixing, rain in the rest of the flour.

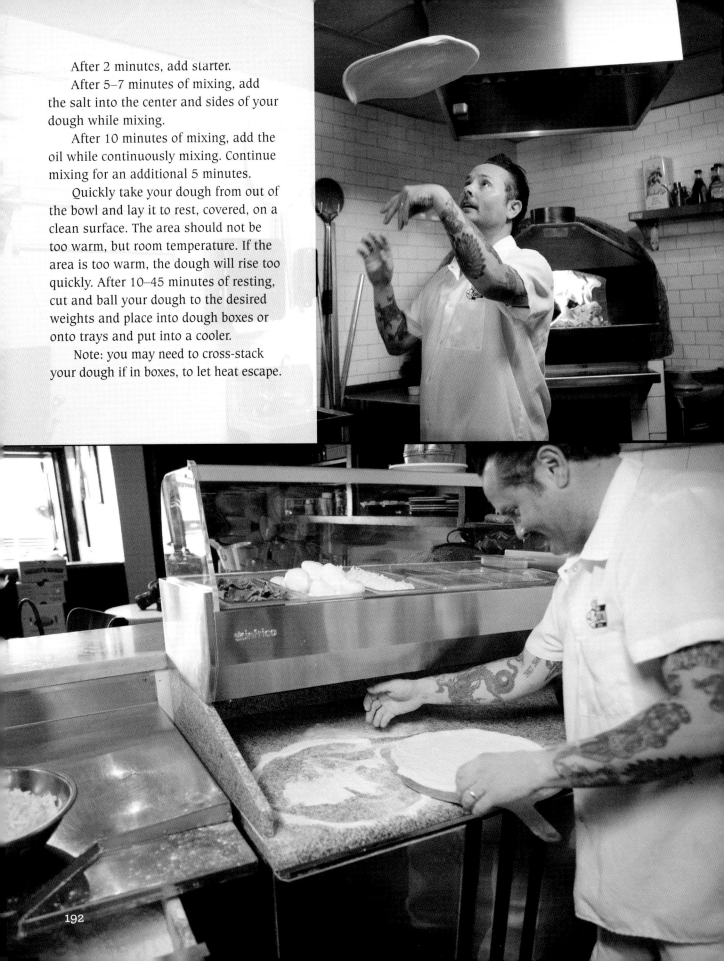

After 2 minutes, add starter.

After 5–7 minutes of mixing, add the salt into the center and sides of your dough while mixing.

After 10 minutes of mixing, add the oil while continuously mixing. Continue mixing for an additional 5 minutes.

Quickly take your dough from out of the bowl and lay it to rest, covered, on a clean surface. The area should not be too warm, but room temperature. If the area is too warm, the dough will rise too quickly. After 10–45 minutes of resting, cut and ball your dough to the desired weights and place into dough boxes or onto trays and put into a cooler.

Note: you may need to cross-stack your dough if in boxes, to let heat escape.

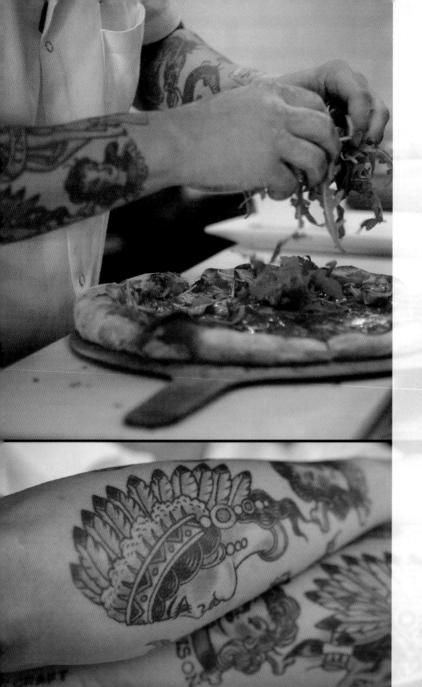

Pizza

- 1 12–13-ounce dough ball
- 150 grams tomato sauce
- Semolina and flour for dusting
- 8 ounces shredded whole-milk mozzarella
- 10 medium–large slices Soppressata Piccante
- Hot pepper oil
- Crushed red pepper flake
- Arugula
- Shaved Parmigiano-Reggiano
- 1 ounce serrano pepper slices (optional)

EQUIPMENT NEEDED

- 2 baking steels or stones positioned in your oven on top of the highest and lowest rack setting
- 13-inch pizza peel
- Pizza wheel or knife
- Vegetable peeler
- Dough bencher

Remove dough ball from refrigerator for 1 hour before use. Make sure you keep the dough wrapped and airtight.

Add tomato sauce to a bowl.

Preheat your oven to the highest setting (500–550°F) at least 45 minutes before use.

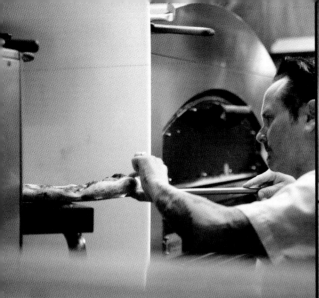
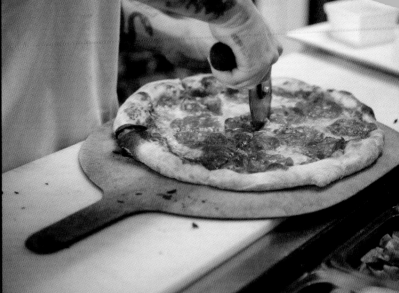

Dust your peel with semolina and a light amount of flour.

Gently scrape your dough out, leaving its round shape, and dust it completely with semolina and flour.

Using your hands, gently stretch your dough into a 12–13-inch circle.

Lay your pizza onto the pizza peel.

Sauce your dough, leaving a ½-inch border.

Cover your sauce with the shredded mozzarella, keeping your border clean with no cheese hanging over.

Decorate your pizza, starting with the Soppressata, following your cheese and sauce line.

Quickly shake your peel left to right, holding the handle to make sure your pizza isn't sticking, before going into your oven.

Gently slide your pizza onto the upper steel or stone and cook for 6 minutes.

Take your pizza out of the oven, using your peel, and rotate halfway, then place onto the bottom of your stone or steel and continue baking for 6 minutes, or until golden brown.

Take your pizza out if the oven, cut into 6 equal slices, and finish your pizza with hot pepper oil, red pepper flakes, arugula, shaved Parmigiano-Reggiano, and serrano peppers if desired, and serve.

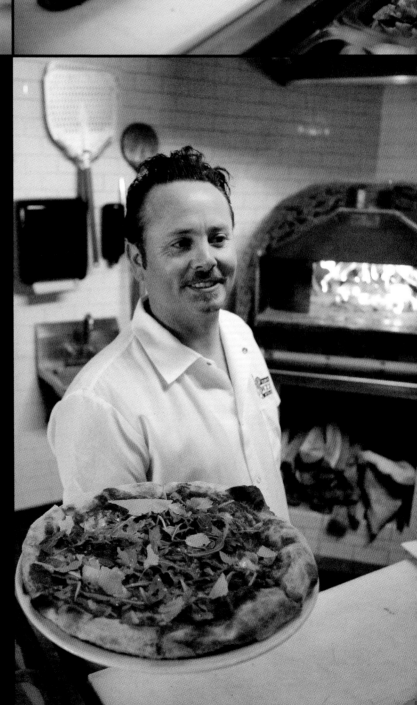

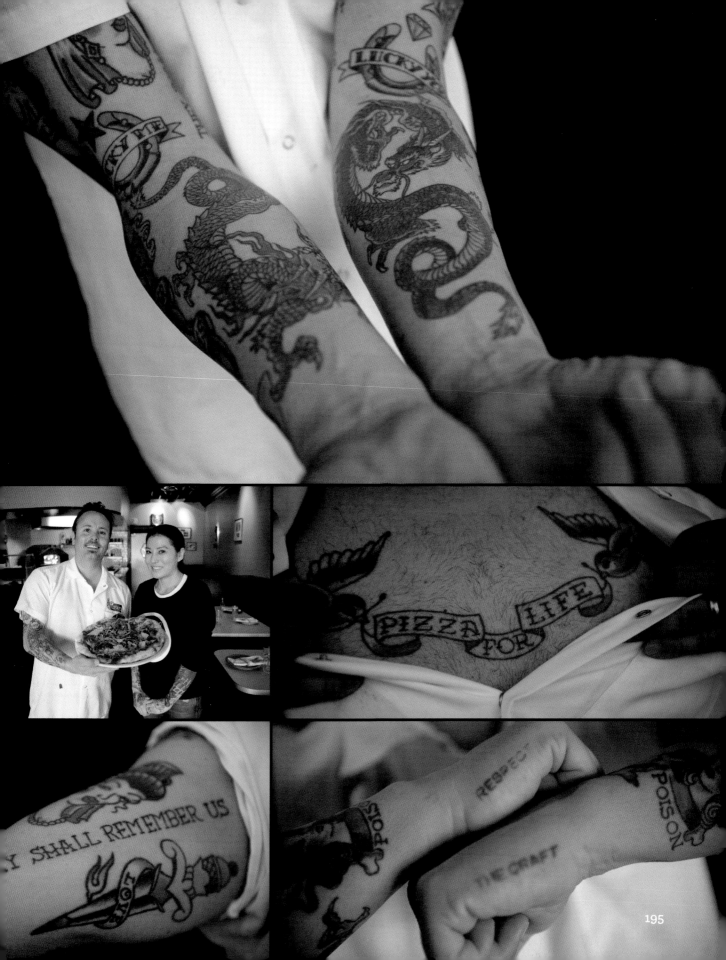

YOSHIYUKI MARUYAMA

Yoshiyuki Maruyama is a very accomplished chef. He is a true entrepreneur, with four restaurants in the Bay Area and possible expansion plans in the future. His ramen shop, Orenchi Ramen, as well as his Sumika, are Michelin recommended. Celebrity figures, tech moguls, and locals flock to his restaurants, often waiting over an hour for his famed offerings! Maruyama emigrated from Japan and began his culinary career as a sushi chef over twenty years ago. His cooking profile has grown exponentially since, even learning the art of *himono* (salted and dried seafood) from local fishermen in Japan. His respect for traditional cooking can be seen in all of his restaurants. My favorite of his restaurants is Iroriya. The subtle lack of signage and the plain but beautifully crafted wooden door, with just a very small peek-in type of window, adds a sense of "speakeasy style" mystique. Once inside, the interior and the patrons give you the feeling that you have been transported to Japan. Maruyama strives for authenticity and perfection. He imports most of his ingredients from Japan, such as gray salt from Hokkaido or the special cedar charcoal for his robata grill. His knowledge of Japanese cooking and its components is amazing. He also professes a love for French cooking and finds it to be similar to Japanese cuisine. At home, Maruyama loves to cook a nice pasta dish.

Maruyama began getting tattooed at a young age and wants to continue on—he's planning on the names of his newborn twin daughters next! From there, Maruyama plans on working on his thighs. Like his cooking, when he goes for something, he does it with wholehearted passion. Arigatou-gozaimasu Maruyama-san!

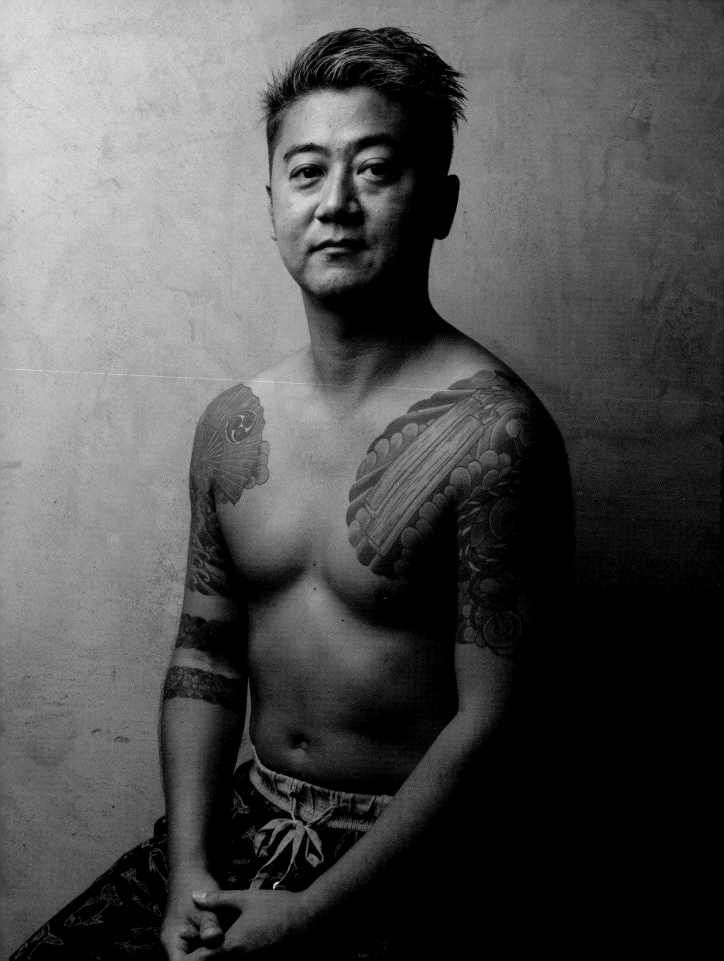

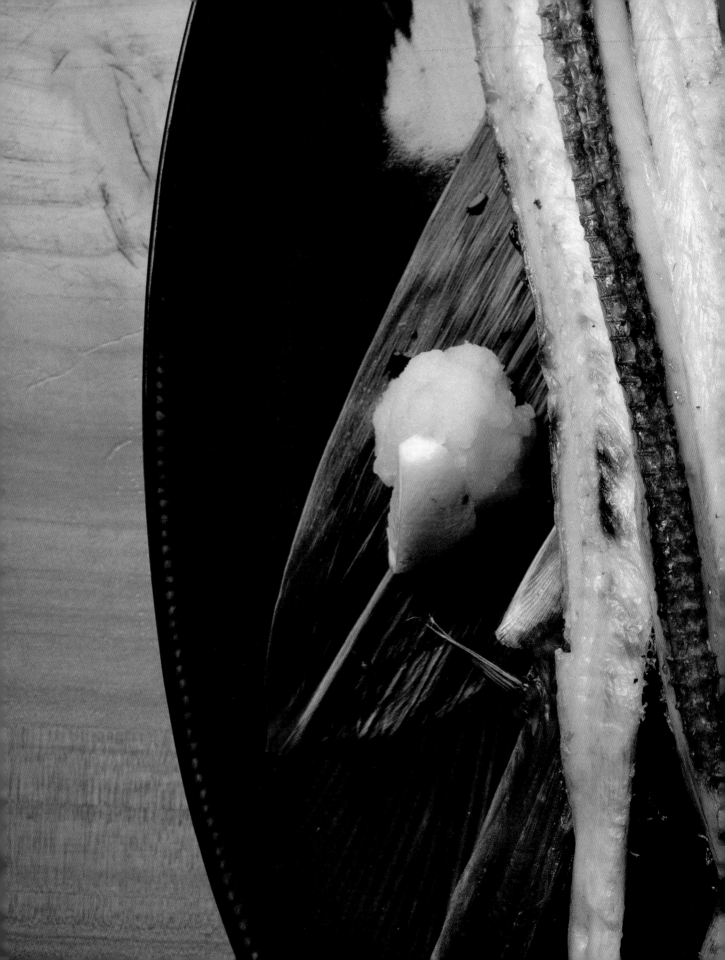

MARUYAMA'S HIMONO

- 1 whole fish, preferably mackerel or barracuda or something similar
- 1 liter water
- 100 grams sea salt
- 2-inch piece of daikon radish
- 1 lemon wedge
- 1 tablespoon soy sauce

Descale the fish and clean out the innards. Then butterfly the fish down the middle, leaving the spine in. Marinate the fish in the salt and water for 60 to 90 minutes. Next, take the fish out of the salt water and dry the fish for 10 to 14 hours in a shaded, open-aired place. Make sure there is good ventilation. Hanging it outdoors is ideal, especially if you live by the ocean. The sea air can really add an organic nuance to the fish. Meanwhile, grate the daikon radish with an oroshigane grater. Strain the excess moisture from the grated radish and place it in a bowl. Set it aside. After the fish is dried, grill it over high heat on a charcoal grill. Grill until the skin and meat just start to brown. Serve with the grated radish and a lemon wedge. Pour the soy sauce over the radish and enjoy!

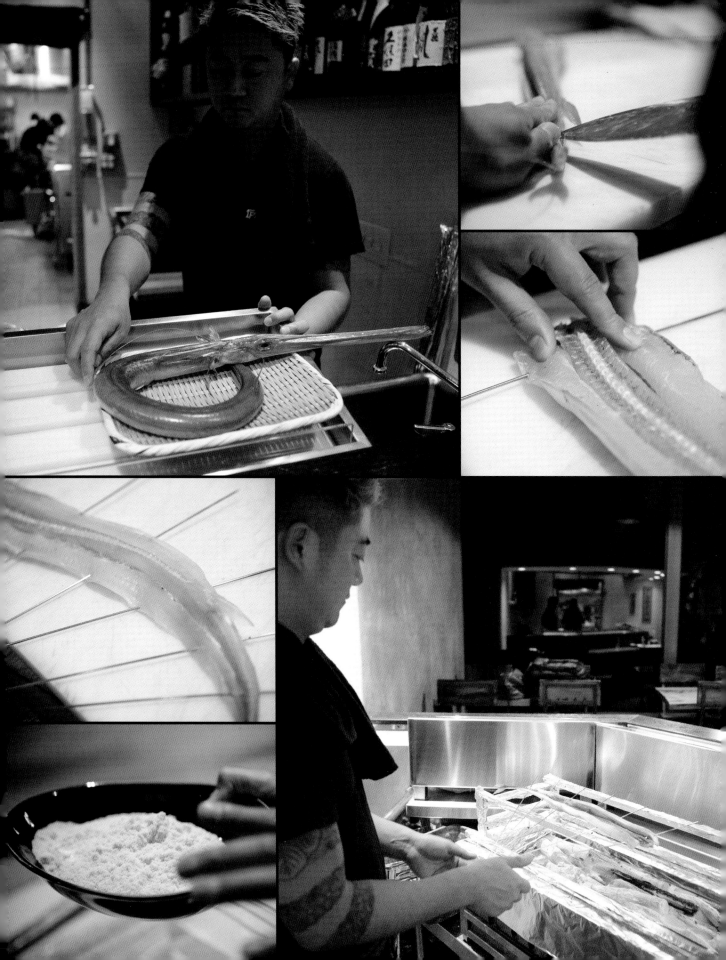

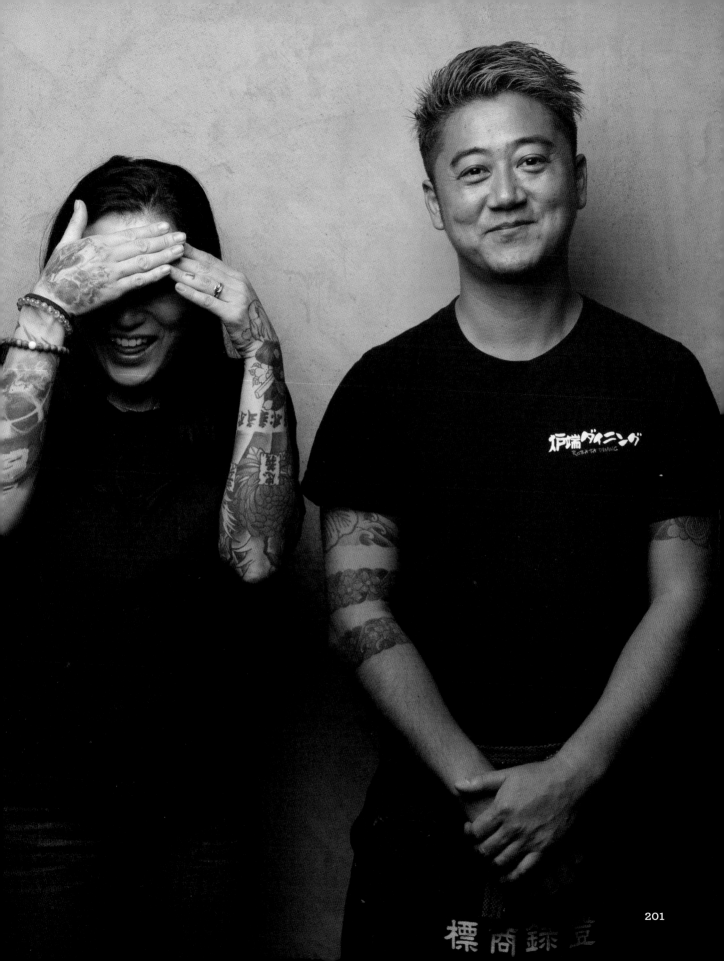

ZAC SCHEINB

Zac Scheinbaum is so sweet and generous! After my husband and I spent some time with his parents, David and Janet, on a New Mexico trip last summer, it was easy to see where he got his good nature from. Zac was born in Santa Fe, New Mexico, and began his tattoo career apprenticing under Mark Vigil at Four Star Tattoo. Eventually, he found his way to New York for an eight-year stint, first working at Saved Tattoo and then Kings Avenue Tattoo Manhattan. Recently, Zac has relocated to the West Coast and works at Seventh Son Tattoo in San Francisco. Because Zac was midmove during the completion of this book, Janet was kind enough to photograph his segment for us. Janet and David are professional photographers with their own successful gallery in Santa Fe, as well as a cadre of self-published books. It's clear where Zac got his creative side from! Thank you, Janet, and I'm glad you were able to be a part of this "recipe"!

Food and cooking have always been a part of Zac's life. It's been something he and his family have always enjoyed doing together. Zac prefers "clean tastes," stripped down and relying on natural flavors appreciated in their simplest forms. One of his daily go-tos is rice with an egg and avocado. He likes to cook with fresh vegetables and makes the occasional meat dish. For this book he wanted to show off a New Mexico staple that is easy to make and share with family and friends!

ZAC'S SOUTHWESTERN GUACAMOLE & MARGARITA

SERVES 4–6

Guacamole

...

- Three avocados, peeled and cored
- $1/4$ of a red onion, chopped
- $1\frac{1}{2}$ half limes, juiced
- 1 teaspoon salt
- 2 tablespoons salsa
- $1/4$ cup cilantro, chopped
- $1/2$ teaspoon cumin
- Sprinkling of ground black pepper
- 1 teaspoon white vinegar (the vinegar stops the avocados from browning)

...

Mash it all up in a bowl till ready! And enjoy!

Margarita

...

- 2-second-pour tequila
- 1-second-pour triple sec
- 1 whole lime, cut into slices
- Half a lemon, juiced

...

Rub a lime slice on the edge of glass, all the way around, then dip in salt.

Shake all other ingredients in a drink shaker with ice, then pour it all into the salted glass.

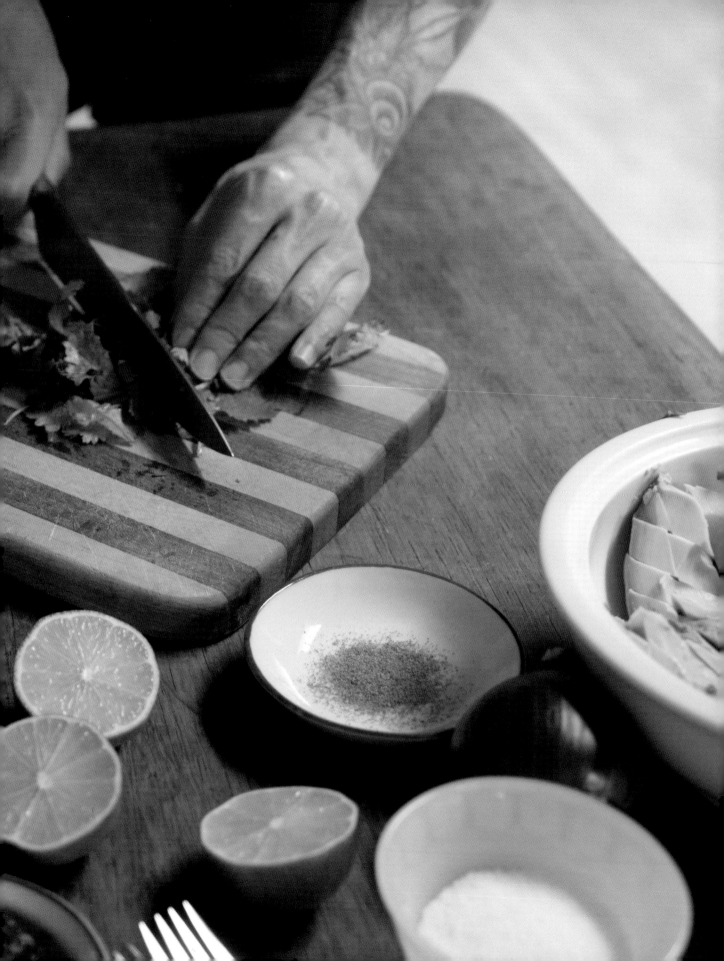

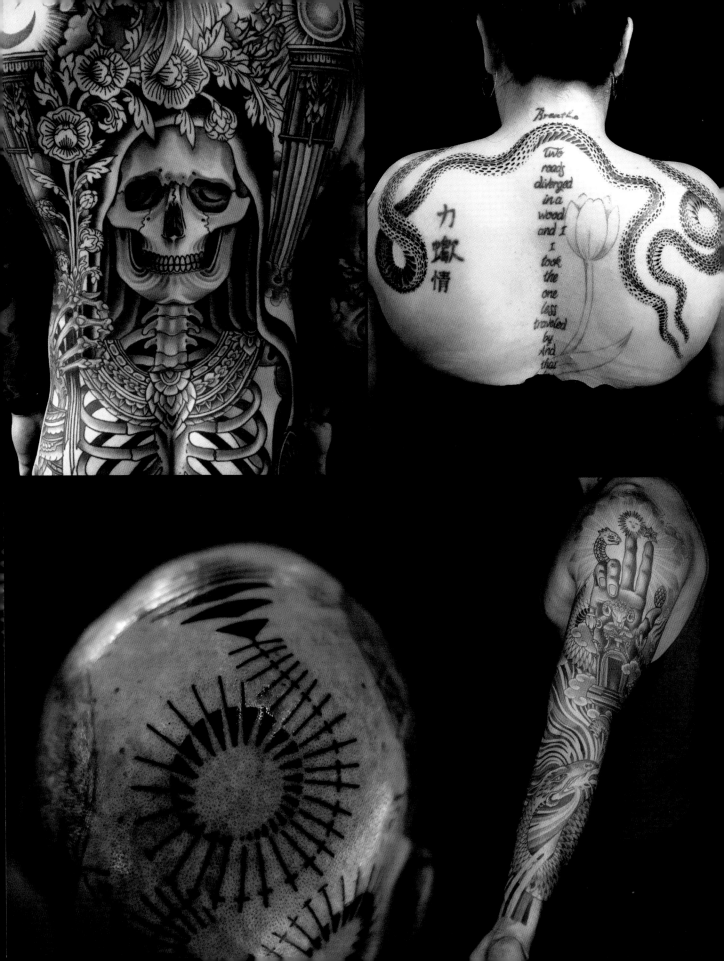

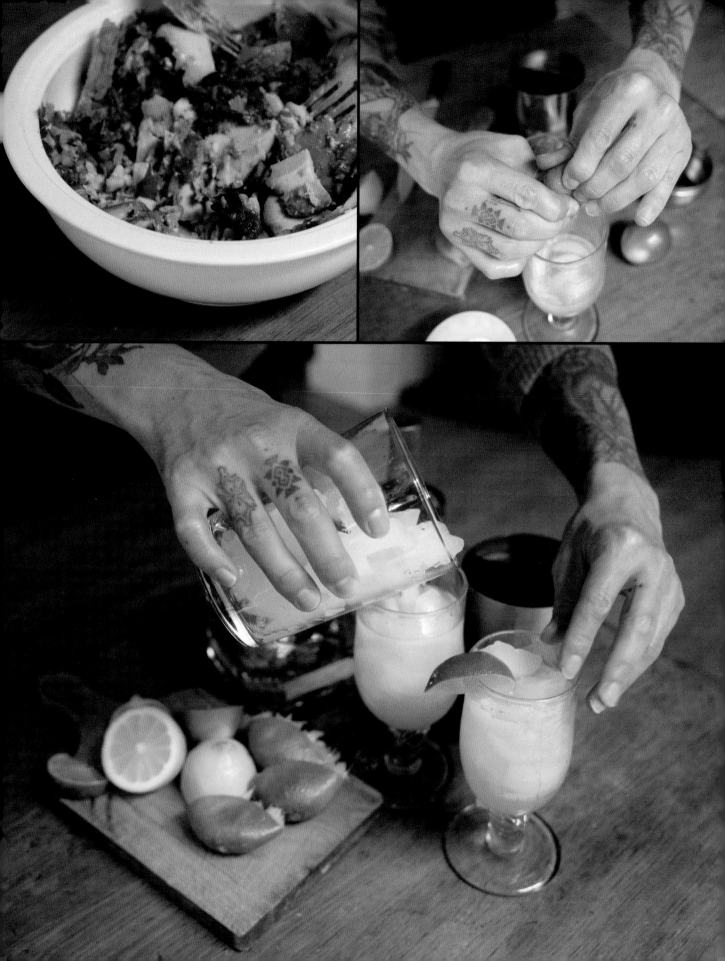

JOHN AGCAOILI

JOHN'S BRUSCHETTA

SERVES 4–6

- 10 roma tomatoes, diced small
- 6–8 cloves of garlic, finely chopped
- 8–10 leaves of fresh basil, chiffonade
- 2 inches of a good Parmesan cheese, finely grated
- ¼–½ cup balsamic vinegar
- ⅛–¼ cup olive oil, with more for brushing on the bread
- Salt and pepper, to taste
- 1 loaf of French baguette, sliced

Combine all the ingredients except the bread into a medium-sized serving bowl, adding the vinegar and olive oil last, to taste. Then, salt and pepper to taste. Set aside. Brush the slices of baguette with olive oil, and toast until golden on a griddle over medium-high heat. Place toasted pieces of bread on a serving platter and generously top with the tomato mixture. Enjoy!

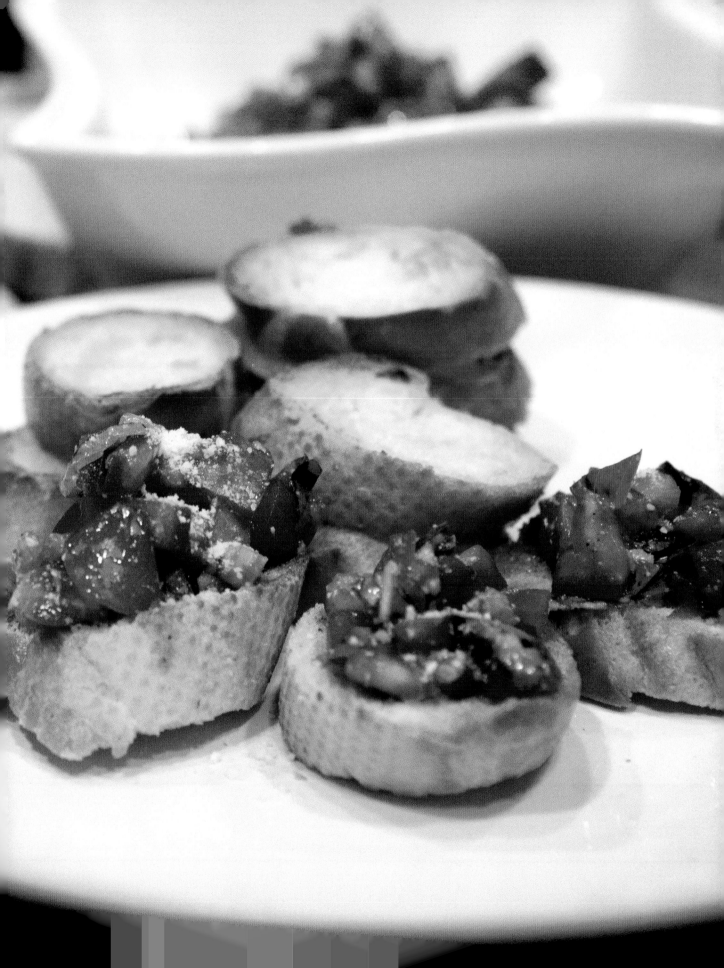

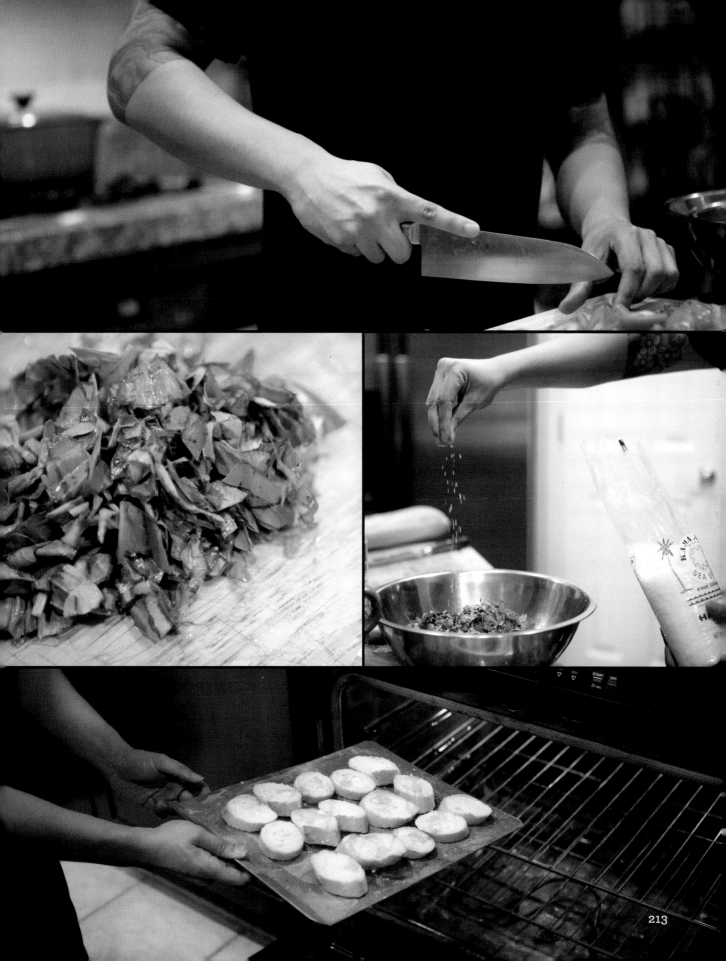

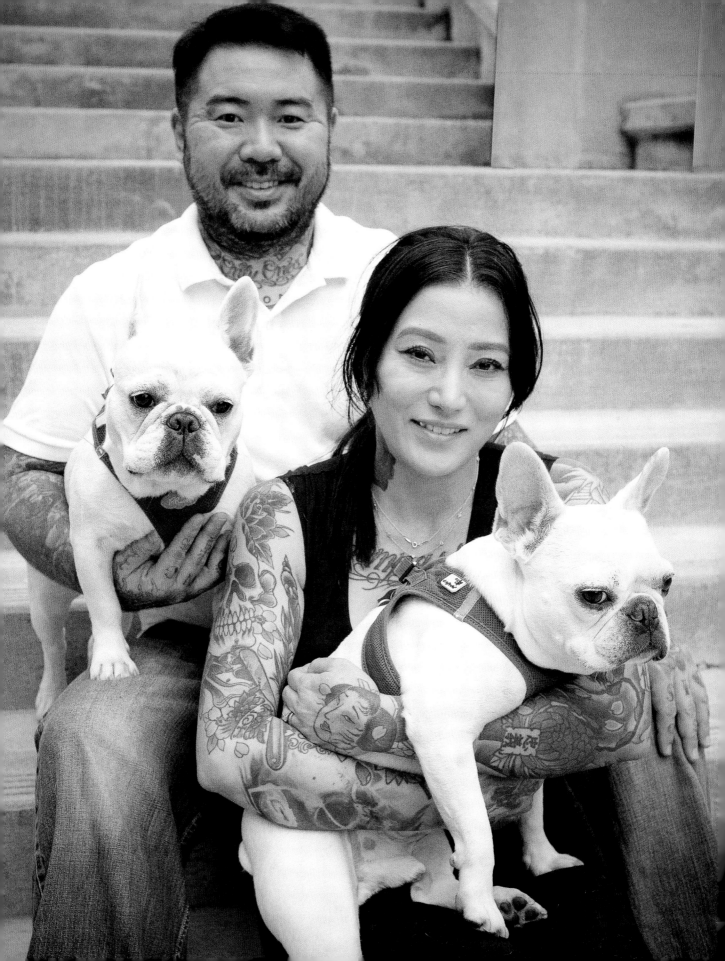

MOLLY
& TAKI

When I was five years old, I told my mom I wanted to be a chef on a cruise ship. She replied by telling me every great chef starts out washing dishes. It was a good lesson to learn, and one I have always remembered. I have worked in the restaurant industry for about twenty years—roughly sixteen years of that time was actually cooking. I first got a job in a pastry kitchen and fell in love with cooking in a professional environment. The buzz of the kitchen, the smells and flavors, the camaraderie; it was all so enthralling and addicting. I was fortunate to learn sushi early on in my career in Miami from a couple of very talented Japanese chefs. From there, sushi took me around the world. I experienced many different cultures and the local cuisines along the way. Because of that, it was really difficult to choose what I wanted to make for this book. Sushi was obvious but seemed too predictable for me. I wanted to share something completely different and unintimidating to make at home. So please read on and enjoy what Taki and I cooked up.

Taki has been tattooing for over eighteen years and grew up in Northern California. He owns and operates State of Grace Tattoo in San Jose, California. Taki is also an author, publisher, public speaker, and convention organizer, and more recently he has added museum exhibition curator to his resume. Japanese is probably his favorite cuisine—he loves to cook Japanese curry rice, and his cooking advice is to shave the curry roux for better incorporation. Taki also loves Italian food and Thai food. When not tattooing or cooking, Taki loves playing with his two Frenchies, Mr. K and Chaja. He has the most *amaaaaaazing* wife.

Milanesea di Napolitana is one of my favorite things to eat. I became sort of a connoisseur: I would literally eat it three or four times a week at different spots around Buenos Aires. It became a staple for me as much as it is a staple dish for most Argentines. Most restaurants there will have it. It is usually deep fried and served with a simple wedge of lemon and a side dish of a small green salad. It is also commonly served with a starch like mashed potatoes, mashed squash, or French fries. I have also had it served in sandwich form with mayonnaise, lettuce, and tomato, which, I must say, is amazing. The "di Napolitana" part is the extra topping you can order at some restaurants. I am using panko bread crumbs, since you will bake instead of deep fry for this recipe. Panko will give it a crispiness you might not get with fresh bread crumbs. In the photos it is served with a seasonal fennel and tomato salad, but please get creative and serve it with anything you want, or just eat it alone!

MOLLY & TAKI'S
MILANESA DI NAPOLITANA

SERVES 4

- 4 pieces of ¼-pound, thinly sliced sirloin or top round, pounded flat to about ¼–⅛ inch thick if not sliced that way already
- 2 cups flour
- 3–4 eggs, lightly beaten
- 3–4 cups panko crumbs
- Olive oil, to brush on
- 1 cup tomato sauce—*see recipe*
- 4 thin slices of ham
- 2–3 cups mozzarella cheese
- 4 sprigs of basil
- Salt and pepper

EASY TOMATO SAUCE

- 3 fresh tomatoes, quartered
- 1 medium-large yellow onion, large dice
- 3 cloves garlic, lightly chopped
- 3 tablespoons dried oregano
- 1 teaspoon dried chili flakes
- 1 large bay leaf
- 1 box of Pomi crushed tomatoes
- Olive oil

Tomato Sauce

Put a medium saucepot on the stove over medium-high heat. Coat the bottom about a ½ inch thick with olive oil. When the oil heats up a bit, about 1–2 minutes, add everything but the box of Pomi tomatoes. Turn the heat down to medium and sweat the onions until they turn transparent and start to brown. Add more oil if you notice that it starts drying up. Once the onions are caramelized, add the boxed tomatoes. Bring the heat back up to a light simmer and then lower it to keep the simmer—do not boil. Stir occasionally and simmer for about 45 minutes. After that, puree the sauce with a hand blender or in a blender. Salt and pepper to taste.

Milanesa

Preheat the oven to 450°F. Brush olive oil onto the surface of two baking sheets and set them aside. Salt and pepper each piece of meat well and set aside. Set out 3 wide bowls or deep pans: one for flour, one for egg, and one for panko crumbs. Take the first slice of meat and coat it well in flour. Next, wash it in egg, making sure every inch of meat gets coated in egg. Last, coat the beef with the panko. Press firmly down on the meat into a layer of panko, on each side and repeatedly. You want to really press the bread crumbs to the meat so they really stick and you end up with a thick crust. Set aside on the oiled baking sheet. Repeat with each piece of beef: you will end up with 2 Milanesa per baking sheet. Lightly brush olive oil over the top of each Milanesa and slide into the oven for about 8–10 minutes. After that, flip the Milanesa and top with tomato sauce, ham, and cheese. Slide them back into the oven and bake until the cheese melts and starts to brown slightly, another 8–10 minutes. If your oven cannot hold both baking sheets, cook them in batches. When they are finished, top each one with a sprig of basil.

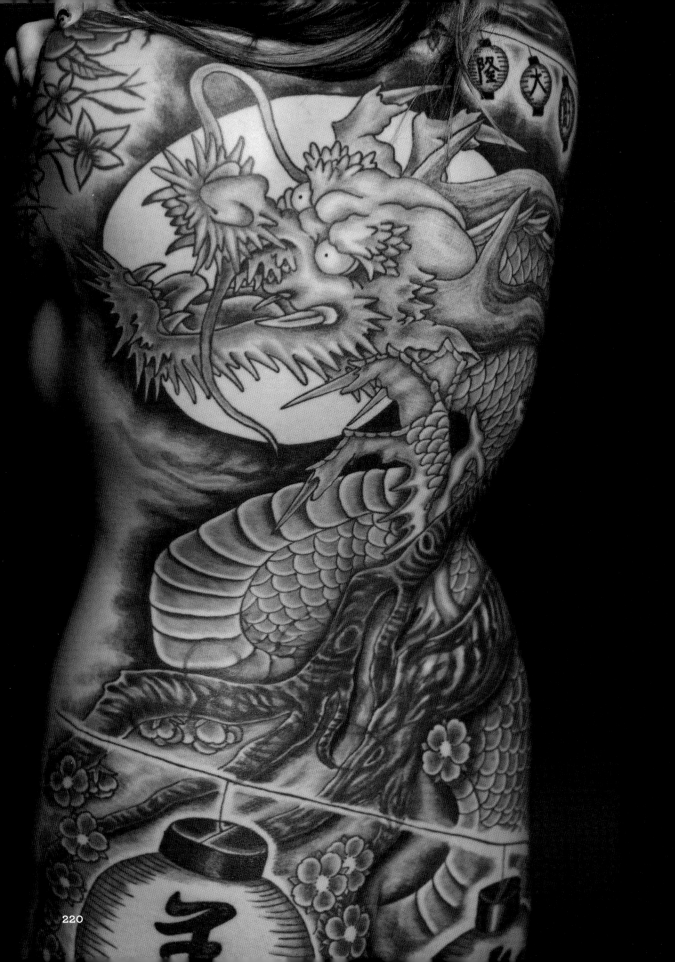

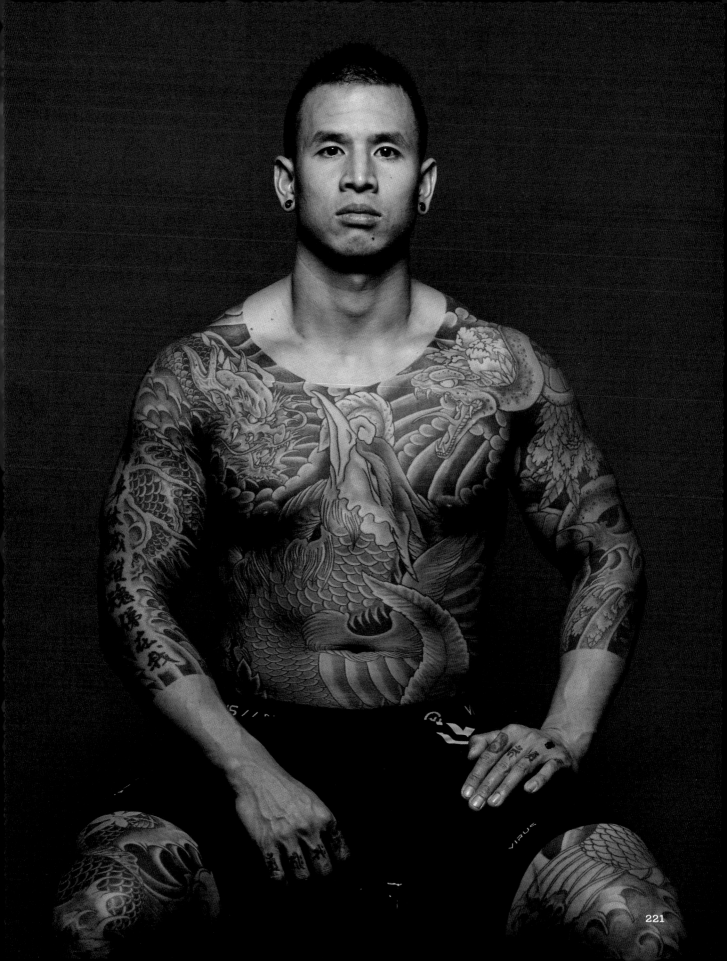

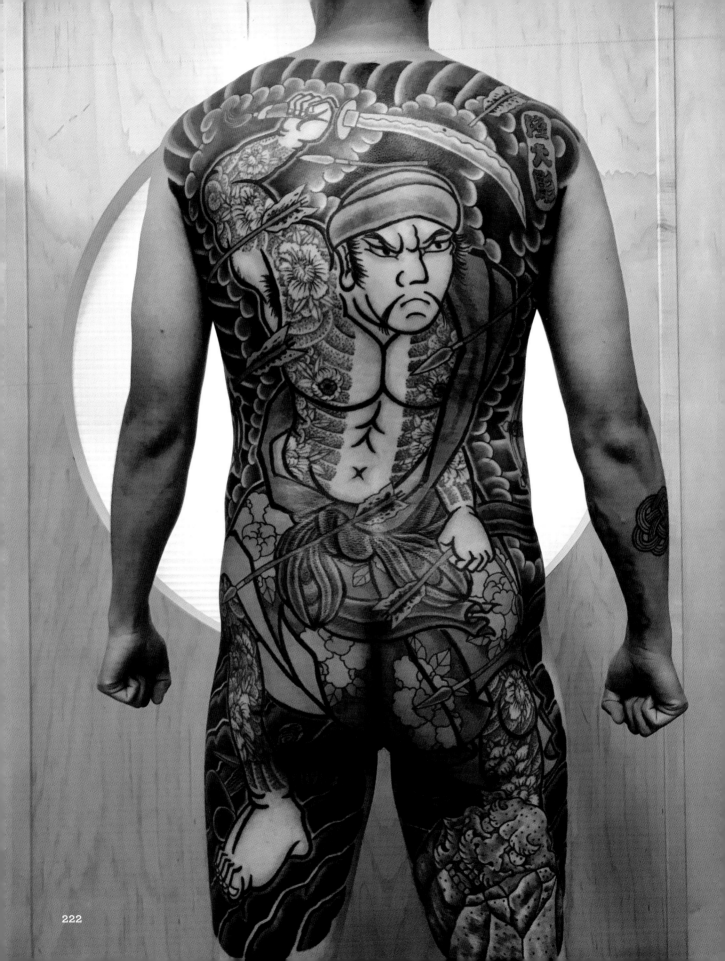

223

ABOUT *the* AUTHOR

Molly Kitamura has worked in the restaurant industry for over 20 years, 15 of which were as a sushi chef. She has worked and lived in nine countries around the world, including in South America, Europe, and Asia. Her love of tattoos and food gave her the inspiration to put this book together. Molly now lives in the US with her husband and her two French bulldogs, Mr. K and Chaja, and cooks for her family and friends.

John Agcaoili is a freelance photographer and the cofounder of Darkside of the Moon, a production company based in California's Silicon Valley. He is an avid content creator and director of photography of the award-winning short film *Reproach*. John graduated from the Art Institute of San Francisco in 2010 with a degree in media arts and animation. He has lectured on cinematography and lighting at Adobe Systems. John's signature photography style is clean, artful, and classic. Throughout the years, he has found inspiration in collaborating with some of the most influential artists of our generation.